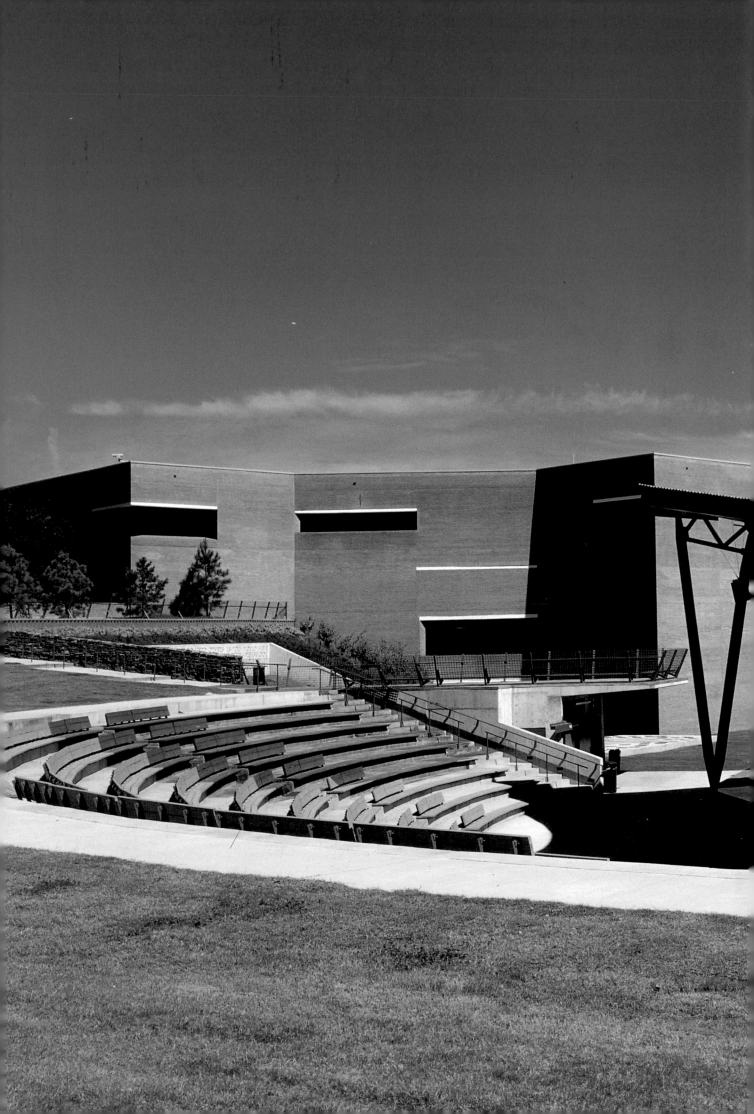

EDITOR: REBECCA MARTIN NAGY
COPYEDITOR: JUNE SPENCE
CONSULTING EDITOR: VIKI BALKCUM
DESIGNER: DEBORAH LITTLEJOHN
PHOTOGRAPHERS: BILL GAGE, KAREN MALINOFSKI, LYNN RUCK, GLENN TUCKER
PHOTOGRAPHIC ARCHIVIST: WILLIAM HOLLOMAN
PRODUCTION ASSISTANTS: KIM BLEVINS, TRACY MARION

PRINTER: AMILCARE PIZZI, S.P.A., MILAN

The publication of this book was made possible by generous gifts from the First Union Foundation, the John Wesley and Anna Hodgin Hanes Foundation, the Broyhill Family Foundation, Inc., and a grant from the National Endowment for the Arts.

COVER: *The Green Bridge II* (detail) by Lyonel Feininger, American, 1871–1956. For complete image see page 216.
FRONTISPIECE: View of NCMA and Museum Park Theater.

The North Carolina Museum of Art, Lawrence J. Wheeler, Director, is an agency of the North Carolina Department of Cultural Resources, Betty Ray McCain, Secretary. Operating support is provided through state appropriations and generous contributions from individuals, foundations, and businesses.

DISTRIBUTED BY HUDSON HILLS PRESS, INC.
122 East 25th St. 5th Floor
New York, NY 10010
Editor and Publisher: Paul Anbinder
Distribution in the United States, its territories and possessions, and Canada through National Book Network.
Distribution in the United Kingdom, Eire, and Europe through Art Books International, Ltd.
Exclusive representation in China through Cassidy and Associates, Inc.

Library of Congress catalogue number 97-076050
ISBN 0-88259-978-X

Contents

Preparation of the *North Carolina Museum of Art Handbook of the Collections* has been a group effort dependent on the hard work and cooperative spirit of many individuals. For their thoughtful authorship of entries on works of art in the collections, sincere thanks are extended to John W. Coffey, Chair of the Curatorial department; Joseph P. Covington, Director of Educational Services; Daniel P. Gottlieb, Museum Planner; Dr. Abram Kanof, Adjunct Curator of Judaica; Huston Paschal, Associate Curator of Modern Art; Mary Ellen Soles, Curator of Ancient Art; David Steel, Curator of European Art; and Dennis Weller, Associate Curator of European Art. Former Curatorial Assistant Virginia Burden also wrote several entries. Gratitude is due to Museum Director Lawrence J. Wheeler for his support and encouragement of the *Handbook* team, and for his introduction, which provides a lively and informative history of the Museum since its founding fifty years ago.

In its earliest phases the *Handbook* project was shepherded by Lisa Eveleigh, former Museum editor, whose capable organization facilitated subsequent work on the book. Its successful completion was made possible by the hard work and expertise of June Spence, copyeditor for the project, who was lured away from her own creative writing to assist Museum staff members with this undertaking. Viki Balkcum, Museum Publications Editor, provided valuable advice and assistance as consulting editor. Art historian Kristine K. Door read the completed text. Her astute suggestions have been incorporated into the book to its decided improvement. Hanif Miller, an intern in the Education department, assisted in preparation of the glossary.

In numerous ways Museum Registrar Carrie Hedrick and her staff, especially Michael Klauke, Museum Cataloguer, have contributed to the timely and successful publication of the *Handbook*. The beautiful photographs are the work of present and former members of the Museum staff: Bill Gage, Chief Photographer; Karen Malinofski, Assistant Photographer; and before them Glenn Tucker and Lynn Ruck. Photographic Archivist William Holloman was an essential member of the team.

The handsome design of the *Handbook* is the achievement of Deborah Littlejohn, Chief Graphic Designer, whose outstanding work has been encouraged and supported by Stephanie Miller, Chief Designer, and other members of the Design department.

Publication of the *Handbook* would not have been possible without generous financial support from the First Union Foundation, the John Wesley and Anna Hodgin Hanes Foundation, the Broyhill Family Foundation, Inc., and the National Endowment for the Arts. To these four organizations the Museum is exceedingly grateful.

Rebecca Martin Nagy
Associate Director of Education and
Curator of African Art

Introductory essays were written by Rebecca Martin Nagy.
Authors of all other entries are identified by initials.

VIRGINIA BURDEN	*VB*
JOHN W. COFFEY	*JWC*
JOSEPH P. COVINGTON	*JPC*
DANIEL P. GOTTLIEB	*DPG*
ABRAM KANOF	*AK*
REBECCA MARTIN NAGY	*RMN*
HUSTON PASCHAL	*HP*
MARY ELLEN SOLES	*MES*
DAVID STEEL	*DS*
DENNIS WELLER	*DW*

Introduction

THE CREATION OF THE NORTH CAROLINA MUSEUM OF ART and its distinguished collection is in many ways an expression of the impulses, vicissitudes, and opportunities of the twentieth century, especially as they came to characterize and shape the American South. The Museum was not born of a single action, though the appropriation act by the North Carolina General Assembly on April 5, 1947, merits singular celebration. The act stipulated that $1 million in public funds were to be set aside and matched to assemble a collection of Old Master paintings for the people of North Carolina.

At the beginning of the twentieth century there were three fledgling art museums in the South: the Gibbes in Charleston, the Telfair in Savannah, and the Valentine in Richmond. The great centers of industry and commerce in the Northeast and Midwest, such as Boston, New York, Philadelphia, and Chicago, had already established important museums boasting the best of mankind's artistic genius. These secular temples, objects of civic and social pride, were symbols of the growing prosperity and cosmopolitan quality of life in those cities, at least for some of their citizens. These museums became, as well, poignant reminders to the post-Civil War South of its economic inferiority and its slow pace in catching up with the industrialized world. In a 1917 essay for the New York *Evening Mail*, Baltimore pundit H. L. Mencken pointedly reminded these volatile Southerners that they continued to live in "the Sahara of the Bozarts."

From these psychic wounds poured determination, at least in North Carolina, to provide rich cultural and educational opportunities for the struggling people of the state. In 1924 a group of citizen leaders formed the Fine Arts Society, whose purpose was to create an art collection and museum for the people of North Carolina. (So much for the oft-quoted characterization of North Carolina as "the vale of humility between two mountains of conceit.") This museum would be different from those mentioned above, as it would emerge from the leadership of an entire state and not serve merely a single locality.

Fortuitously, in 1927 North Carolina native Robert F. Phifer, a wealthy businessman who had resided in New York for many years, bequeathed to the new Fine Arts Society his collection of paintings as well as endowment funds for the subsequent purchase of works of art. On view in the galleries today is William Merritt Chase's *The Artist's Daughter, Alice* from the original Phifer gift. The Phifer Trust, by 1997, had provided funds for the purchase of more than 250 works of art for the permanent collection.

Gerhard Richter's *Station (577-2)*, acquired in 1996, forms the central point of this view from the Museum entrance.

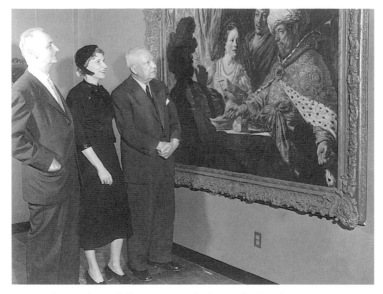

Director William R. Valentiner (left) views Jan Lievens's *The Feast of Esther* with Museum visitors. Reprinted by permission of the NC Division of Archives and History and *The News & Observer* of Raleigh, North Carolina.

With the advent of the Great Depression and the subsequent world war, efforts by the North Carolina State Art Society (so named when placed under state patronage in 1929) to create a comprehensive state art museum came to naught. The state, however, did provide gallery space in government buildings for the temporary exhibition of art from New York galleries and local artists.

It was not until the conclusion of World War II that commitment and conditions converged to favor the long-sought art museum for North Carolina. Into the general prosperity of the postwar era strode Robert Lee Humber. Having lived for many years in Paris as an international attorney, Humber returned in 1940 to his hometown of Greenville and almost immediately embraced the Art Society's cherished goal of establishing an art museum. Following a failed statewide effort to raise $50,000 for the museum, Humber, as chairman of the Citizen's Committee for a State Art Gallery, went in 1943 to New York, where he engineered an introduction to Samuel H. Kress. Kress, a national five-and-dime store magnate, had assembled one of the great collections of European art, primarily Italian pictures from the early Renaissance forward. Humber succeeded in securing from the philanthropist a verbal commitment to contribute $1 million to help establish a state art museum, but Kress insisted that his identity remain anonymous.

Armed with this extraordinary pledge, Humber hastily leveraged political support from Governor Gregg Cherry and key legislative leaders to gain a $1 million grant to match the promised Kress gift. Despite the favorable fiscal circumstances, North Carolina was still socially and politically quite conservative. There was no certainty that the recurring topic of establishing a state art museum would

find satisfactory resolution. Representative John H. Kerr, Jr., of Warrenton, however, introduced the museum legislation in a persuasive — now famous — speech, with the opening words: "Mr. Speaker, I know that I am facing a hostile audience, but man cannot live by bread alone."

Finally, by the narrowest of margins, on April 5, 1947, the appropriation was passed with the provision that it be matched by private gifts. The matching private gift, however, was in jeopardy. As a result of Samuel Kress's failing health, Rush H. Kress, his younger brother, had assumed the management of the Samuel H. Kress Foundation. He could find no confirmation of the verbal pledge of Samuel Kress to Robert Lee Humber. Following months of persistent effort by Humber, Rush Kress in early 1951 assured Humber that the Kress Foundation would cooperate with the state's efforts to create the museum by naming it as a regional gallery that would receive a Kress collection of paintings "consisting of outstanding Italian Renaissance Art and other similar paintings of a value of at least one million dollars." The state agreed that this arrangement met the requirements of the matching provision of the 1947 legislation.

1951 and 1952 were pivotal years in crafting a collection of the art of Western civilization for the people of North Carolina. The remarkable promise of the Kress Foundation liberated the newly appointed five-member Art Commission to seek American art and other European works to complement the probable Kress Italian gifts, thereby fulfilling their mission of assembling a survey of Western painting from the Renaissance to the end of the nineteenth century. Carl Hamilton, a highly regarded New York art dealer and collector, was appointed as consultant to the Art Commission. It was Hamilton who orchestrated the contacts with dealers who could provide the types and quality of art being sought. In all, 147 works were acquired with the $1 million appropriation (and an additional 21 purchased with a combination of state and private funds) at prices ranging from a few hundred dollars

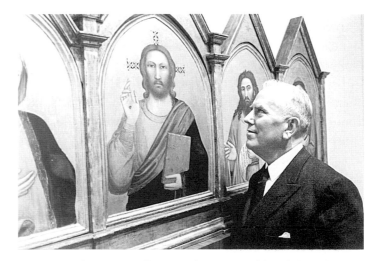

Robert Lee Humber admires The "Peruzzi Altarpiece" by Giotto and assistants, one of the works donated by the Kress Foundation. Reprinted by permission of the NC Division of Archives and History and The News & Observer of Raleigh, North Carolina.

to as much as $65,000. The imagination of the international art world was stirred by this improbable sequence of events in Raleigh, North Carolina.

As plans moved forward to develop the former State Highway Building on Morgan Street in Raleigh into the first home of the North Carolina Museum of Art, a major figure who became key to shaping the collections was entering the stage. William R. Valentiner was an eminent scholar in the fields of Italian Renaissance sculpture, Dutch seventeenth-century painting, and German modern art. He was director of the Detroit Institute of Arts (1924 – 45), co-director of the Los Angeles County Museum (1946 – 49), and founding director of the J. Paul Getty Museum (1954 – 55). The Art Commission asked Valentiner to review and approve the proposed art purchases from the state appropriation. The agreement by Valentiner to appraise the chosen works of art for North Carolina was fortuitous. In 1955 he was invited to become the first director of the new North Carolina Museum of Art. It was of extraordinary significance to this fledgling art gallery in the agrarian South that one of the most respected art connoisseurs and art museum directors in America accepted the post.

Valentiner's enormous responsibilities included organizing the plan for installing the new collection so that the building could open to the public by the spring of 1956. (The Kress gifts would not be agreed upon and made available to the Museum until 1960.) To assist him in this mammoth effort, he brought in James Byrnes, director of the Colorado Springs Fine Arts Center and previously Valentiner's assistant in Los Angeles. Together with a minuscule staff, they achieved a presentation of the collection at high standards of professionalism and design, qualities which would endure as hallmarks of North Carolina's art museum. When the NCMA opened on April 6, 1956, crowds of blockbuster proportions were thrilled with the result of a decade of brilliant and focused leadership committed to gathering great examples of Western civilization's art into the trust of the people of North Carolina. On view in the new Museum were works by Jacob van Ruisdael, Jan Steen, Peter Paul Rubens, Jacob Jordaens, Pierre Mignard, Claude Lorrain, Bartolomé Esteban Murillo, Luis Meléndez, Bernardo Bellotto, Canaletto, François Boucher, Elisabeth Louise Vigée Le Brun, Thomas Gainsborough, Jean-François Millet, John Singleton Copley, Thomas Cole, Winslow Homer, and George Inness.

Until Valentiner's retirement and subsequent death in 1958, he continued to expand the program, the collections, and certainly the reputation of the Museum. He instituted the *North Carolina Museum of Art Bulletin*, for which he wrote most of the scholarly articles; he organized the international loan exhibition *Rembrandt and His Pupils*, which premiered at the brand new Museum in 1956, the 350th anniversary of Rembrandt's birth; he installed new galleries of Egyptian, Greek, and Roman art; he developed broad-ranging education programs for the public; he instituted a research library to which he left his exceptional book collection; he organized the first museum-sponsored exhibition in the United States on the German Expressionist painter Ernst Ludwig Kirchner; he gave and sought gifts of twentieth-century works

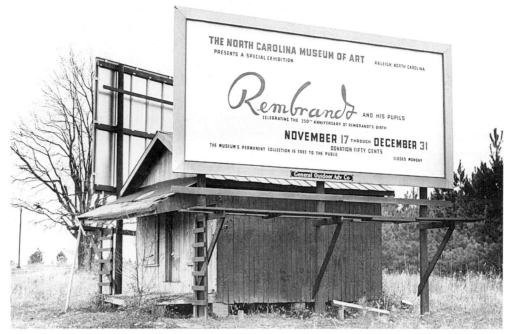

Billboards announced the 1956 Rembrandt exhibition across the state.

of art for the collection; and he participated in defining the Kress gifts to the Museum.

The largest and most significant Kress gift, except that given to the National Gallery of Art in Washington, D.C., was bestowed on the North Carolina Museum of Art. Sixty-nine paintings and two sculptures, mostly Italian from the fourteenth to the eighteenth centuries, but also including Dutch, Flemish, German, and French works from the same era, were agreed upon between 1958 and 1961. The formidable core of the Kress gift was presented to the public in November of 1960. As a result of this extraordinary gesture, the collection of the NCMA now included works by Giotto, Botticelli, Titian, Paolo Veronese, Domenichino, Massimo Stanzione, Alessandro Magnasco, Pompeo Batoni, Lucas Cranach the Younger, and Hendrick Ter Brugghen. Almost suddenly, a museum of national importance had appeared.

While distinguished works of art were added in the 1960s, supported by state appropriations and income from the Art Society's Phifer Bequest, the scale of acquisitions declined while development of new programs, including the experimental Mary Duke Biddle Gallery for the Blind, increased. Dr. Justus Bier, an authority on the Late Gothic German sculptor Tilmann Riemenschneider, directed the Museum from 1961 to 1970. Bier's exhibition *Sculptures of Tilmann Riemenschneider*, the first devoted to the master outside of Germany, brought international attention to the young Museum and resulted in the acquisition of Riemenschneider's great sculpture *Female Saint* with funds from the North Carolina Art Society (Robert F. Phifer Bequest) and the State of North Carolina. The Museum's twentieth anniversary in 1967 inspired a number of gifts to the collection, including works by Eugène Boudin

5

Paintings arrive at the new Museum on Morgan Street for the *Valentiner Memorial Exhibition* in 1959.

from N.C. National Bank (now NationsBank), Camille Pissarro from Wachovia Bank, and the acquisition with state funds of Claude Monet's *The Cliff, Etretat, Sunset* and Thomas Eakins's *Portrait of Dr. Albert C. Getchell.*

The state office building housing the NCMA was intended from the outset to be temporary. On July 5, 1967, during the Museum's twentieth anniversary year, the N.C. General Assembly created the State Art Museum Building Commission, whose mission was to select a site to build a new museum facility. Senator Thomas White of Kinston chaired the commission until the conclusion of its work in 1983. The building commission studied population trends, traffic patterns, and a broad range of technical issues relating to the impact of future growth on a museum site. It then stated a preference for a site on Blue Ridge Road on the western edge of Raleigh and on the threshold of the emerging Research Triangle Park.

By early 1973, as all official approvals were given to the Blue Ridge location, a public outcry insisted that the Museum should remain in downtown Raleigh. A series of lawsuits and appeals resulted in the Supreme Court of North Carolina ruling in 1975 to uphold the authority of the State Art Museum Building Commission to select the site. Edward Durrell Stone, an architect of international importance and designer of the N.C. Legislative Building and the Museum of Modern Art in New York, and Holloway Reeves of Raleigh were chosen as the architects for the new Museum intended to span some of the 174 acres assigned to it. However, by 1975 inflation was running rampant and the $10.75 million appropriated by the state was insufficient to realize Stone's architectural goals. The size of the building was reduced, the design modified, and a private effort was initiated to raise an additional $5 million. In 1977 construction began, and on April 5, 1983, the completed 181,000 square-foot building with its stunning installations, four times the size of the Morgan Street facility, opened to the public.

Moussa Domit, director from 1974 to 1980, had overseen the development of the program plan that would drive the design for the new Museum, but it was

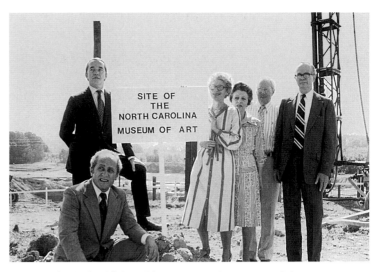

Director Moussa Domit (kneeling) with (left to right) Roy Lawrence, Beth Cummings Paschal, Mrs. Dan K. Moore, Gordon Hanes, and Joseph C. Sloane at the construction site for the new Museum in 1977.

under the directorship of Edgar Peters Bowron, previously curator of Renaissance and Baroque art at the Nelson-Atkins Museum in Kansas City, that the new Museum was given life. Director from 1981 to 1985, Bowron determined the design aesthetics, lighting systems, organization of galleries, and the philosophy for presenting and interpreting the collections. The result, much of which the visitor experiences today, was beautiful, fresh, and thrilling for the audience. Bowron, as well, added professional strength to the staff with the selection of curators, educators, conservators, and designers with proven experience and credentials.

The collection was augmented and expanded into new directions under the tutelage of Domit and Bowron. With the partnership of magnanimous new patrons Mr. And Mrs. Gordon Hanes of Winston-Salem, exceptional examples of Egyptian, Greek, Roman, African, New World, Oceanic, and twentieth-century art were added to the expanding collection. In all, 288 works of art were given by Mr. and Mrs. Hanes and their affiliated foundations between 1968 and 1997, including major works by Henry Moore, Morris Louis, and Frank Stella. The unflagging generosity of the Haneses is evident in virtually all of the galleries of the Museum. During the same period, Dr. Abram Kanof and his wife, Dr. Frances Pascher Kanof, contributed an exemplary collection of Jewish ceremonial objects around which they organized additional gifts. The Judaic art collection, now presented in a permanent gallery, adds a rich dimension to the Museum's core collection.

Once the new Museum facility was professionally staffed and the program defined, considerable effort was invested in assessing the collection, with an eye toward deaccessioning material of faulty attribution and below the quality of the collection on view. With resources gained from the sale at auction, the Museum, under the directorship of Richard Schneiderman, added strength to sections of the European collection with the addition of Pierre Peyron's *Death of Alcestis*, the Antonio Canova Studio sculpture of *Venus Italica*, Pieter Aertsen's *A Meat Stall with the Holy Family Giving Alms*, as well as a fine example of John Singleton Copley's

American portraiture, *Mrs. James Russell (Katherine Graves)*. Under my direction, funds from deaccessioning have been used to acquire the monumental Anselm Kiefer triptych, an excellent collage by Romare Bearden, and the Roman bronze *Head of a Woman in the Guise of a Goddess*.

Schneiderman oversaw, as well, a thoughtful consideration of how the 147 acres of land surrounding the Museum should be used and programmed. A national competition for team-driven concepts, funded by the National Endowment for the Arts, resulted in the acceptance of the plan *Art + Landscape* from the team of architects Henry Smith-Miller and Laurie Hawkinson, artist Barbara Kruger, and landscape architect Nicholas Quinnell, all of New York. The concept defined zones in the landscape that would be programmed for both formal sculptural installations and temporary interactive pieces. The goal was to provide visitors with exciting arts experiences while they explored the landscape. The first expression of the plan was the completion in 1996 of the Joseph M. Bryan, Jr. Theater, a center for performance and film woven into Barbara Kruger's large scale (eighty foot) letters spelling "PICTURE THIS" on the landscape. The project has received international architectural acclaim and awards.

As the Museum charts its course for a dynamic future propelled by a developing prosperity in the region and a burgeoning population interested in the arts, it seeks to add significant space to the building for education, public programs, and the growing collection. Moreover, the Museum is advancing its efforts to extend knowledge about its exceptional collections to the public that owns them by developing computer programs for schools, colleges and universities, and homes statewide.

Central, of course, to a meaningful future for the Museum is the integrity of the collections and the quality of their presentation to the public. Even before the expansion of the building is completed, the Museum will reinstall, with updated modes of interpretation, its entire permanent collection. The recent addition of major works of the twentieth century to the public trust indicates the Museum's strong

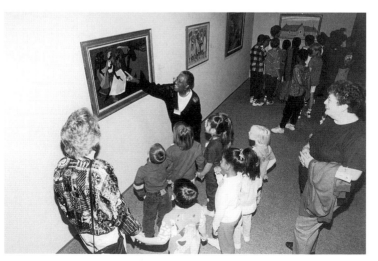

Museum docent Helen Sanders discusses with students an episode from the life of Harriet Tubman as portrayed by Jacob Lawrence in his painting *Forward*.

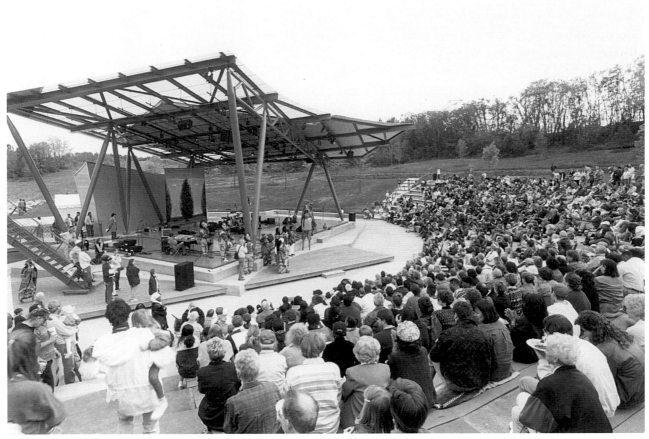

The crowd enjoys a performance by the Chuck Davis African American Dance Ensemble and the Turtle Vision Powwow Dancers at the festive opening of the Joseph M. Bryan, Jr. Theater in the Museum Park in April 1997.

commitment to acquiring great works of our own time. This move does not diminish in any way the Museum's established tradition of adding works of art of world-class stature from Europe, the Americas, Africa, and Oceania.

Published on the occasion of the Museum's fiftieth anniversary, this handbook is a manifestation of our commitment at the NCMA to assist our visitors and our public in gaining knowledge about a collection of art which points to high moments of mankind's creative genius. May you experience inspiration, delectation, awe, and tranquillity. And may you discover the questions, too.

Lawrence J. Wheeler
Director

9

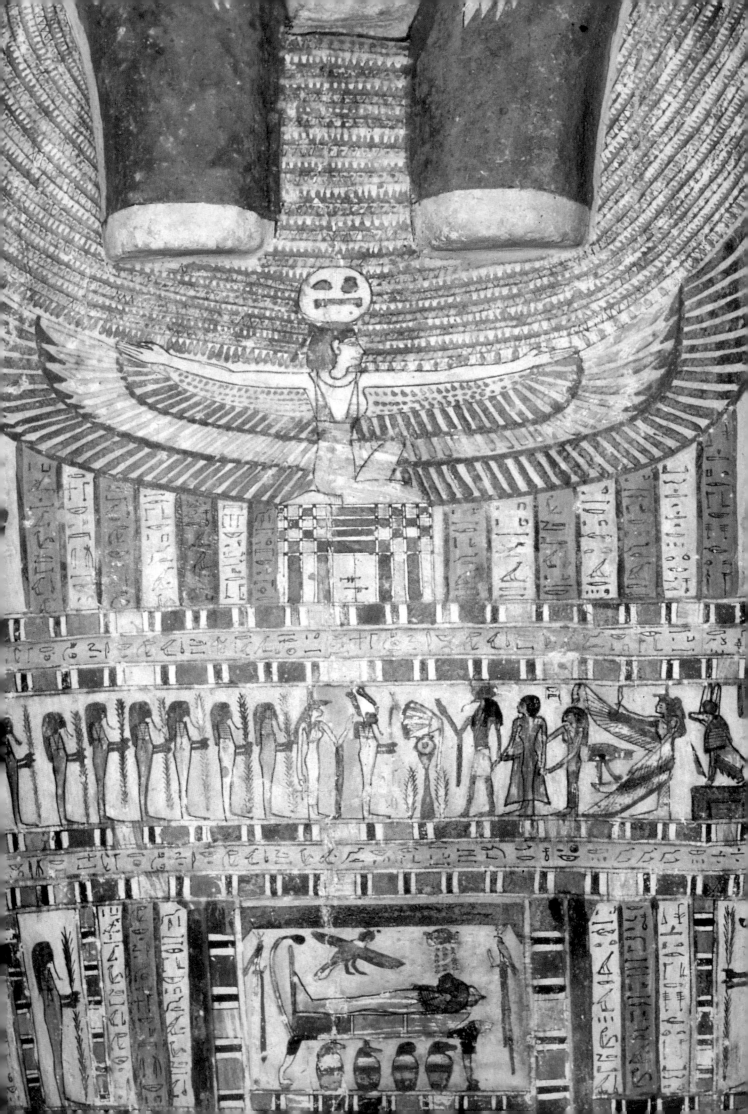

Ancient Egyptian Art

ANCIENT EGYPTIAN CIVILIZATION, which developed along the narrow floodplain of the Nile River, enjoyed continuity in environmental conditions and relative political stability for three thousand years. In a land marked by the reliable annual flooding of the Nile, the Egyptians came to value predictability and permanence in politics, religion, and art. Having once established standards for the representation of humans, animals, and the natural world in sculpture and painting, Egyptian artists observed these ideals throughout the millennia, deviating only rarely from established traditions. It is easy, therefore, to recognize a work of art as Egyptian, whether it was made in the Old Kingdom five thousand years ago (the *Striding Man* in the NCMA's collection, for example) or during the Ptolemaic period after the conquest of Egypt by the armies of Alexander the Great in 332 B.C. (the Museum's cartonnage *Mummy Covering*).

The vast majority of Egyptian objects found in museums today were preserved in tombs; relatively few works of art survive from other contexts, such as mortuary and cult temples. Although due in part to accidents of survival, this fact reflects to a great degree the preoccupation of ancient Egyptian society with preparation for the afterlife. Although reserved at first for the pharaoh, his family, and members of his court, over time solidly constructed and well-furnished tombs of various types, shapes, and sizes were provided for all those who had the financial means to prepare in this way for the next world.

The Egyptians believed that they would continue to enjoy the pleasures of this life after death. To make use of food and drink, beautiful furnishings, and all the other joys of life, however, the deceased must have a body and adequate provisions in the tomb. This conviction gave rise to the development of elaborate processes for mummifying the body so that it would endure throughout eternity as a vessel for the soul. Actual grave goods were supplemented with depictions in sculpture and painting, which the Egyptians believed magically would become real when required in the next world.

Old Kingdom, end of
Dynasty VI

**Reliefs from the
Tomb of Khnumti
in Saqqarah**,
about 2181 B.C.

Limestone
23 7/8 x 19 5/8 in.
(60.5 x 50.0 cm) and
21 1/2 x 18 15/16 in.
(54.4 x 48.0 cm)

Gift of the James G.
Hanes Memorial Fund,
1972 (72.2.1/2)

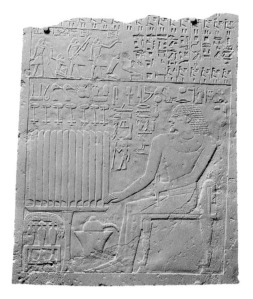

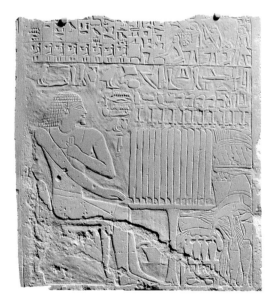

These reliefs from a tomb chapel symbolically provide for the needs of the deceased through all eternity. In one scene (top), Khnumti, identified by an inscription as a lector priest (one who reads sacred texts for religious observances), is seated before a table on which stand twelve loaves of bread. Beneath it sit a variety of vessels and a bundle of leeks. Khnumti wears a kilt and a broad collar on which floral details would have been painted. In conformity with Egyptian sculptural practice, Khnumti's head, arms, and legs are seen in profile, while his eye, shoulder, and torso are shown frontally.

The hieroglyphic text above Khnumti's head promises him bread, beer, cattle, fowl, alabaster, and linen, and the line of repeated plant symbols below indicates thousands of these provisions. Columns of text in sunken relief below the broken top edge extend a menu of offerings. This list is invoked by the five officials visible at the upper left, three of whom wear sashes identifying them as lector priests like Khnumti. The first figure kneels before a low offering table; the last walks away from the scene, dragging a herbal broom to clean and perfume the chamber in final preparation of the tomb for Khnumti's afterlife.

The second relief (bottom) from the same tomb was originally part of a panel on the opposite wall. Almost a mirror image of the other relief, its differences provide information on the technique of the ancient sculptor. The figure of Khnumti is seated in a similar pose, but in order to portray both the right arm reaching toward the table and the whole left arm with its hand holding a folded cloth, the left arm is bent awkwardly back across the chest. The area beside the table features a wealth of offerings, including fruits and vegetables, vessels, and a trussed duck. Most of these offerings are only outlined with incision, a preliminary step to removing the stone from the background to create the low raised relief seen in the more finished section of the panel. The inscription above the figural scene is striking in its unfinished state, with the marks of the chisel still visible in the background. It is tempting to suppose that the hasty execution of this panel was due to the unexpected need to prepare quickly for Khnumti's burial.

MES

Old Kingdom,
Dynasty V, about
2494 – 2345 B.C.

Figure of a Man

Wood with traces
of gesso and paint
h. 52 1/4 in.
(132.7 cm)

Gift of Mr. and Mrs.
Gordon Hanes, 1979
(79.6.3)

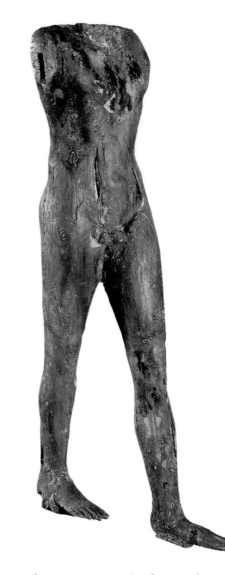

Like the vast majority of Egyptian artworks, this wooden statue of a nude male survives because it was sealed in a tomb for thousands of years. It was probably originally in the *serdab* chamber of a tomb, where funerary statues of the deceased were placed to watch over offering ceremonies through eternity; the tomb, known as a *mastaba*, was probably located at Saqqarah, the great aristocratic cemetery area of ancient Memphis (near modern Cairo).

Poised in the conventional Egyptian stance of left leg forward but weight evenly distributed on both feet, this wooden statue of a nude male was covered with a layer of gesso (plaster) that was painted red. His ruddy complexion underscores his participation in the outdoor activities reserved for men. Representations of nudes are rare in ancient Egypt, so the statue may have worn a linen kilt that has not survived. The separately attached arms, now missing, may have held insignia identifying his rank or position.

Without these emblems or the head, or exact knowledge of the place of discovery, the identity of the statue remains anonymous, but some information can be deduced. The expense of large pieces of wood suitable for such finely modeled sculpture suggests that the deceased was a wealthy official.

MES

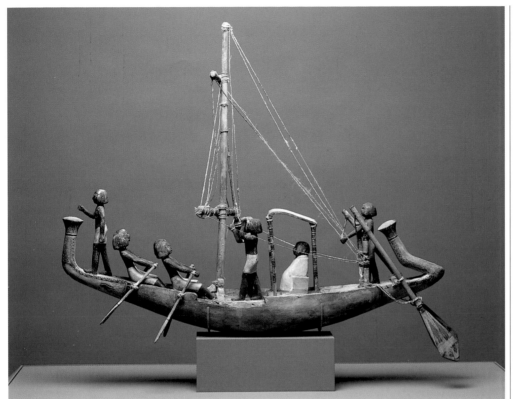

Middle Kingdom,
Dynasties XII – XIII,
about 1991 – 1633 B.C.

Model of a Boat

Wood, gesso, paint, twine
h. 30 1/2 x w. 20 1/2
x l. 41 in.
(77.5 x 52.0 x 104.0 cm)

Gift of Mr. and Mrs. Gordon
Hanes, 1982 (82.12)

Egyptians believed that the dead had to cross a stretch of water before they could achieve resurrection in the afterlife. In the Middle Kingdom, tombs were provided with models of boats to ensure that the deceased had transportation for the journey. This round-bottomed boat with prow and stern in the shape of stylized papyrus echoes the form of actual papyriform boats used on the Nile. It is steered by the helmsman with two steering-oars suspended at the stern. The craft was propelled by a broad sail (now missing) held by rigging, some of which survives intact, and attended by two sailors and four rowers. A pilot at the prow surveys the river ahead. The deceased, dressed in a close-fitting white garment, sits under a canopy with a curved roof as he impassively watches his progress toward the afterlife.

MES

New Kingdom, Reign of
Amenhotep III, about
1417 – 1379 B.C.

Goddess Sekhmet

Granite
h. 23 in.
(58.5 cm)

Gift of Mr. and Mrs.
Gordon Hanes, 1982
(82.11)

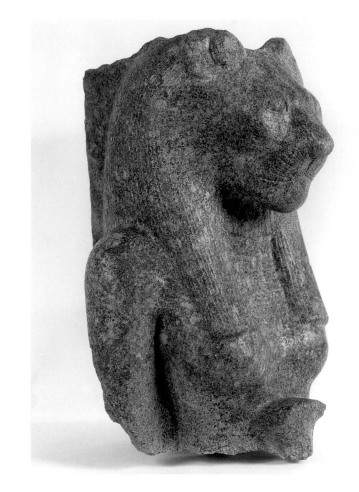

Sekhmet, whose name means "the mighty one," was a goddess of war, always allied with the king during battle. Her name may derive from the story of her terrible fury when her father, the sun god Re, sent her to earth to destroy humankind for plotting against him. After a great massacre, Re relented but was unable to restrain his daughter's bloodlust. He finally stopped the killing by flooding a field with beer, dyed red so that Sekhmet mistook it for blood and drank until pacified. Although Sekhmet brought death and disease, the Egyptians also credited her with the ability to cure illnesses, and she became the patron goddess of doctors. Her priests were the earliest known veterinarians.

This is one of the more than 600 granite statues of the lion-headed female goddess erected by King Amenhotep III in his mortuary temple and at the Temple of Mut at Karnak, where many remain in situ. Presented in standing and seated form, both types wore on top of the head a moon disc, now missing from this statue, and both originally stood more than two meters in height. The flower of the papyrus scepter visible beneath her breasts indicates that this statue stood erect, holding the scepter with her left hand. Her right would have held an ankh sign, the symbol of life, along the side of her body. The variegated color of the granite emphasizes the subtle carving of the lion's muzzle and the mane framing the face.

MES

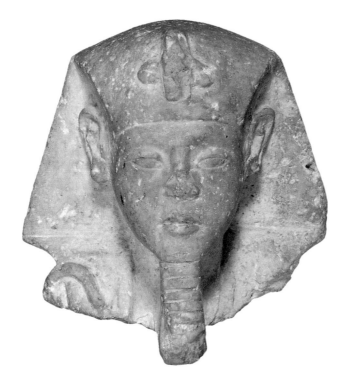

New Kingdom,
Dynasty XVIII,
Amarna Period,
about 1379 – 1362 B.C.

Head from a Shawabti of Akhenaten

Quartzite
h. 2 3/4 in.
(7.0 cm)

Gift of the James G.
Hanes Memorial Fund,
1974 (74.2.8)

To ensure the pharaoh's freedom from menial labor in the afterlife, at least two hundred *shawabti* figures were prepared for the tomb of Akhenaten at his capital Tell el Amarna, but none survived antiquity intact. These figures, whose name means "answerers," were intended to substitute for the king in labors he might be called upon to perform in the next world. As is characteristic for *shawabti* figures, they were mummiform in shape.

The bearded Akhenaten wears the pharaoh's striped headdress; the remains of the royal Uraeus, a serpent symbolic of the pharaoh's power, can be seen above his forehead. He also carried royal insignia, the scepter in the form of a crook and a flail of kingship, as witnessed by the tip of the crook on his right shoulder.

Akhenaten imposed sweeping religious reforms and instituted unprecedented changes in the style of Egyptian art. Here, the eyes slant slightly toward the nose and the lips are full and fleshy, subtle reminders of the curvilinear, naturalistic style of the art produced during Akhenaten's reign. His monotheistic worship of a sun god, Aten, and the use of exaggerated curves in the depiction of the human figure did not, however, survive his reign.

MES

Late Period,
Dynasty XXII – XXXIII,
about 945 – 715 B.C.

Coffin of Djed Mout

Wood, gesso, polychrome
h. 71 in.
(180.3 cm)

Gift of the James G.
Hanes Memorial Fund,
1973 (73.8.4)

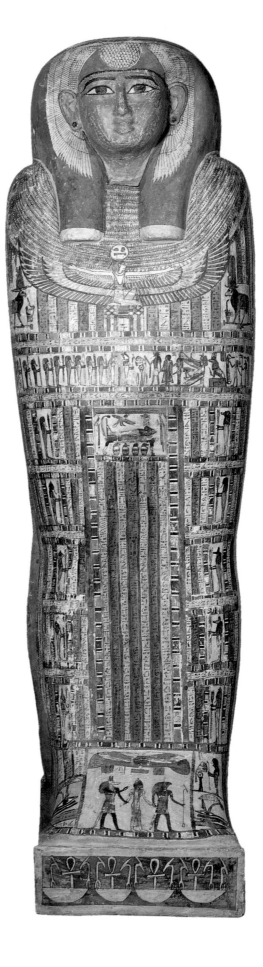

This wooden anthropoid coffin was the final resting place of the deceased, identified by hieroglyphic text on the back as Djed Mout, the daughter of Narht-Hor-erou; both father and daughter are otherwise unknown. The cover is in the form of a stylized woman representing the deceased; she wears a wig, and her face is framed by vulture's wings. The wings represent the protection of the goddess Isis, to whom the vulture is sacred. Below the broad and colorful pectoral collar that ends in falcon heads on the shoulders is the goddess Nut. Flanked by two rams, her wings outspread, Nut kneels atop a small shrine. Djed Mout is led by the ibis-headed god Thoth toward the mummiform god Osiris, who is accompanied by other protective deities in a frieze running across the front.

At the top of the central column, Djed Mout appears again on a bier. Over her flies the *ba*, the deceased's spirit that preserves her identity for eternity. Beneath the bier are four Canopic jars with heads of the four sons of Horus, who protect her liver, lungs, stomach, and intestines inside the jars. Over the lower section of the coffin, vertical lines of text from the Book of the Dead are interspersed with genies. This ritual text provided the deceased with spells and magic to safeguard her journey.

Djed Mout appears once more in the area of the feet, where she is shown between the gods Horus and Anubis. A protective snake lies along the whole length of the cover on both sides. The theme of protection carries over to the interior of the coffin, where Nut is depicted on both the lid and bottom, literally enveloping the mummy.

MES

Ptolemaic Period

Mummy Covering,
about 300 B.C.

Linen with gesso,
paint, and gilding
h. approx. 60 in.
(152.4 cm)

Purchased with funds
from the State of North
Carolina, 1975 (75.1.1)

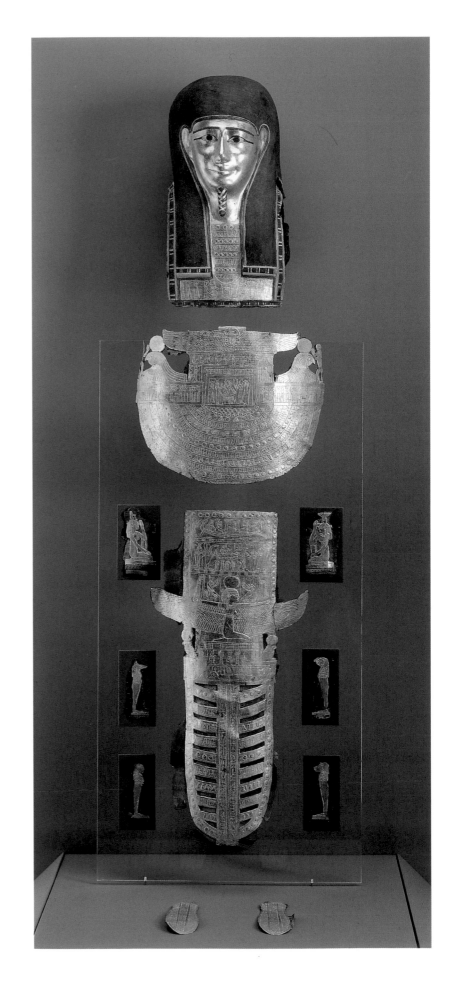

This cartonnage — linen stiffened with glue and covered with a thin coat of gilding — formed the top layer of the linen-wrapped mummy of the deceased. The lowest register of the funerary mask depicts the ceremony of the adoration of the heart, the organ regarded by the Egyptians as the seat of human emotions and intellect. Embossed and incised figures and scenes, designed to ensure a happy afterlife for the deceased, adorn the breastplate and the pieces covering the legs.

Two depictions of the falcon god Horus with a sun disc on his head protect the deceased. A winged scarab, the symbol of the perpetual daily rebirth of the sun, surmounts a depiction of a temple where Osiris, the god who oversaw the afterlife and resurrection, is worshipped by his wife Isis and her sister Nepthys. The goddess Nut, spreading her wings across the mummy's legs, protects the deceased, whose funeral boat and burial can be seen above her. Isis and Nepthys are also arrayed to the sides of the legs, as are the four sons of Horus. The golden soles placed beneath the mummy's feet prevented impure contact with the ground from defiling the dwelling of Osiris. The wrapped and covered mummy would have been placed inside a mummiform coffin.

MES

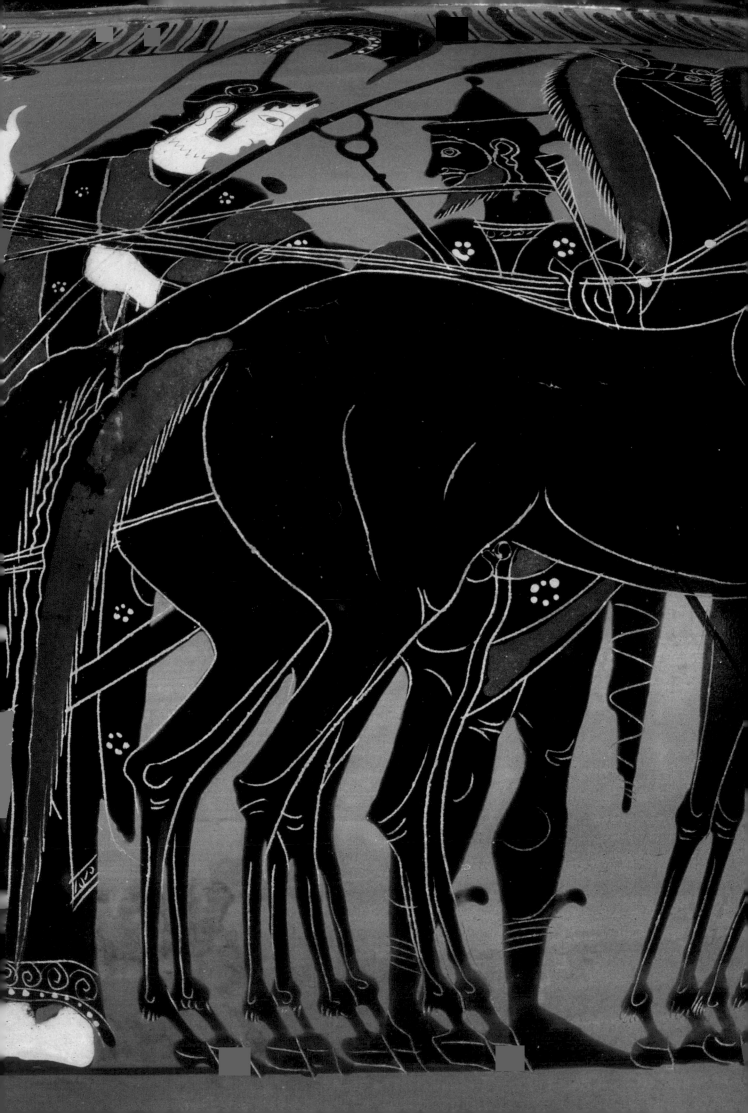

Classical Art

FROM ITS BEGINNINGS AROUND 900 B.C., Greek art underwent continuous and relatively rapid formal and stylistic changes. During the Archaic period (about 650–480 B.C.) artists moved toward a greater naturalism in representations of the human body, but retained from the earlier Geometric period (about 900–600 B.C.) a tendency to simplify anatomy and to emphasize repeating patterns in the rendering of hair and other details. The NCMA's *Cypriot Head* represents this Archaic phase of Greek art.

By the Classical period of the mid-fifth century B.C., sculptors and painters had thoroughly mastered the study of anatomy and of the body in motion and had achieved a completely natural portrayal of human figures. Greek art is also characterized, however, by a tendency to idealize the subject—whether god, hero, or mortal—as young, healthy, and beautiful. Such perfect figures embody the Greek concept of a healthy mind in a healthy body and the philosophy that "man is the measure of all things."

Whereas Greek buildings—temples, theaters, and other public structures—and marble sculptures survive in significant numbers, other aspects of Greek art can be studied only indirectly. The beautiful wall paintings described by ancient writers have not survived, but vase paintings may indicate the subjects and forms of those lost masterpieces. Few monumental bronze sculptures survive, but many Greek originals, in both marble and bronze, were copied during the Roman period.

Throughout the history of Rome, from the Republican period beginning around 500 B.C. through the Imperial period (27 B.C.–A.D. 395), the Romans admired and imitated the Greeks in many areas of life and art. During this time, however, they also made original contributions in art and architecture, as they did in other fields of endeavor, including law and governmental administration. With a practical turn of mind, the Romans excelled in architectural engineering, introducing the use of arches, vaults, domes, and concrete in the construction of immense public buildings as well as in structures such as bridges and aqueducts. In sculpture they emphasized unflinching realism and produced some of the most striking portraits of any period in the history of art.

Unlike the Greeks, who made portraits only of the great and famous, Roman artists portrayed people from all walks of life, from rulers to freed slaves. Well represented in the NCMA's collection are imperial portraits, with marble sculptures of Marcus Aurelius and Caracalla, and a bronze head that may be a likeness of Livia, wife of Augustus Caesar. Also included in these pages are the Museum's portraits of individuals from other social strata—a priest and his wife, and an intimate group portrait of a family of former slaves.

Steiner Master
Cycladic, Syros Group

Female Figurine,
about 2800 –
2400 B.C.

Marble
19 7/8 x 5 1/2 in.
(50.6 x 14.0 cm)

Gift of Mr. and Mrs.
Gordon Hanes, 1986
(86.5)

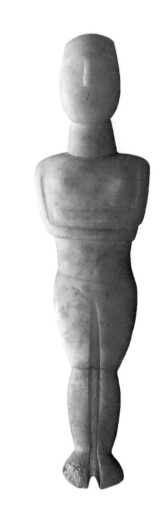

The Cyclades, small islands in the Aegean Sea between Greece and Turkey, had a flourishing Early Bronze Age culture, dating from about 3200 to 2000 B.C. Among the most memorable artifacts of that culture are the marble figurines that were placed in many graves. Most are female, like this one, holding her arms folded beneath the breasts, and reclining rather than standing, indicated by the extended position of the feet. The addition of painted details, such as the eyes, is attested in the ghost of an outline visible in certain light.

The simple geometry of the forms struck a responsive chord in modern artists and accounts for the great appeal of the figurines in the twentieth century. Unfortunately, this popularity led to the plundering of many Cycladic cemeteries in search of the figurines. With the resulting destruction of information on their contexts and the lack of any written documentation from this prehistoric period, interpretation of the meaning and function of the figurines is uncertain.

Scholars now group figurines according to elements of their style. Thus, the broad U-shaped head with its small, high-placed nose, and the distinctive profile with a thick torso and slender legs link our figure to an artist known as the Steiner Master, after the owners of the first figurine to be identified with this style.

MES

Greek, Attic, attributed
to the Three Line Group

Neck Amphora, about 530 – 520 B.C.

Black-figure ceramic
with added red and
white paint
h. 16 5/8 in.
(42.2 cm)

Purchased with funds
from the North Carolina
Art Society (Robert F.
Phifer Bequest), 1990
(90.2)

The figural scenes on this vase come from a rich mythological context. On one side, the hero Herakles is shown standing in a chariot, its four horses steadied by a groom. He wears an elaborate cloak and a lion skin draped protectively around his head. The skin is a trophy from the first of Herakles' twelve labors, the killing of the Nemean lion. His weapon in this exploit was the club, here carried on his shoulder. The goddess Athena gestures toward Herakles as she turns toward Hermes, the divine messenger and guide, who will lead the chariot to Olympus. There Herakles will claim immortality as the prize for the successful completion of his twelve labors.

On the other side, two men turn to one of the two horsemen flanking them. The central warrior armed with helmet, white shield, greaves, and long spear is the king of Ethiopia, Memnon, who went to the aid of his uncle Priam of Troy in his war with the Greeks. He is accompanied by a squire.

The name of the painter of this vase is unknown. The three lines that separate the bands of decoration under the figural scenes are characteristic of the otherwise anonymous painters of the Three Line Group, to whom this vase is attributed. These bands, the palmette and lotus chain on the neck, and the floral motifs by the handles form a rich decorative scheme that articulates the elements of the vase while focusing the viewer's eye on the drama of the figures.

MES

Greek, Attic, attributed to the Painter of the Brussels Oinochoai

Oinochoe, about 470 – 460 B.C.

Red-figure ceramic
h. 9 5/8 in.
(24.5 cm)

Purchased with funds from the North Carolina Museum of Art Foundation (Gift of Mr. and Mrs. Gordon Hanes), 1979 (79.11.5)

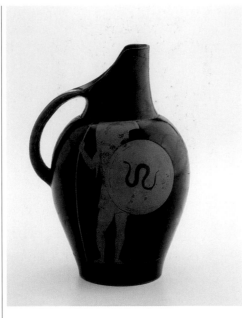 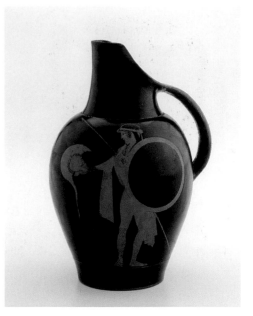

An *oinochoe* is a pitcher used for pouring wine. Highlighted against the surface background of black glaze, two warriors face each other. On one side, an older bearded warrior is armed for battle. He wears a short tunic known as a *chiton*, a cuirass (armor covering his breast and back), and a Corinthian helmet, and carries a spear and a shield on which is depicted a black snake. Standing frontally, he looks toward the youth on the other side. The young warrior is nude except for a long cloak or *chalmys*. His long ringlets are bound by a cloth headband. He carries a spear and plain black shield, and holds a Corinthian helmet in his outstretched right hand. The connection between the two figures established by the expressions and the gesture suggests that the younger warrior is receiving his arms in preparation for military service. Such arming scenes are common in Greek vase painting.

MES

Cypriot

*Head of a God
or Priest*, about
450 – 425 B.C.
Limestone
h. 15 in.
(38.1 cm)

Gift of Mr. and Mrs.
Gordon Hanes, 1979
(79.6.12)

Originally part of a life-sized statue, the head is crowned by a wreath of large bay leaves resting above berries and ivy, but is still without a specific identity. As one of the numerous offerings set up in a sanctuary in the eastern part of the island of Cyprus, the work may represent a god, a priest of the sanctuary, or even the donor of the statue. Large numbers of such statues were dedicated to deities, so many that it occasionally became necessary to bury old statues to make room for new. During the difficult moving process for the ceremonial burials, heads like this one must often have become detached from their bodies. Greek influence is evident in the form, transitional between the Archaic style (a stylized treatment as seen in the tightly curled locks of hair and beard, as well as the faint smile) and the Classical trend toward naturalism, also seen in the expression. Traces of red paint on the eyes, eyebrows, and hair remind us of the Greek practice of painting architecture and sculpture.

MES

Greek, from
Centuripe, Sicily

**Funerary Vase
(Lebes Gamikos)**,
about 225 –
200 B.C.

Terracotta, paint
h. 35 1/2 in.
(90.2 cm)

Purchased with funds
from the State of North
Carolina, 1975 (75.1.9)

Composed of several separate pieces, this vase is in the traditional form of a vessel presented as an offering to a bride on her wedding day. However, its unstable construction and fragile decoration, as well as the documented findspots of Centuripan vases in cemeteries, indicate its use as a funerary offering. The wealth of decorative detail blurs distinctions between the iconography of marriage and that of death. Applied three-dimensional decoration painted in bright colors and gold draws on the vocabulary of Classical architecture: moldings, leaves, flowers, a Doric frieze of triglyphs and metopes, offering vessels in the shape of bulls' heads, and human figures used as supports.

A separate miniature vase in the shape of a funerary vase (*lebes gamikos*) tops the larger vase and depicts the head of a winged female, perhaps Nike, goddess of Victory. The main panel, painted against a vivid pink background, centers on a bride flanked by attendants.

To the left a flying *Eros* profers a garland and a small naked child holds her arms up to the bride's attendants. On the far left, a woman surveys the scene, while on the right, a woman holding a tambourine seems to lead the procession toward a door, a symbol of the house of her groom or of Hades, god of the underworld. The appearance of protective friends, *Erotes* (cupids), and a Nike is appropriate for both of the major transitions of woman's life, marriage and death.

MES

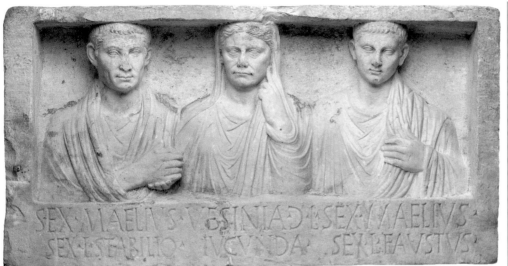

Roman

Funerary Monument for Sextus Maelius Stabilio, Vesinia Iucunda, and Sextus Maelius Faustus, early 1st century

Marble
h. 31 1/2 x w. 59 x d. 8 13/16 in.
(80 x 49.9 x 22.4 cm)

Purchased with funds from the State of North Carolina, 1979 (79.1.2)

This marble relief was carved to fit into the facade of a stone tomb that probably stood along a major road outside Rome. Information about the three people derives both from the Latin inscription at the bottom of the relief and the images themselves. The inscription names the three figures as Sextus Maelius Stabilio, Vesinia Iucunda, and Sextus Maelius Faustus, and indicates that the men were freed slaves of Sextus Maelius and that the woman was freed by a Roman matron named Vesinia. The letter "L" in the inscription is an abbreviation for *libertus*, meaning "freedman," or *liberta*, for "freedwoman." Such reliefs were often commissioned by recently enfranchised slaves and their families as a way of establishing the social and familial identity and relationships that had been legally denied to them.

The handshake shared by the older man and the woman identifies them as husband and wife. Iucunda also wears a bride's veil and her betrothal ring, and she holds her left hand to her face in a wife's traditional gesture of modesty. The younger man is probably the couple's son, born to them while they were still slaves. He may have been responsible for commissioning this monument. The emphasis on the symbols of marriage evident in this relief reflects the importance attached to the family during the reign of Augustus (27 B.C.–A.D. 14)

MES

Roman

*Head of a
Woman in
the Guise
of a Goddess*,
1st century

Copper alloy and silver
h. 11 5/8 in.
(29.5 cm)

Purchased with funds
from the North Carolina
Art Society (Robert F. Phifer
Bequest), the State of
North Carolina, and
various donors, by
exchange, 1995 (95.6)

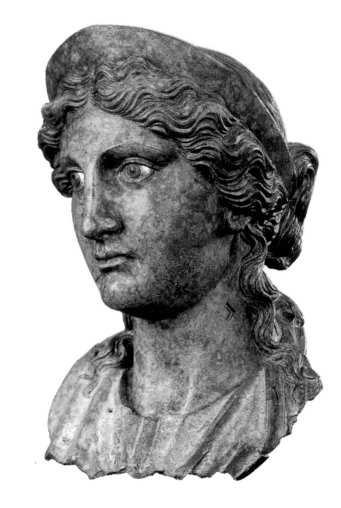

The striking appearance of this portrait is enhanced by the technique of the eyes. The pupils were inlaid with crystalline stone and the whites overlaid with sheet silver. The young woman wears her hair parted in the middle and knotted at the nape of the neck, with large, soft waves framing her face and tendrils escaping onto her shoulders. The lush hairdo suggests a visual link with the goddess Venus, who is characteristically portrayed with a similar coiffure. The diadem, usually worn by gods or deified rulers, also suggests the woman's distinction. Her idealized beauty still reveals individualized features: full, fleshy cheeks, a strong nose, and thin lips. The empress Livia (58 B.C. – A.D. 29), wife of Augustus (ruled 31 B.C. – A.D. 14), may well be represented. The imperial family's association with Venus as its patron deity, Livia's own divine status granted some twelve years after her death by the Emperor Claudius (ruled A.D. 41 – 54), and the similarity to some of her later portraits support this identification.

MES

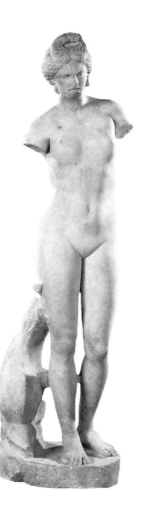

Roman, after a
Hellenistic original

Aphrodite of Cyrene, 1st century

Marble
h. 67 1/2
(171.5 cm)

Purchased with funds
from the State of North
Carolina and the North
Carolina Art Society
(Robert F. Phifer Bequest),
1980 (80.9.1)

The Greek goddess of love and beauty, Aphrodite, known to the Romans as Venus, was born from the sea, a fact alluded to by the support in the form of a dolphin beside her leg. Her connection with Cyrene, a city in North Africa, is a statue of similar type found there in 1913 and now on display in the Museo Nazionale delle Terme in Rome. That statue was the first of this type discovered and thus has given its name to similar statues discovered later.

The gesture of Aphrodite's now-missing arms has been surmised (right). Her right arm was bent at the elbow with the right hand held up to a strand of hair falling to her breast; a trace of hair may still be seen. Her left arm was also probably bent at the elbow to hold a lock that fell from just behind the left ear. Fixing her hair is an appropriate gesture for the goddess as she rises from the sea. Many examples of this type of Aphrodite, known by the Greek term *Anadyomene*, are still extant, attesting to the popularity of the goddess throughout Classical antiquity.

MES

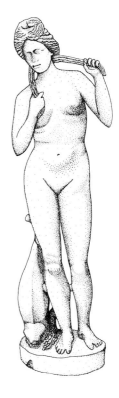

Roman

Portrait of the Emperor Marcus Aurelius, late 2nd century

Marble
h. 26 5/16 in.
(69.4 cm)

Purchased with funds from gifts by Mr. and Mrs. Gordon Hanes, Mrs. Chauncey McCormick, and various donors, by exchange, 1992 (92.1)

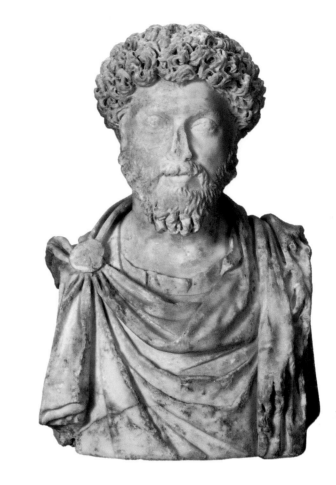

Marcus Aurelius, the last of the "good emperors" of the second century, ruled the Roman Empire from 161 to 180. His successful career as a soldier and an emperor is attested in historical accounts. His adherence to the principles of Greek Stoic philosophy is recorded in his private devotional diary that has survived in a collection of twelve books, given the modern name *Meditations*. Written in Greek rather than Latin, they reveal an intense scrutiny of the burden of power while pursuing an active life in harmony with nature.

In this mature portrait, Marcus Aurelius is wearing a beard, as did his adopted grandfather the Emperor Hadrian, in an acknowledgment of the tradition of the bearded Greek philosopher. The richly carved surface of the hair and beard contrasts with the smooth, imposing planes of the face. The eyes are lightly incised, creating a forceful expression enhanced by the luminous quality of the stone. The image is that of a vigorous yet thoughtful emperor, the personification of Plato's philosopher king.

MES

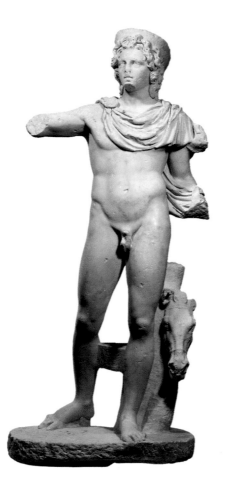

Roman

Emperor Caracalla in the Guise of Helios, early 3rd century

Marble
h. 77 1/4 in.
(196.2 cm)

Purchased with funds from the North Carolina Art Society (Robert F. Phifer Bequest), 1984 (84.1)

In Greek mythology, the god Helios was responsible for drawing the sun daily across the heavens in his horse-drawn chariot. In the fourth century B.C., Alexander the Great, king of Macedon, adopted the god as his personal favorite, no doubt because Alexander had conquered the "lands of the rising sun"—Mesopotamia, Parthia, Bactria, and northwest India. During the later second century A.D., Roman emperors of the Severan dynasty, to which Caracalla belonged, were involved in military campaigns in lands once occupied by Alexander and sought to emulate his glory and conquests.

In this statue, Helios is given the face of a youthful Caracalla, which may portray the emperor prior to his reign of 211–217. There is also a deliberate attempt to associate Caracalla with Alexander. He is portrayed with Alexander's distinctive hairstyle and also with the attributes of Helios: the crown that originally had twelve bronze rays framing his face, the torch he carried in his left hand (traces of the flame are visible on the upper left arm), and the horse's head that indicates his chariot. His right arm would have pointed to the route across the sky. As in the *Torso of an Emperor in the Guise of Jupiter* (page 34), religious symbols are here artfully employed for the purposes of political propaganda.

MES

New World Art

MOST WORKS OF ART THAT HAVE SURVIVED from the ancient cultures of Mexico and Central and South America were preserved in tombs. These civilizations viewed death as a journey from one realm of existence to another. Burial rites and grave offerings were intended to prepare and equip the soul for this transition. Many objects placed in graves had been used previously and thus reflect aspects of daily life as well as mortuary customs. Maya cylindrical vessels, such as the one described in the following pages, were used by members of the ruling elite for drinking a favorite chocolate beverage and later were buried with their owners.

Ceramic sculptures ranging in scale from small figurines to life-size images were placed in tombs. Some represent priests and deities, some show people from various walks of life, and others portray animals, including the creatures that inhabit the rain and cloud forests of Costa Rica. In their multiplicity of form and subject, these figures reflect a view of the world as multilayered, every part controlled by deities whose personalities and activities symbolized the forces of the universe.

Some of the native peoples of the Americas, such as the Maya and the Teotihuacans, were highly accomplished builders, constructing immense pyramidal tombs and temples and other monumental stone buildings, which they adorned with sculpture and frescoes. By contrast, the people of ancient Costa Rica were not great builders in stone, but excelled in the production of small objects of the types represented in the NCMA's collection: ceramic sculptures of humans and animals, and objects fashioned of jade or gold.

Shared by many cultural groups in ancient Mesoamerica (parts of the modern nations of Mexico, Guatemala, Honduras, El Salvador, and Belize), urban and rural alike, was a game played with a rubber ball. At some sites the stone ball courts survive. The Museum's *Ball Court Marker*, carved with the image of a ballplayer in his game costume, came from such a place. Europeans who witnessed the game took rubber balls home as novelties, thus introducing ball games to Europe.

In their desire to control both new territories and the minds of local inhabitants, Europeans intentionally destroyed the indigenous cultures they encountered in the New World, beginning in the sixteenth century. Entire libraries of Maya books were burned, so scholars today must reconstruct Maya history, religious beliefs, mathematics, astronomy, and other achievements from inscriptions on stone monuments and elite painted pottery. The meaning and significance of objects from other ancient American civilizations for which no written records survive can never be fully recovered.

Mexico, Vera Cruz,
El Zapotal Style

*Standing Female
Deity or Deity
Impersonator*,
about 600 – 900

Terracotta and paint
57 1/4 x 22 3/8 in.
(145.4 x 56.8 cm)

Gift of Mr. and Mrs.
Gordon Hanes,
1986 (86.8)

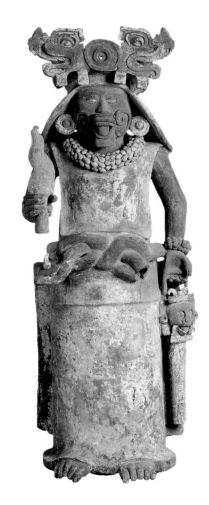

The Vera Cruz culture is named for the modern Gulf Coast region of Mexico, where remains of this ancient civilization have been excavated. Monumental sculptures by Vera Cruz artists of the Classic period (about 600 B.C. – A.D. 900) are the largest ceramic figures known from pre-Columbian America. They are hollow and were designed with various openings to allow heated air to escape so that they would not explode as they were fired. It was also necessary to reinforce the sculptures structurally so that they would not collapse before the clay had hardened. Because no ancient Vera Cruz kilns have been found, it is thought that such sculptures were fired in open pits.

The Vera Cruz culture apparently had no written language, and little is known about the mythology of its Classic period. Although the identity of this figure is uncertain, it may have been part of an elaborate burial offering of sculptures of deities, deity impersonators, and human attendants depicting religious rituals. The figure wears a half-face mask over her mouth and a heavy necklace of shells or large seeds. Her impressive circular earflares indicate her elite status. She holds a curved sacrificial knife in her upraised right hand, and an incense bag in the shape of a skull hangs from her left hand. The serpents that appear on her belt and headdress may associate the figure with the cult of a particular goddess.

MES

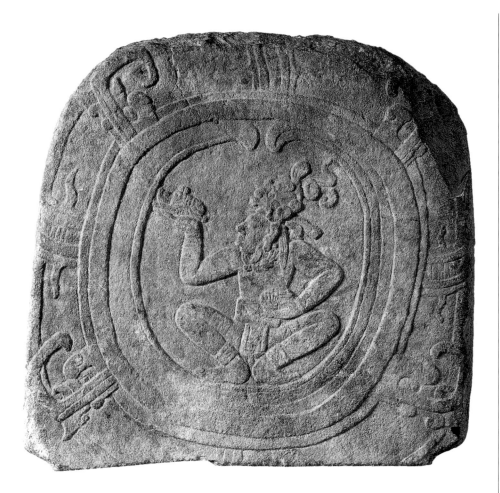

Mexico, Chiapas, Maya

Ball Court Marker,
about 550–850

Limestone
23 1/8 x 24 in.
(58.8 x 61.0 cm)

Gift of Mr. and Mrs.
Gordon Hanes, 1982 (82.14)

A game played with a large rubber ball and resembling soccer was common to most of the cultural groups of ancient Mesoamerica. This sculpture may have been placed in the playing alley of a ball court, possibly functioning as some kind of marker important to the rules of the game. Many ball court markers are sculpted with imagery identifying the court as a symbolic opening into the underworld. This example is unique because the mouth-like opening framing a male figure is marked with symbols that refer to other kinds of supernatural places. The outermost circle is embellished with parallel lines symbolizing shiny materials (jade, the sun, the surface of a mirror). The inner circle is a sign referring to the moon. At the corners are symbols for supernatural beings.

A Maya ballplayer squats in the center of these cosmic symbols. He wears a wide, belt-like yoke and holds what appears to be the ball close to his body. Although no ball has survived from Maya culture, this depiction suggests that the ball was composed of tightly wrapped strings of natural rubber. The ballplayer wears a headdress that refers to one of the Hero Twins from the Maya epic the *Popol Vuh*. (The *Popol Vuh* is a tale about vanquishing death, represented by the Lords of the Underworld, and how to achieve everlasting life.) The Hero Twin is rendered in his aspect as the sun god; his solar headdress reaffirms that this marker represents a cosmological opening into a supernatural realm.

MES

Oceanic Art

OCEANIA REFERS TO THREE GROUPS OF ISLANDS in the Pacific Ocean: Melanesia, Polynesia, and Micronesia. Altogether, the area encompasses thousands of islands inhabited by many different cultural groups speaking more than a thousand languages. Most works in the NCMA's collection of Oceanic art come from Melanesia, which includes New Guinea, New Ireland, and Vanuatu.

Although each of the many cultures of Melanesia has its own language, customs, belief systems, and distinctive art tradition, certain shared concepts are recognized. Sculpture made of a wide variety of natural materials—wood, stone, bone, feathers, textiles, fibers, seeds, shells—most often portrays human figures and animals, sometimes together. Animals are important in creation myths and clan histories and are thought to be vitally linked with humankind. In addition to animal spirits, works of art honor and placate other nature spirits believed to be powerful and influential.

The veneration of ancestors is important throughout Melanesia. Deceased family members are thought to influence the daily affairs of their living relatives. The departed are honored to ensure their benevolence and aid in maintaining a positive balance between human and spiritual realms. The *Ancestor Figure* from the Sepik River region of New Guinea included in this book illustrates this important principle.

In New Ireland, ceremonies to commemorate deceased members of a clan also provide opportunities to reinforce family bonds and enhance the prestige of the group through bountiful feasts, elaborate dance performances, and extravagant displays of art, such as the *malanggan* carving in the Museum's collection. Competition for prestige is an important impetus for art among many groups in Melanesia.

New Ireland

Helmet Mask (Tatanua), prior to 1900

Wood, paint, fiber, and other natural materials. h. 17 x w. 8 1/8 in. (43.2 x 20.6 cm)

Gift of Mr. and Mrs. Gordon Hanes, 1986 (86.9)

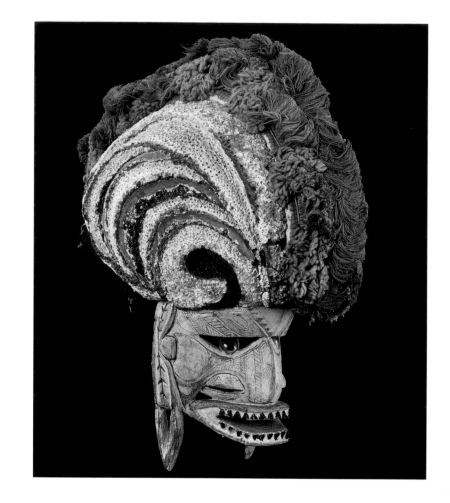

Melanesia, a group of Pacific islands to the north and east of Australia, produced many objects associated with memorial rites to honor ancestors and help ensure their continued propitious intervention in the lives of members of the community. At these ceremonies, helmet masks (*tatanua*) such as this were worn by dancers, who performed to the accompaniment of a chorus and the beat of bamboo slit gongs.

Tatanua masks portray the souls of the dead, who were thought to inhabit the masks and fill them with power during the ritual dance. The design of each mask was specific to an individual in the details of shape, the patterns painted in white, red, blue, and black, and the configuration of the large fiber crest. The elaborate curves and linear designs are divided bilaterally along the crest and feature distinctly different motifs on either side. This aspect of the design was highlighted in the mortuary festival, during which the dancers performed in a line, turning suddenly and in unison from one side to the other. Unlike *malanggan* carvings (page 48), helmet masks were not destroyed after the performance, but were stored for future use.

MES

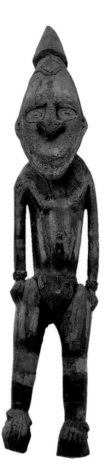

Sepik River area of
Papua, New Guinea

Ancestor Figure
(Kandimbing),
20th century

Wood, rattan, tapa, paint
h. 33 3/8 in.
(84.8 cm)

Gift of Mr. and Mrs. Gordon
Hanes, 1986 (86.12)

This squat, somber figure with his hands placed on his hips is typical of the art found in the basin of New Guinea's Sepik River, which flows from the center to the central east coast of the island. The region, occupied by approximately thirty-five distinct cultural groups, each speaking a different language, is one of the richest art-producing areas of New Guinea.

The figure represents an important and powerful ancestor of a clan. He wears a tapa (bark) loincloth and plaited rattan armbands. The elongated conical cap originally supported a wig. Incised designs on the figure represent the body scarification of its owner. Traces of paint indicate that it was further adorned with patterns in black, white, yellow, and red. The image was used to provide a temporary abode for the spirit of the ancestor, so that he would use his power to ensure his descendants' prosperity and success in hunting, fishing, and agriculture. Such figures also were used during the initiation ceremonies of the sons and brothers of the ancestors.

MES

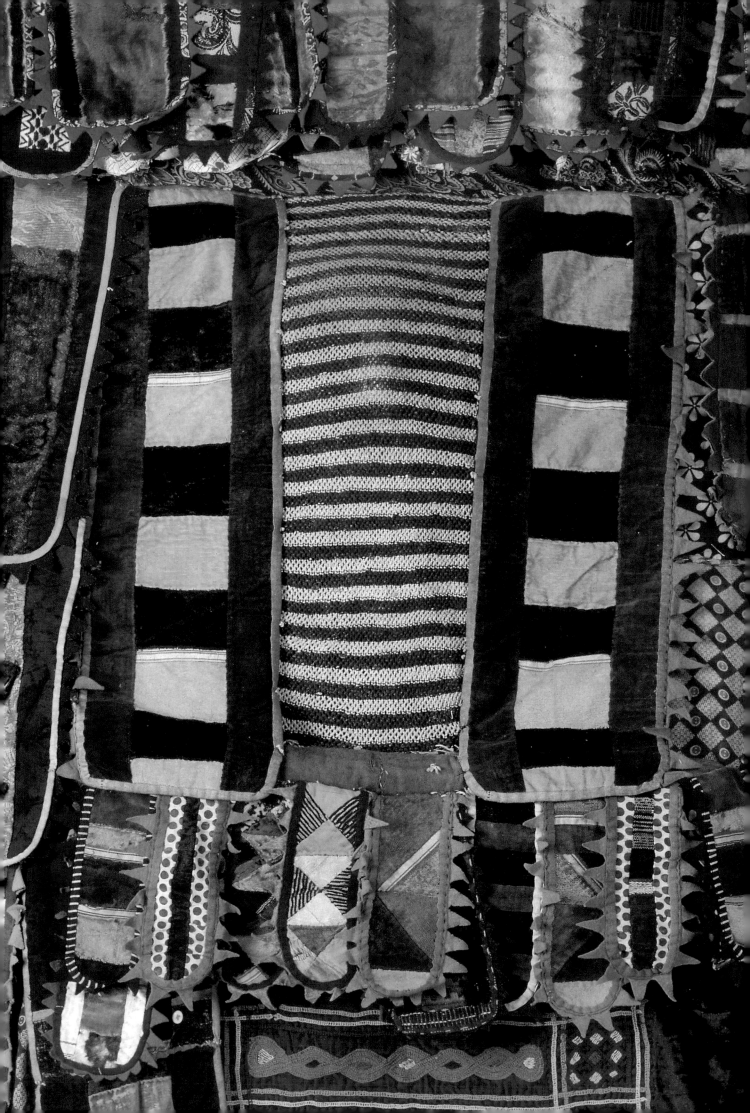

African Art

AFRICA IS A VAST CONTINENT, more than three times the size of the United States. The many peoples of west and central Africa have produced some of the continent's most varied and sophisticated cultural traditions, rich in sculpture, textiles, and other visual arts, in poetry, and in performance arts such as dance and masquerade. Most of the NCMA's African art originates from these prolific art-producing regions. Yoruba art is particularly well represented in the collection, as reflected in the selection of objects for this publication. Although the objects in the Museum's collection date to the nineteenth and twentieth centuries, some of them are based on traditions that go back hundreds of years. Others demonstrate more recent innovations resulting from cross-cultural contacts and the experiences of the modern era.

Each cultural and ethnic group has distinctive beliefs and customs and its own systems of aesthetics and symbolism within which artists are trained. Thus, works of art from numerous cultures reflect a wide range of symbolism, styles, materials, techniques, and functions. Styles vary, for example, from naturalism in the portrayal of humans and animals to extreme forms of geometric abstraction. Among some groups, artists exaggerate certain features, such as the head or stomach, which are assigned symbolic significance.

Whereas the majority of objects in the collection are sculptures carved of wood, a readily available material in most of west and central Africa, a variety of other materials is also in evidence, including terracotta, beads, cast metal, textiles, and ivory. Within the established traditions of their peoples, many artists developed individual styles that won wide recognition in their communities — and sometimes far beyond. Although the names of most of these artists are lost today, some are known, and the works of others can be identified by their distinctive styles.

It has often been observed that traditional African art is essentially functional rather than "art for art's sake." If so, function must be broadly defined. Works of art may be used to enhance worship, to reinforce status, to symbolize royal power and prestige, in civil and religious ceremonies and festivals, in the administration of justice, and to add beauty and meaning to daily life.

Egungun Costume (detail)

Nigeria,
Egbado region,
Yoruba

Lid of a Ceremonial Vessel, late 19th or early 20th century

Terracotta with
indigo pigment
h. 14 x d. 12 1/4 in.
(35.6 x 31.1 cm)

Gift of Lee and Dona
Brunson, 1977 (77.7.4)

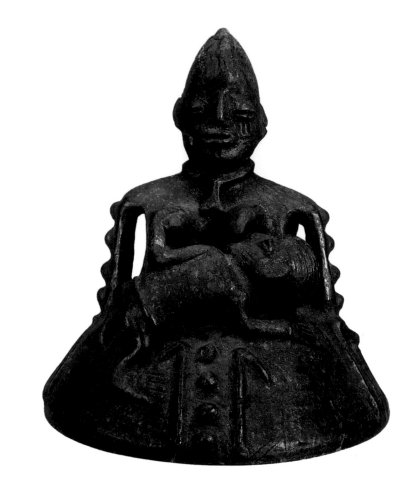

This vessel lid of baked clay, colored dark blue with indigo pigment, can be attributed to a Yoruba artist of the Egbado region of Nigeria. Although the artist has not been identified by name, her work is somewhat related in style to that of Abatan of Oke Odan, probably the most renowned traditional Yoruba potter of the twentieth century. (While Yoruba wood carving, beadwork, and weaving are the domains of male artists, pottery is made by women.)

Although its companion bowl-shaped container is lost, the vessel lid is well preserved. It is in the form of a mother with twin infants, one of whom she nurses; the other child she carries on her back. The woman is a devotee of the river god Eyinle, to whom river stones, sand, and water are sacred. The vessel, a container for such substances, would originally have stood on a domestic altar to Eyinle. Together with its contents, the vessel symbolized abundance, longevity, and the promise of an afterlife, endless like the waters in which Eyinle dwells.

The lid rises into a four-sided, open-work summit, which seems to form the torso and arms of the female figure. It is decorated with bosses, small projections that refer to the river stones within. The cheeks of the mother figure bear lineage marks (facial scarification) that probably correspond to those of the patron of the vessel.

RMN

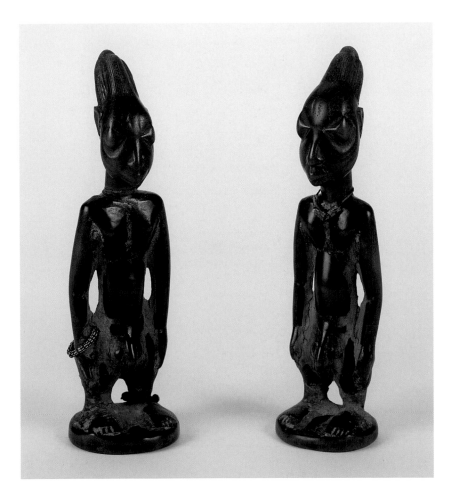

Nigeria, Yoruba,
Igbomina Subgroup

***Twin Figures
(Ere Ibeji)**, late
19th or early
20th century*
Wood with beads
and camwood powder
h. 10 1/4 in.
(26.1 cm),
each figure

Purchased with funds
from various donors, by
exchange, 1985 (85.2/1 – 2)

The Yoruba people have one of the highest rates of twin births in the world, but because of low birth weight, infant mortality is also high. Twins are considered to be a great blessing and to have special powers. Traditionally, when a twin died the family sought guidance from a divination priest, who often directed the parents to commission a commemorative carving of the deceased child. Through the figure, the parents could honor and placate the dead twin, whose spirit might otherwise call away the spirit of the one yet living. For the Yoruba, who say that "children are the wealth of life," losing both twins is an unspeakable tragedy.

The Museum's figures, similar in style and in patterns of wear, undoubtedly were carved when a pair of male twins died. Whatever the age of the twin at death, the sculptor always portrayed him or her in youthful maturity, emphasizing the male or female characteristics. Twin figures are not portraits, although the parents may specify that family lineage markings (facial scarification) be carved on the figures. Otherwise, the figures embody the Yoruba ideal, which defines beautiful art as that which captures the essential nature of a person or thing, balancing realism and abstraction. Large heads are further emphasized by elongated hairstyles, in keeping with the Yoruba belief that a person's character and spirituality are centered in the head.

This pair has been adorned with beads and rubbed with red camwood powder, a valuable cosmetic. Frequent caressing of the figures produced the lustrous patina characteristic of *ere ibeji* that have been lovingly tended.

RMN

Ogbomoso, Nigeria,
Yoruba

Egungun Costume,
20th century

Cloth, wood, and buttons
h. approx. 60 in.
(152.4 cm)

Purchased with funds
provided through a
bequest from Lucile E.
Moorman, 1997 (97.5.3)

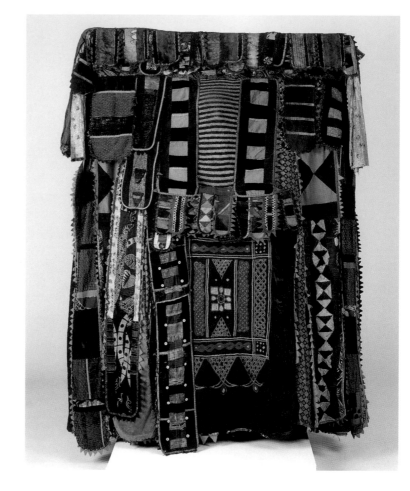

The Yoruba people believe that deceased individuals can intervene for good or ill in the lives of their living family members. It is essential, therefore, to honor ancestors, known as *ara orun* ("dwellers in heaven"), with elaborate rituals performed over a period of several weeks during the *egungun* ("powers concealed") ceremony held every one or two years in traditional Yoruba communities. Among the many types of costumes and masks worn during the festival, one of the most popular is a masquerade made up of multiple layers of cloth in many vibrant colors, textures, and patterns. The number of layers often reflects the age of a costume; each year, the family members who own it may add new layers of valuable cloth to honor their ancestor. The earliest fabrics in this costume are French cotton voiles from the 1930s, while the outer layers consist of fabrics produced in the 1950s.

The wearer of the masquerade would balance the wood panel (from which the many panels of cloth hang) on top of his head and peer out through the hand-knotted net face panel. His acrobatic dance included rapid spinning, which caused the panels of the costume to fly out in a spectacular display of color and pattern. Clothed in a body stocking, the dancer remained concealed, while the presence and power of the ancestor were revealed through the drama of the masquerade.

RMN

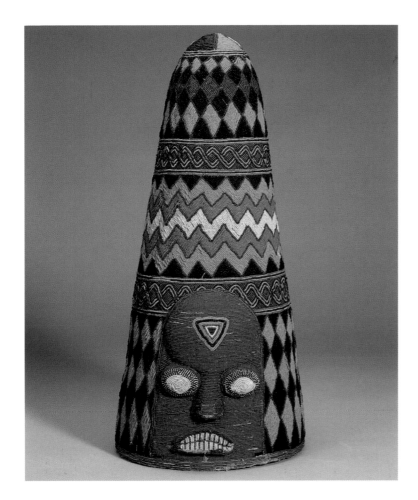

Nigeria, Yoruba

Beaded Crown,
20th century

Glass beads and
grass cloth
h. 20 3/8 in.
(51.7 cm)

Gift of Mr. and Mrs.
Gordon Hanes, 1977
(77.2.10)

Among the Yoruba, each *oba* (ruler) has authority over a city-state, a city or town and its surrounding territories. For ceremonial occasions, the *oba* wears a conical beaded crown within which are sealed powerful herbal medicines. The tiny glass beads used here are typical for crowns made in the nineteenth and twentieth centuries, when Yoruba beadworkers (who were always male) replaced the traditional red beads of coral or carnelian with multicolored glass "seed beads" obtained through trade with Europeans.

Faces on either side of the crown may refer to Olokun, god of the sea and "owner of the beads"; to ancestors of the *oba*; or to the "inner [spiritual] face" of the *oba* himself. They also serve as a reminder that the *oba* sees and hears all, even that which takes place behind his back. Other designs include an interlace pattern symbolic of the ruler's power, and zigzag motifs representing energy and/or the lightning bolts of the god Shango. The elongated shape of the crown emphasizes the importance of the head, which the Yoruba believe to be the center of an individual's character, destiny, and spirituality.

Although generally well preserved, the crown may have suffered some losses. Often a veil of beads hangs over the *oba*'s face, separating him from earthly concerns and uniting him with the spiritual realm. In addition, a three-dimensional beaded bird may surmount such a crown as a symbol of the spiritual power of older women, called "our mothers," whose support and cooperation is essential to the *oba*'s successful rule. It is also possible that the crown never had these features, for rulers wore simpler or more elaborate conical crowns, depending on the occasion.

RMN

Nigeria, Niger River
Delta

Sawfish Headdress,
20th century

Wood, mirrors, and paint
h. 27 1/4 x w. 19 7/8
x l. 89 3/8 in.
(69.3 x 50.6 x 227 cm)

Purchased with funds
from various donors, by
exchange, 1985 (85.1)

Horizontal water spirit headdresses in the forms of sawfish, sharks, crocodiles, and other predatory aquatic animals probably originated among the Ijo, coastal fishermen in the delta region of the Niger River. The use of these colorful masquerades then spread to neighboring groups, including the Abua, Ekpeya, and Igbo. Among these riverine peoples, annual festivals honoring water spirits were held to ensure their benevolent influence on fish and crop harvests in the coming year. According to an eyewitness account, in one Ijo community a sawfish headdress, worn by an athletic young male, was brought to the village downriver in a canoe. Having disembarked, the sawfish danced on land, where he was "hunted" by masqueraders representing fishermen.

Whereas many African carvers take great pride in carving an elaborate sculpture from a single piece of wood, the makers of water-spirit masks such as this _Sawfish Headdress_ took advantage of carpentry techniques, whereby fins, teeth, and other components of the whole were carved from separate pieces of wood and attached. Mirrors obtained by trade with outsiders were used for the eyes and to adorn the tail of the sawfish.

RMN

Mali, Bamana

Antelope Headdresses (Tji Wara), 20th century

Wood, twine, and metal female figure, h. 26 7/8 in. (68.3 cm); male figure, h. 33 1/4 in. (84.5 cm)

Purchased with funds from the North Carolina Art Society (Robert F. Phifer Bequest), 1986 (86.1/1 – 2)

The Bamana people honor Tji Wara as the spirit who taught their ancestors how to till the earth and grow crops. At traditional planting and harvest festivals, champion farmers are chosen to dance in honor of Tji Wara. The headdresses represent male and female antelopes to symbolize the procreative forces of nature and the marital cooperation necessary for successful farming. They are attached to woven caps by which they can be secured to the heads of the dancers, whose bodies are covered with long, thick raffia costumes that signify rain. While the costumed men leap in imitation of an antelope, women dance alongside them, singing praises to the ideal farmer, who exhibits the grace, strength, and endurance of an antelope. Two long sticks held by each dancer represent the rays of the sun.

The abstraction and decorative patterning of the sculptures emphasize the antelope's essential qualities: a narrow head, gracefully arching neck, and long horns. The zigzag design of the male's neck and mane represents the path of a running antelope; the tall horns suggest waving stalks of grain. Combined with the features of an antelope on each headdress are the squat lower body and legs of the aardvark, a type of anteater that burrows in the soil as farmers do when they cultivate the earth. In addition, human characteristics are incorporated into the portrayal of the female antelope, who wears earrings and a nose-ring and imitates human mothers in the way she carries her baby on her back.

RMN

Democratic Republic
of the Congo, Kongo,
Yombe Subgroup

***Oath-Taking and
Healing Image***
(***Nkisi N'kondi***),
20th century

Wood, metal, and quills
h. 14 3/4 in.
(37.5 cm)

Gift of Mr. and Mrs.
Gordon Hanes, 1991 (91.7)

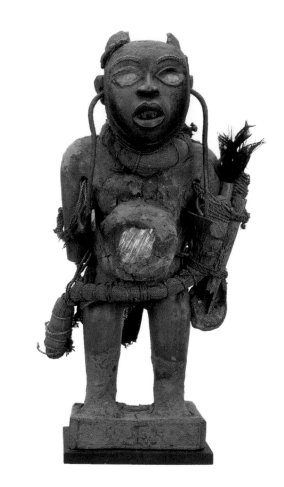

This *Oath-Taking and Healing Image* was carved by a sculptor and completed by a ritual practitioner, who added powerful ingredients (such as medicinal herbs, blood, or soil from a sacred place) to the receptacle on the figure's stomach. This cylindrical container is sealed with a mirror, which recalls the reflective surface of a river in which spirits dwell, and so refers to spiritual powers within the figure. Other potent objects and materials were attached to the limbs and torso of the figure to enhance its efficacy. The ritual practitioner would have used the figure when clients sought advice on personal matters such as illness or familial conflicts, or judgments on legal matters such as real estate transactions or peace treaties between warring villages. The nails and spikes driven into the image on these occasions activated its power and also solemnized oaths that were sworn before it by the practitioner's clients.

The Kongo people call such objects *nkisi n'kondi* (plural *minkisi minkondi*). The word *nkisi* refers to the container for medicines, while *n'kondi* means "hunter." The hunter, revered for his strength, courage, and skill, was seen as an implacable individual who sought out wrongdoing and exacted retribution. As is characteristic for *minkisi minkondi*, the face of this figure is strikingly naturalistic, with mirrored eyes and an open mouth, as if he would speak.

RMN

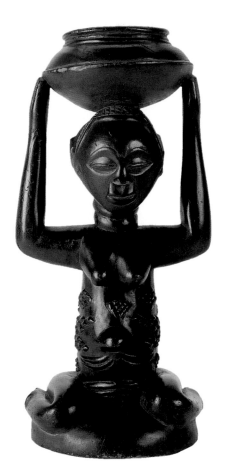

Democratic Republic
of the Congo, Luba

Bowl Bearer,
20th century

Wood
h. 17 7/8 in.
(45.5 cm)

Gift of Mr. and Mrs.
Gordon Hanes, 1972
(72.19.38)

Luba vessels and stools adorned with female figures, which served as symbols of royal authority and status, reflect the central role of women in Luba court life. Royal women served as emissaries, ambassadors, and tribute collectors in dealings with neighboring states, and their marriages to rulers of other groups helped expand the Luba domains. Artistic traditions established during the glory days of the Luba empire, from the sixteenth to the nineteenth centuries, have survived into the twentieth century in traditional Luba communities.

This caryatid figure is characteristic of Luba court art in her erect, dignified posture, which is emphasized by the straight, elongated arms. The legs, by contrast, are fluid and hug the ground, so that the genital area is close to the earth, the source of all life. The elaborate cross-shaped coiffure (on the back of the head), coffee-bean shaped eyes, and scarification patterns are typical of Luba court sculpture.

Sculptures of bowl bearers were used in royal investiture ceremonies and were important emblems of Luba kings. They also served as containers for a white clay used by divination priests. In traditional Luba court art, bowl-bearing figures usually hold their bowls in front of them, whereas caryatid figures such as this one typically support stools above their heads, not bowls. Several theories can be suggested for the deviation from standard Luba court iconography in this carving. The artist may have been influenced by the art of a neighboring culture. The sculpture may postdate classic Luba art, and may have been made with the international art market in mind. Whatever the reason, the maker of this object employed an innovative combination of traditional Luba motifs in the use of a caryatid figure as a bowl bearer.

RMN

וקטב מרירי ... ואה הארץ כי יהעדתי
עם חמת זחלי עפ תשלחתון וסרדוב כן
ומחורדים איבד זו וקראת אתהכם הרעה
יונק עם איש שיבד זו את הרע בעיני יהוה
אשביתה מאנוש זכר ב וידבר משה באזני כל
פן ינכרו ש...יפ י השירה הזאת עד תמם
ולא יהוה פעל כל זא

ואין בהם תבונה והשמע הארץ אמרי פי
יבינו לאחריתם הזל כטל אמרתי
ושנים ינסו רבבה וכרביבים עלי עשב
ויהוה הסגירב הבו גדל כאלהינו
ואיבנו פלכלים כי כב דרכיו משפט
ומשדמות עמרה צדיק וישר הוא
אשכלת מררת למו דור עקש ופתלתב
וראש פתנים אבזר עם נבל ולא חכב
לחום באוצרתי הוא עשך ויכננ
לעת תמוט רגלב בינו שנות דר ודר
וחש עתדת למו זקניך ויאמרו כר
ועל עבדיו יתנחם בהפרידו בני אדב
ואפס עצור ועזוב למספר בני ישראל
צור ... חסיו בן יעקב חבל נחלתו
ישתו יין נסיכם יבהתו ויכל ישבן
יהי עליכם סתרה יצרנדו כאישון עינו
ואין אלהים עמדי עכ גוזכיו יר...זף
מחצתי ואני ארפא ישאהו על אברתו
כי אשא אל שמים ידי ואין עמו אל נכר
אם שנותי ברק חרבי ויאכל תנובת שדי
אשיב נקם לצרי ושמן מחלמבוש צור
אשכיר חצי מדב עם חלב כרים
מדם חלל ושביה עם חלב כליות חטה
הרנינו גוים עמו וישמן ישרון ובעט
ונקם ישיב לצריו ויטש אלוה עשהו

ויבא משה וידבר את כל דב יקנאהו בזרים
באזני העם הוא והושע בן נון יזבחו לשדים לא אלה
הדברים האלה אל כל ישראל חדשים מקרב באו
כבבכם לכל הדברים אשר א צור ילדרך תשי
אשר תצום את בניכם בשמר יירא יהוה וינאצ
התורה הזאת כי לא דבר רק ה ויאמר אסתירה פני מהם
ובדבר הזה תאריכן ימים על הא כי דור תהפכת המה
את הירדן שמה לרשתה הם קנאוני בבא אל
וידבר יהוה אל משה בעצם הי ואני אקניאם בבא אנ
אל הר העברים הזה הר נבו אש כיאש קדחה באפי
על פני ירחו וראה אתהארץ כנ והאכל ארץ ויבכה
 אספה עלימו רעות

Jewish Ceremonial Art

THROUGHOUT THE MILLENNIA, beautifully crafted and adorned ceremonial objects have enhanced the experience of worship and the sacred quality of important events in Jewish life. Although the second commandment (Exodus 20:4–5) prohibits art for fear of idolatry, there has always been a place for decorative and symbolic ceremonial art.

Few examples of Jewish ceremonial art (Judaica) survive from a period earlier than three or four centuries ago. Throughout history, Jews have often been forced to flee from persecution, taking with them only their most essential belongings. Although bulky ceremonial objects were often left behind, manuscripts and books were saved; some describe the works of art that perished.

In the Museum's Judaic art collection, many of the objects are made of precious materials such as silver, gold, and ivory and are decorated in the heavily adorned Baroque style that originated in the seventeenth century. Some pieces, such as the *Pair of Sabbath Candlesticks* described in this section, are in the more delicately ornate style of the eighteenth-century Rococo period. During the Baroque and Rococo periods, many Jews in France and Germany grew prosperous enough to commission expensive ceremonial objects in the prevailing styles. The richly decorative approach of this period has remained popular ever since. Some objects in the collection, such as the *Torah Case (Tik)* from North Africa, belong to the Sephardic tradition (that of Jews in North Africa and the Near East) and reflect the influence of the art of the dominant Islamic culture of that region.

In many parts of Europe, Jewish artists were not permitted to join artists' guilds, and therefore were restricted from practicing certain kinds of metalwork. Thus Jewish patrons of necessity commissioned objects for religious use from non-Jewish artisans. Although they worked in the styles and techniques with which they were familiar, these craftsmen decorated objects for their Jewish clients with appropriate Jewish symbols and biblical subjects.

With the artistic freedom afforded them in the twentieth century, many Jewish artists have turned with enthusiasm and tremendous creativity to the design of ceremonial objects that combine traditional functions and symbolism with modern form. The Passover seder set described in the following pages embodies this modern aesthetic in the service of traditional ceremonial observance.

North African

Torah Case (Tik),
1908

Silver: die-stamped,
repoussé, cast, appliqué,
chased, engraved, partially
gilt; wood; textile
h. 36 7/8 in. x
diam. 10 1/2 in.
(93.7 x 26.7 cm)

Judaic Art Fund and
Museum Purchase
Fund, 1980 (80.3.5)

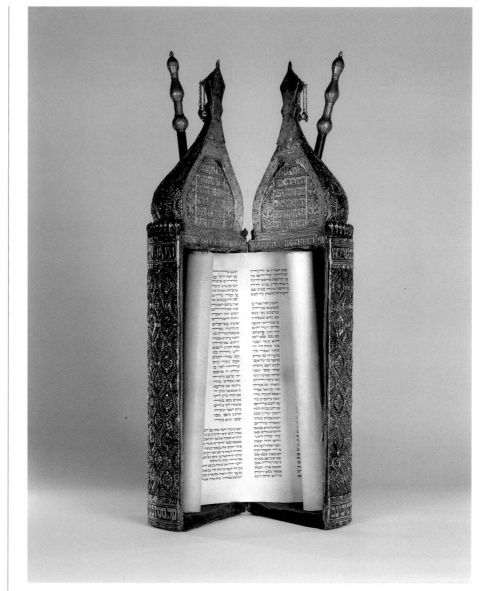

The Torah, consisting of the first five books of the Hebrew Bible, is the central text in Judaism. Inscribed by hand in Hebrew on a leather scroll, it is the most revered object in the synagogue, enshrined in a special ark—a cabinet or niche—on the wall facing Jerusalem. During the regular religious services, successive portions of the text are read to the congregation so that the entire Torah is recited over the course of the year or, in some congregations, three years.

Among the Sephardim (Jewish communities of North Africa and the Near East), the Torah scroll is traditionally kept in a hinged wooden case called a *tik*. The scroll is wound on two rollers and remains within the case at all times. During readings, the open case stands upright on a table. *Tiks* are often ornately embellished. This particular example is sheathed in silver, its surface heavily worked with a trellis and flower pattern, perhaps derived from textile designs. The case is crowned with a dome from which dangle pendants. They recall the bells, which, alternating with pomegranates, adorned the robes of the high priests of the ancient Jewish Temple (Exodus 28:33–35). Attached to the dome are two brass finials, called in Hebrew *rimmonim*, literally "pomegranates," because of their bulbous shape.

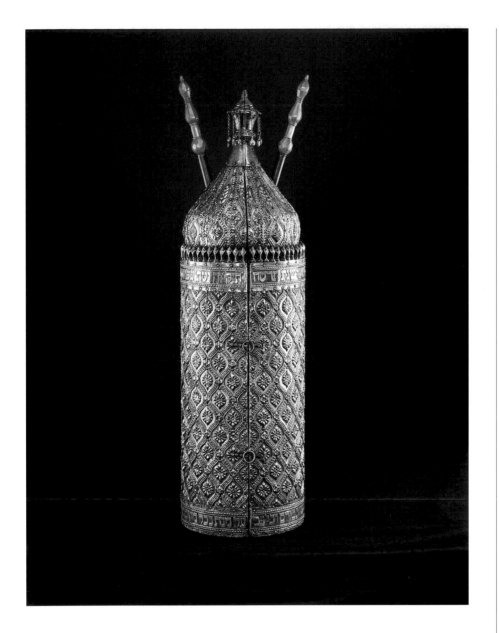

Middle Eastern,
possibly Yemen

*Pair of Torah
Finials (Rimmonim)*,
18th – 19th century

Brass: hollow-formed,
chased
each: h. 10 1/8 in.
(25.7 cm)

Judaic Art Fund and
Museum Purchase
Fund, 1980 (80.3.6a – b)

 Hebrew inscriptions adorn the case both inside and out. Some of the inscriptions quote appropriate lines from the Bible: "This is the Teaching that Moses set before the Israelites" (Deuteronomy 4:44). Another records that the case and its scroll were "dedicated to the soul of the righteous woman (may glory rest upon her) Dina, the daughter of Hannah, may she be remembered always . . . "

AK

German

Pair of Sabbath Candlesticks,
mid-19th century

Silver: cast, die-stamped, chased, engraved
each: h. 8 x diam. of base 3 3/4 in. (20.3 x 9.5 cm)

Purchased with funds given by family and friends in memory of Dr. Frances Pascher Kanof, 1989 (89.1/1 – 2)

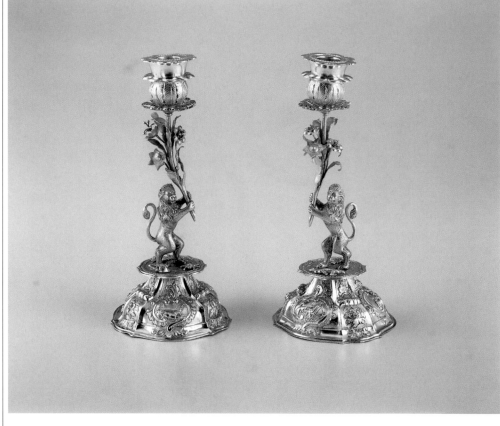

The most sacred of Jewish holy days is the Sabbath, a day of rest in obedience to the biblical commandment: "Six days shall you work, but on the seventh day you shall cease from labor" (Exodus 34:21). The Sabbath begins on Friday evening before sundown, when the Jewish woman lights candles and then covers her eyes while reciting the blessing. When she opens her eyes, it is to the lights of a new and holy day. The lighting of candles also marks the onset of all other Jewish religious holy days, including Passover, *Shavuot*, *Sukkot*, and Rosh Hashanah.

This ornate pair of silver Sabbath candlesticks is of German workmanship. Though they date from the mid-1800s, their fanciful decorative style echoes Rococo designs of the previous century. On each, a rampant lion upholds a flowering branch topped by a candle holder in the form of a large blossom. Heraldic pairs of fierce animals as guardians of sacred objects have their origin in the art of the ancient Near East. Lions in particular have a long symbolic association with the Jewish people: in the Hebrew Bible, the tribes of Israel are lauded as "a people that rises like a lion, leaps up like the king of beasts" (Numbers 23:24). Around the base of each candlestick are three scenes, framed in elaborate cartouches. Five of the six scenes are biblical: Jacob's dream, Moses as a shepherd, Samson and the lion, the sacrifice of Isaac, and the judgment of Solomon. Appropriately, the sixth scene depicts a woman blessing the Sabbath lights.

AK

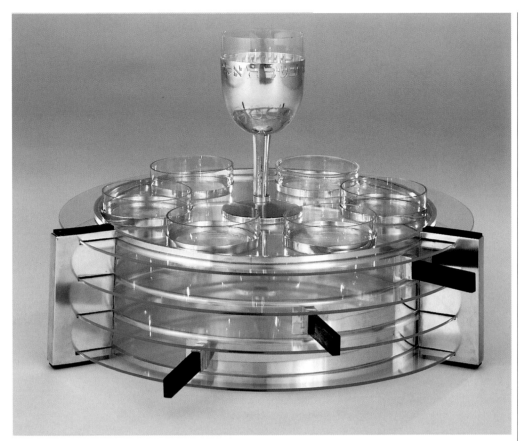

Ludwig Yehuda Wolpert
American, born
Germany, 1900 – 1981

**Passover Seder
Plates with Dishes
and Wine Cup**,
designed 1920s,
fabricated 1975

Silver: hollow-formed,
pierced; glass; ebony
h. overall, with cup:
9 3/4 in. (24.8 cm);
plate assembly:
h. 4 in. x diam. 13 3/4 in.
(10.2 x 34.9 cm);
cup: h. 6 x diam. 2 3/4 in.
(15.2 x 7.0 cm);
dishes: h. 7/8 x
diam. 2 7/8 in.
(2.2 x 7.3 cm)
Judaic Art Fund, 1976
(76.4.6/a j)

The most colorful and family-centered of the Jewish festivals is Passover, which commemorates the liberation of the Israelites from bondage in Egypt as recorded in the Book of Exodus. The principal celebration is a ritualized family meal known as a seder. Traditionally, the seder begins with prescribed prayers, followed by the retelling of the story of the Exodus, and the blessing of wine and bread. The bread (*matzah*) is unleavened to recall the haste of the Israelites' departure from Egypt. Other symbolic foods are served, among them horseradish in remembrance of the bitterness of slavery; a mixture of fruit and nuts moistened with wine (*haroset*) to recall the sweetness of life; and lamb shank to commemorate the sacrifice of the paschal lamb, whose protective blood was sprinkled on the door posts of the Israelites before the Exodus.

This coolly elegant seder set is a masterwork of Ludwig Wolpert, a German-trained silversmith renowned for introducing modernist design to the creation of Jewish ceremonial objects. Wolpert was strongly influenced by the industrial design aesthetic of the Bauhaus, an internationally important German design school which advocated the clear, unadorned exposition of an object's function. Wolpert's set is superbly crafted of silver, glass, and ebony, its various elements and functions organized architecturally. The *matzah* is stored in glass shelves, one for each of the three ancient divisions of the Jewish people: Kohen, Levite, and Israelite. The six glass dishes are for the symbolic foods. The Hebrew inscription on the wine cup quotes an appropriate verse from Psalm 116: "I raise the cup of deliverance and invoke the name of the Lord."

AK

Northern European Medieval and Renaissance Art

THE ROMANESQUE PERIOD (approximately tenth through twelfth centuries) of the Middle Ages was an era of significant church construction, a time when builders drew inspiration from Roman architecture in erecting massive stone walls, round arches, and barrel vaults. The Romanesque period also saw a revival of large-scale sculpture, which had been out of favor — in part because of its association with idolatry — since the fall of the western Roman Empire in the fifth century. Especially important was the stone relief sculpture that embellished the facades and interiors of churches, but artists also crafted freestanding wood sculptures, such as the NCMA's *Madonna and Child in Majesty*.

During the Gothic period (approximately mid-twelfth through fifteenth centuries), a new style of architecture originated in France and spread through much of Europe. With pointed arches, high vaults, flying buttresses, and thin walls pierced by stained glass windows, Gothic churches seemed to soar heavenward. Figures represented in architectural and free-standing sculpture were also attenuated, graceful, and elegant, qualities embodied in the Museum's ivory *Madonna and Child*.

In the later part of the fifteenth century northern Europe witnessed a new humanistic interest in the individual, reflected in realistic portraiture, and a fascination with the natural world, apparent in accurate portrayals of domestic interiors and carefully observed landscapes as settings for figures. Some artists, such as the anonymous painter of the *Latour d'Auvergne Triptych*, combined these elements with Italian Renaissance-style architecture and the use of linear perspective to create the illusion of three-dimensional space. In sculpture, the new enthusiasm for the observation of nature was apparent in certain realistic details of human figures, such as the double chin and heavy-lidded eyes of Peter Koellin's *Madonna*, or the bony, veined right hand of Tilmann Riemenschneider's *Female Saint*.

While Church patronage remained important during the late Middle Ages, the early Renaissance period also saw the rise of a self-made merchant class, whose members became important art patrons, acquiring primarily portraits and religious pictures. Some of the most active centers of painting and patronage were in the Netherlands, an area corresponding to present-day Holland, Belgium, Luxembourg, and parts of France. Evident in the work of several Netherlandish painters in the Museum's collection are three major developments in Northern Renaissance art: realistic portraiture (Antonis Mor), the emerging importance of landscape as a worthy subject in and of itself (the Master of the Female Half-Lengths and Jan Brueghel the Elder), and early experimentation with still-life subjects (Pieter Aertsen). In Aertsen's *A Meat Stall with the Holy Family Giving Alms*, the old order of things is inverted so that the religious scene is relegated to the background and the lavishly rendered still life looms large in the foreground. Aertsen's work already foreshadowed the market scenes and still-life subjects that would emerge as favorite themes of Dutch and Flemish artists of the seventeenth century.

French,
Auvergne region

Madonna and Child in Majesty, about
1150 – 1200

Wood and traces
of paint
h. 29 1/2 in.
(74.9 cm)

Purchased with funds
from the State of North
Carolina, 1962 (62.1.7)

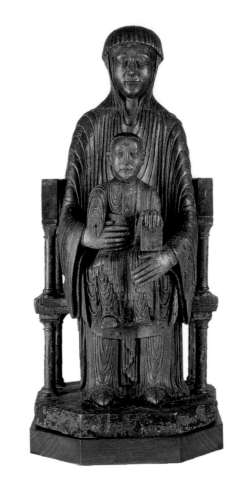

Rigid, strictly frontal, and solemn in expression, the enthroned Mary and Christ Child embody *maiestas* ("majesty"), the term used by twelfth-century writers to describe this type of sculpture. Seated on a throne with round, Romanesque arches, the Madonna serves in turn as a throne for the child; she is the "Throne of Wisdom," according to the Latin liturgy. The mature appearance of the Christ Child suggests his divine, all-knowing nature, and he holds a Bible to show that he is the fulfillment of the Old Testament prophesies. (The heads of both figures appear to be later replacements carved in the characteristic style of twelfth-century "Majesties" from the Auvergne region.)

Traces of blue and red pigment reveal that the sculpture originally was painted, as wooden sculptures almost always were in the Middle Ages. The heads and hands are disproportionately large, while the rigid bodies are concealed beneath draperies defined by incised lines in symmetrical patterns. This rendering of the human form contributes to the apparent otherworldliness of the figures, which were intended to inspire reverence and religious devotion.

Small in scale and relatively lightweight, the sculpture might have been carried in processions during religious festivals. At other times, it probably stood on an altar or pedestal in a church as an inspiration to worshippers. Sculptures of this type also may have been used to represent Mary and Jesus in liturgical dramas enacting the story of the three wise men, while other roles were played by the clergy.

RMN

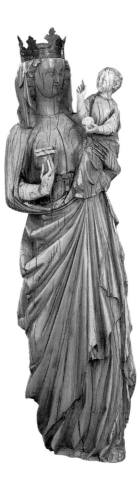

French, Paris

Madonna and Child, about 1250 – 70
Ivory and metal
h. 11 3/4 in.
(29.9 cm)

Gift of Mrs. Edsel B. Ford in memory of W. R. Valentiner, 1959 (59.6.1)

The slender, elongated figures of the Madonna and Child echo the shape of the elephant tusk from which they were carved. They also embody the "courtly" style of Gothic sculpture developed in Paris in the mid-thirteenth century under the patronage of King Louis IX. In keeping with this refined style, Mary is elegantly attired and crowned like a queen, her delicate features enlivened by a sweet smile.

Mary's crown also identifies her as the Queen of Heaven, while the rose she holds symbolizes her purity as a "rose without thorns," a metaphor often used by medieval religious poets. The Christ Child turns in his mother's arms, suggesting an intimacy between the two figures. In his left hand, he holds an apple to signify that he is the "New Adam" who will redeem mankind from the sin introduced into the world by Adam and Eve when they ate the forbidden fruit in the Garden of Eden.

This small sculpture probably was kept by its owner in a private chapel or bedchamber. The warmth and tenderness it conveys reflect the important role Mary played in the devotions of the thirteenth century, when she was seen as a merciful and forgiving intercessor with Christ on behalf of mankind.

RMN

Master of the Latour
d' Auvergne Triptych
French, active about
1490 – 1500

**The Annunciation
with Saints and
Donors**, called
**The Latour
d'Auvergne Triptych**,
about 1497

Tempera and oil on panel
center: 26 11/16 x 19 3/8 in.
(67.8 x 49.3 cm),
wings (each):
26 5/8 x 9 1/2 in.
(67.7 x 24.2 cm)

Gift of the Samuel H. Kress
Foundation, 1960 (60.17.61)

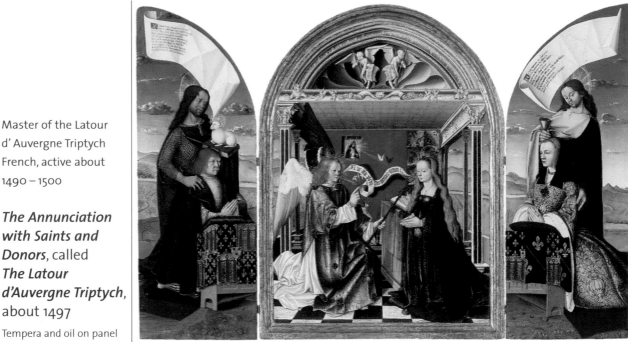

The subject of this three-panel painting, or triptych, is the angel Gabriel's Annunciation to the Virgin Mary that she is to be the mother of Christ. His words to her, taken from Luke's gospel (chapter 1:28), are inscribed in abbreviated Latin on the scroll between them, "*Ave gra[tia] plena dominus tecum*" ("Hail [Mary], full of grace, the Lord is with you").

The wings of the triptych, which close like shutters, have preserved the painting in excellent condition. They bear the likenesses of the donors of the work, the count and countess of Latour d'Auvergne. Their names, Jean and Jeanne, are the French masculine and feminine equivalents of the name John and therefore link the subjects with their patron saints. On the left wing, John the Baptist wears a hair shirt, a reminder of his sojourn in the wilderness, and holds a lamb that refers to his pronouncement, "Behold the Lamb of God." On the right wing, John the Evangelist is identified by his chalice filled with poison (indicated by the dragon), which he was forced to drink, according to legend.

French verses on the banners above the donors offer prayers to the Virgin on their behalf. The verses on the left scroll refer to Gabriel's annunciation and pray for the salvation of the count. The verses on the right request that the countess be blessed with children. Since the count and countess married in 1495 and are believed to have had their first child in 1498, the inscription dates the painting to about 1497.

The painting is from the beginning of the Renaissance in France. The treatment of the landscape background extending across all three panels reveals the Renaissance interest in portraying biblical events in a natural setting. The hills and vegetation accurately depict both the

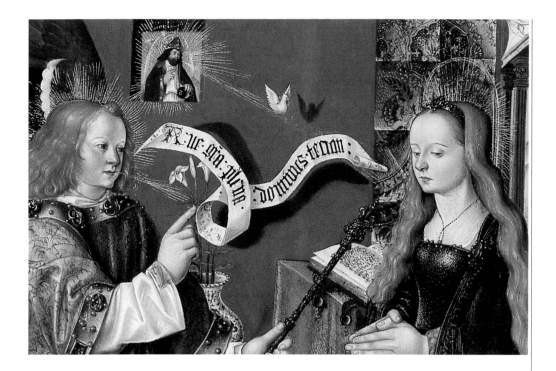

locality of Auvergne, the province of the count and countess, and the traditional date of the Annunciation, March 25. Other hallmarks of the Renaissance style are the landscape and architecture's recession into space and the shadows cast by the dove and the angel's scroll. Some of the architectural details of the columns and capitals show that the artist had some familiarity with Italian Renaissance architecture, perhaps through engravings. Medieval symbols that survived into this period include the Holy Spirit entering the room in the form of a dove, the gilded rays of light emanating from the tiny figure of God in the window, and the white lilies, symbolizing the Virgin's purity.

There is a remarkable attempt at realism in the figures as well as in the landscape. The faces of the count and countess appear to be true portrait likenesses, and those of the Virgin and the angel seem closer to observed models than to idealized conceptions. While the anatomy of the figures is not completely successful, the extensive detail of the Virgin's hands reveals the painter's efforts to reproduce them accurately. A mallard duck was the model for the markings on the angel's wings.

The desire for a child expressed on the scroll was fulfilled. The couple's daughter married a member of the illustrious Medici family of Florence and had a daughter, who returned to France as the wife of the future king Henri II. Known as Queen Catherine de Medici, she played a dominant role in French politics and culture.

The style of the painting indicates that it is a rare example of a local work by a provincial artist aware of contemporary trends in Italian and Flemish painting. An eighteenth-century

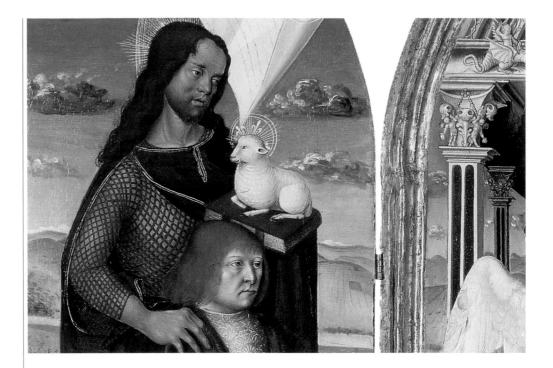

inscription painted in gold on the backs of the shutters and a paper attached to the back of the central panel provide an unusually complete history of its ownership. After the count's death, the countess kept the painting in her castle in Vic-le-Comte. She later bequeathed it to the Franciscan monastery of that town, which retained possession of it until 1703, when it was returned to the Latour d'Auvergne family. Art historians lost track of the triptych for many years, until Samuel H. Kress purchased it on the art market in 1957. The Kress Foundation subsequently donated it to the Museum.

JPC

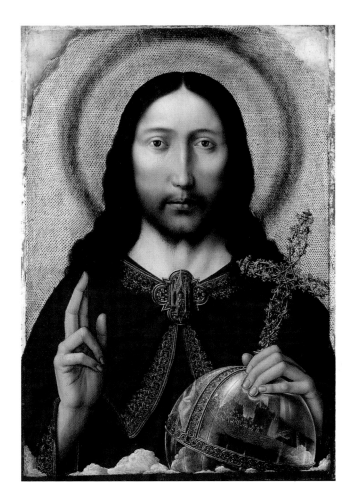

Attributed to
Quentin Massys
Netherlandish,
1465 – 1530

Salvator Mundi,
about 1500 – 1510

Oil on panel
21 x 14 1/2 in.
(53.3 x 36.8 cm)

Gift of the Samuel H.
Kress Foundation, 1960
(60.17.62)

In his role as "Savior of the World" (*Salvator Mundi*), Christ gives the sign of benediction and holds a jeweled crystal orb, a symbol of the world created and ruled by God. This painting has been attributed to the Antwerp painter Quentin Massys based on a comparison of details with motifs in other works known to be by the master. These details include an open-work cross set with jewels, a morse (brooch) portraying Moses holding the tablets of the law, and the brilliantly painted reflections of the cityscape and the hand of Christ on the orb. However, the dark circular halo around Christ's head and the red dots across the gold background are not typical of Massys's work, although such details are found in works by at least one of his contemporaries.

Such severe, frontal representations of Christ were especially popular in Northern Renaissance art and were often paired with the praying Madonna. In existing examples of this type by Massys and his circle, the panels are usually rounded at the top. Although this may have been the original shape of the *Salvator Mundi*, at some point in its history the image apparently was expanded into a rectangular format. Clouds now cover the additions in the upper right and left corners. Use of a procedure known as dendrochronology has revealed that the oak tree from which the panel was cut grew in the Baltic/Polish region of eastern Europe and was felled between 1497 and 1503.

DW

Master of the
Female Half-Lengths
Netherlandish, active
about 1525 – 50

**The Flight into
Egypt**, about
1530 – 35

Oil on panel
25 3/4 x 24 7/8 in.
(65.4 x 63.2 cm)

Purchased with funds
from the North Carolina
Art Society (Robert F. Phifer
Bequest, 1952 (52.9.105)

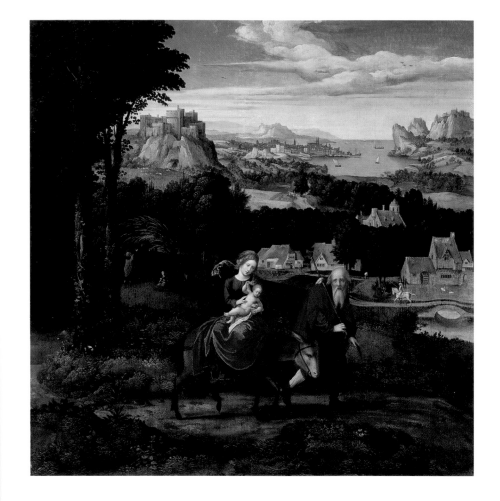

The identity of the artist who painted this panel is not known, so art historians have named him after a group of his paintings—images of female saints portrayed from the waist up. The master's portrayals of figures and landscapes distinguish his unsigned paintings.

This northern European landscape provides the setting for a story related in the Gospel of Matthew (2:13 – 18). In the foreground, Joseph, Mary, and Jesus flee to Egypt to escape the wrath of King Herod. Having heard from wise men of the birth of a Jewish king and fearful that the child would become a threat to his own rule, Herod ordered the deaths of all children two years old or younger in Bethlehem and its environs.

In the middle distance are several small scenes, including one of a village where soldiers carry out Herod's terrible command. The artist also depicted two events which were not mentioned in Matthew's account but were popular episodes drawn from apocryphal gospels during the Middle Ages. One scene shows the Holy Family resting beneath a date palm, which bends its branches for Joseph to reach its fruit. In the background, soldiers on horseback converse with a man in a field of wheat, which miraculously grew up overnight. When asked by the soldiers if a family had recently journeyed past, the farmer truthfully answered they had come by when his wheat field was freshly planted. Thus the soldiers were discouraged from pursuit and the family was saved.

RMN

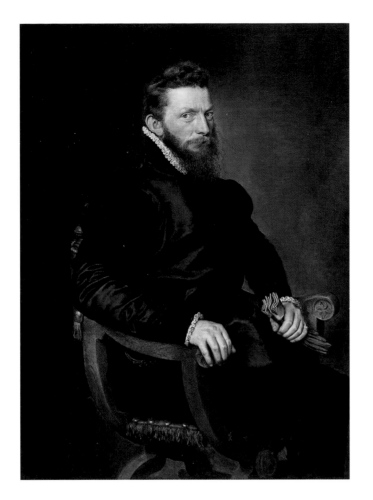

Antonis Mor, called
Antonio Moro
Netherlandish, about
1516/20 – about 1575/77

**Portrait of a
Gentleman**,
about 1570

Oil on panel
48 x 35 1/4 in.
(122.0 x 89.5 cm)

Gift of Mr. and Mrs.
Ralph C. Price, 1955
(55.4.1)

Although this man's identity is unknown, his alert, intelligent expression and intensely focused gaze convey a vivid sense of his personality. The visual interest of his face is heightened by the contrast between the sharp, well-defined features and the soft textures of the beard and hair. Seated in a chair Mor used for several other portraits, the man is fashionably dressed in a black silk costume of Spanish style. While the somber colors and plain background result in an austere portrait, the sitter's high social status is conveyed by his dignified pose and the realistic and detailed rendering of his elegant, dark clothing. He holds a pair of fine leather gloves, an indication of wealth and breeding in sixteenth-century portraits.

A native of Holland, Mor traveled widely and spent much of his career in Spanish-ruled Flanders, where he served as court painter to the Spanish governors in Brussels and was a member of the Antwerp painters' guild. The Spanish version of his name is Antonio Moro.

RMN

Attributed to
Peter Koellin
German, active
about 1450 – 75

*Madonna and
Child Sheltering
Suppliants under
Her Cloak*,
about 1470

Lindenwood, paint,
and gold and silver leaf
h. 57 in.
(144.8 cm)

Gift of R. J. Reynolds
Industries, Inc., 1961 (61.13.1)

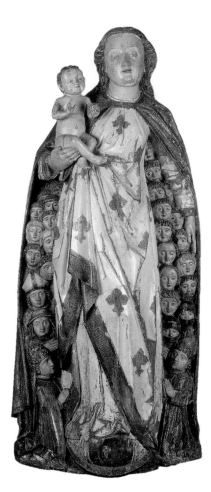

The image of the Madonna enfolding the faithful under her protective cloak is known as the "Madonna of Mercy." The term refers to the Virgin Mary's role in Catholic theology as an intercessor, always ready to plead to Christ for mercy on behalf of those in physical or spiritual distress. In the Middle Ages, the subject was especially popular among members of monastic orders and charitable lay fraternities. In this sculpture, the Madonna shelters members of the spiritual estate: a pope, a cardinal, and a bishop can be identified by their distinctive hats. On the other side are representatives of the secular estate, including an emperor and knights. Held high in Mary's arms, the Christ Child makes a gesture of blessing and holds an apple, symbolizing his role as the "New Adam" who redeems humankind from the consequences of sin.

Mary's white gown is lined with blue and adorned with gold *fleurs-de-lis* ("lily flowers"), symbols of purity. She stands on a crescent moon from which a layer of silver leaf has all but worn away, revealing the red preparatory layer beneath the metal; what remains of the silver has darkened. The moon refers to Mary's role as Queen of Heaven and also reflects the vision of the "Apocalyptic Woman" described in the Revelation of St. John: "A great portent appeared in heaven: a woman clothed with the sun, with the moon under her feet, and on her head a crown of twelve stars" (Revelation 12:1).

RMN

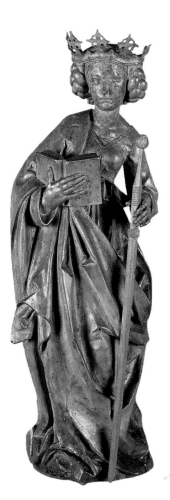

Tilmann
Riemenschneider
German, about
1460 – 1531

Female Saint,
about 1505

Lindenwood and
traces of paint
h. 38 in.
(96.5 cm)

Purchased with funds
from the North Carolina
Art Society (Robert F. Phifer
Bequest) and the State of
North Carolina, 1968
(68.33.1)

Tilmann Riemenschneider was one of the leading German sculptors of the late fifteenth and early sixteenth centuries, a period of transition between Late Gothic and Renaissance styles in northern European art. His portrayal of a female saint continues Gothic traditions in its treatment of pose and drapery. The figure forms an S-curve, sometimes referred to as the hip-shot pose because of the pronounced swing of the hips. Large, angular folds of drapery conceal the body underneath. The new Renaissance emphasis on the close observation of nature is apparent in the naturalism of the face and right hand, with the bone structure, veins, and fingernails meticulously rendered (the left hand is a modern replacement). The somber expression of the long, slender face is characteristic of Riemenschneider's female saints, as is the coiffure of heavy, coiled braids.

The saint's crown indicates that she was of royal blood, while her book suggests a woman of learning. The sword, a symbol of martyrdom, is not original to the statue, so the identity of the saint cannot be ascertained, although she is probably either St. Catherine or St. Barbara. Both were princesses known for their learning who were martyred for their Christian beliefs. Hollowed out in the back to allow for even drying of the wood, the statue likely was once part of a larger ensemble in a church.

RMN

Lucas Cranach the Elder
German, 1472 – 1553

Madonna and Child in a Landscape, about 1518

Oil on panel
16 1/2 x 10 1/4 in.
(41.9 x 26.0 cm)

Gift of Mrs. George
Khuner, 1964 (64.35.1)

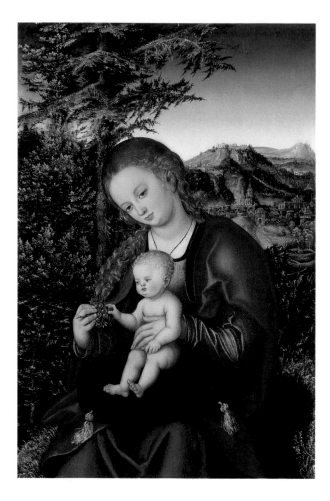

Lucas Cranach was one of the major artists of the German Renaissance. As court painter to the prince-electors of Saxony in Wittenberg, Cranach relied on a large group of apprentices and assistants to meet his patrons' demands for portraits, mythological subjects, interior decorations, court costumes, and armorial devices. Around 1518, Cranach painted the series of small devotional images of the Madonna and Child to which this panel belongs.

The smooth, enamel-like application of deeply saturated colors characterizes Cranach's paintings of this period. From his earlier association with the painters of the Danube School, he retained an interest in the German landscape, dark and fecund. Brilliant highlights sparkle on the foliage and branches of the lush evergreen forest. The Madonna is seated directly on the forest floor, which emphasizes her humility, while the chubby Christ Child sits upon a tasseled, velvet pillow. The grapes offered by his mother symbolize the wine of the Eucharist, which in turn represents the shed blood of Christ. Renaissance artists often included in their images of the Madonna and Child some symbolic reference to the Crucifixion as a reminder of Christ's ultimate sacrifice.

RMN

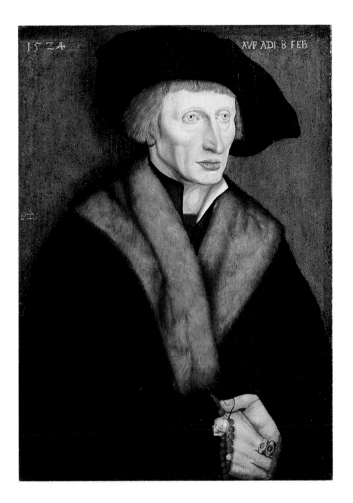

Peter Gärtner
German, active
about 1523 – 39

Hans Geyer, 1524

Oil on panel
19 x 13 in.
(48.3 x 33.0 cm)

Purchased with funds
from the State of North
Carolina, 1952 (52.9.138)

The dry flesh of Hans Geyer, age 54, is pulled tightly over prominent bones. He stares blankly ahead from pale blue eyes and holds a rosary in his tightly clasped hands. Dangling from the prayer beads is a tiny skull, a reminder to Geyer of his own mortality, and to others of theirs. Characteristic of German portrait painting of this period are the precise rendering of the details of the figure and his clothing and jewelry, and the linear definition of forms. The wide-brimmed hat, fur-trimmed coat, and signet rings reveal that the sitter was a prosperous man. His name and year of birth originally were inscribed on the back of the panel. The inscription has been lost, but was recorded in the inventory of a previous owner of the painting.

The artist dated the panel February 8, 1524, and signed it with his monogram, which combines his initials with a garden spade emblematic of his name (Gärtner means "gardener" in German). The portrait is one of the earliest documented works by the artist, who later, in the 1530s, worked as a portrait painter at various German courts.

RMN

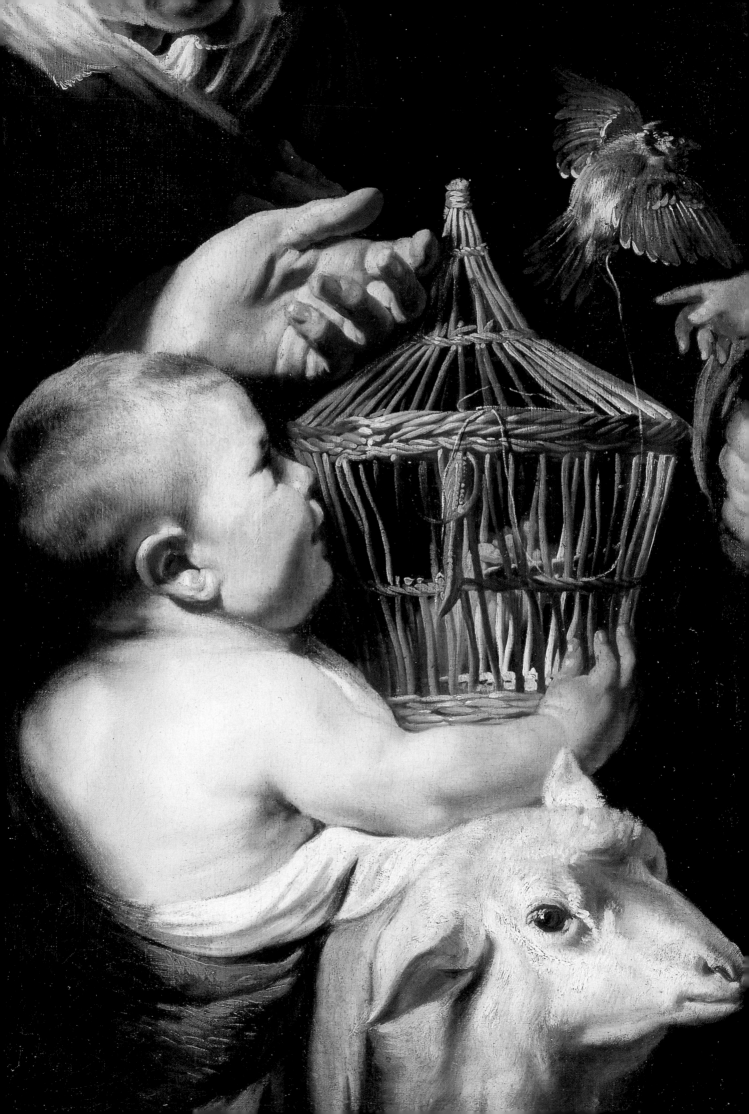

Flemish Baroque Art

IN THE SIXTEENTH CENTURY THE NETHERLANDS came under the control of Philip II, the Hapsburg ruler of Spain. Because Philip was so repressive toward Protestants, the northern provinces, including Holland, broke away and eventually gained their independence. The southern province of Flanders (present-day Belgium) remained under Spanish control. Thus seventeenth-century Flanders, administered by royal governors, was monarchical, aristocratic, and staunchly Catholic.

During the first half of the century, Flemish art was dominated by one larger-than-life figure, Peter Paul Rubens. Master of a large workshop with many assistants and apprentices, Rubens received commissions from the royalty, nobility, and religious orders of Europe. In addition, he was a savvy collector of art and antiquities, a skilled linguist, an accomplished diplomat, and an astute businessman. Only after his death in 1640 did other Flemish painters rise to prominence, most notably Anthony van Dyck (who by then was active in England), Jacob Jordaens, and Frans Snyders. Earlier, all of these artists had collaborated with and/or worked under Rubens in his Antwerp atelier.

As a young artist, Rubens spent eight years in Italy (1600–1608), where he studied the arts of Classical antiquity, the Italian Renaissance, and the early Italian Baroque. When he returned to Flanders, Rubens brought with him the new Baroque idiom that would soon become popular throughout most of Europe. In *The Holy Family with St. Anne*, various elements of Rubens's dramatic style are evident— monumental and abundant figures, rich and varied colors, fluid brushwork, bold lighting, and the tender emotions of the Christ Child's parents and grandmother (the Virgin Mary's mother, St. Anne).

Although the economy of Flanders stagnated in the seventeenth century, particularly after 1621 (when a twelve-year truce in the war with the Dutch ended), the arts and learning flourished as the Catholic Church and wealthy individuals pro-vided steady patronage. The Baroque style found vivid expression in both religious and secular paintings. Large, strikingly naturalistic figures fill the canvases of Jacob Jordaens, Theodoor Rombouts, and Gerard Seghers. Theatrical lighting was most dramatically expressed in night scenes, such as Seghers's *Denial of St. Peter*. Secular paintings encompassed many subjects, such as Rombouts's gaming scene in *The Backgammon Players*, David Teniers's bustling forge in *The Armorer's Shop*, and Frans Snyders's array of foodstuffs in *Market Scene on a Quay*. In the Baroque period, still life came into its own as a favorite type of painting, and in his *Market Scene*, Snyders exploits to the fullest the genre's potential for rich, saturated colors, varied textures, and multitudinous forms.

The Holy Family with St. John and His Parents (detail)

Gerard Seghers
Flemish, 1591 – 1651

*The Denial of
St. Peter*, about
1620 – 25

Oil on canvas
62 x 89 5/8 in.
(157.5 x 227.7 cm)

Purchased with funds
from the State of North
Carolina, 1952 (52.9.112)

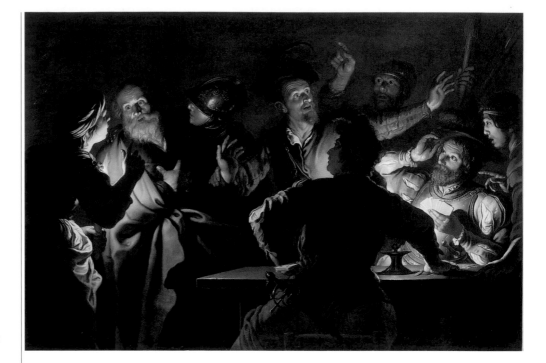

The serving maid of the high priest Caiaphas, recognizing Peter, said to him, "'You also were with Jesus, the man from Nazareth.' But he denied it, saying, 'I do not know or understand what you are talking about'" (Mark 14:66 – 68). After three such denials, Peter realized he had fulfilled Christ's prophecy that he would disown him three times before a cock crowed twice (Mark 14:30).

Peter's encounter with the serving maid and a soldier at the far left is the most dramatic detail of the composition. Although the candle's flame is hidden by the woman's arm, it strongly illuminates Peter's face just as he utters one of his denials. The subject is well-suited to the theatrical approach popular with Seghers and other northern painters who had been to Rome and adopted the naturalistic manner of Caravaggio and his Italian followers.

Many copies of *The Denial of St. Peter* are known to exist, but this picture appears to be the prime version. The details which have bled through the paint layers provide evidence for this conclusion. Motifs that the artist originally included in the work, but later painted over, have gradually reemerged. The most prominent of these — readily visible when standing before the actual painting — is a hand holding a staff, which appears as a ghostly image to the right of St. Peter's hand. Seghers ultimately decided to move this motif further to the right of his composition. Because there would be no need for such changes, called *pentimenti*, to appear in a copy, their presence here strongly supports the conclusion that this is the original version.

DW

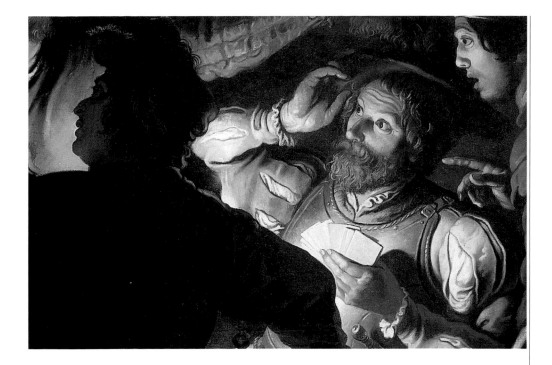

The Dutch Golden Age

ALTHOUGH THEY EFFECTIVELY FREED THEMSELVES from Spanish control in 1609, the seven provinces of the northern Netherlands, frequently called Holland after the name of the largest province, were not recognized by treaty as the Dutch Republic until 1648. With its newfound political, economic, and religious freedom, the Dutch Republic achieved unparalleled commercial prosperity and intellectual and artistic sophistication. Commerce, banking, and shipping led to the rise of an affluent middle class for whom collecting art soon became a passion. This patronage led to a thriving market for popular types of paintings: portraits, biblical and historical scenes, landscapes, still lifes, and scenes of everyday life (genre paintings).

While the art of Spanish-controlled Flanders to the south was profoundly influenced by one man, Peter Paul Rubens, the burgeoning Dutch market created an environment in which many artists achieved wide renown and financial success. Although Rembrandt van Rijn is the most famous Dutch Baroque artist today, he was but one among many highly regarded painters in his own time. Like Rubens in Antwerp, Rembrandt had numerous pupils and assistants in his Amsterdam studio. Some of them, such as Govert Flinck, whose *Return of the Prodigal Son* is in the Museum's collection, had very successful independent careers.

With the notable exception of the sizable Catholic population of Utrecht, most citizens of the Dutch Republic were Calvinist. This Protestant faith forbade religious art in its churches, thus eliminating church patronage. Individuals sometimes commissioned paintings of biblical subjects for their homes, however, and even still-life and landscape paintings often contained moral messages with religious implications. Jan Jansz. den Uyl's *Banquet Piece*, for instance, with its gold-covered beaker, pewter pitcher, fine glasswares, and other luxury items, can be seen as a celebration of Dutch affluence and taste. On the other hand, details such as the half-empty glass, the snuffed-out candle and wick trimmer, the silent lute, and the general disarray of the feast are symbols of the transience of earthly life and its pleasures, and thus a reminder to pay heed to the health of one's immortal soul.

Although Dutch Baroque art is not as grandiose in scale or theme as its Flemish counterpart, both styles share certain artistic elements—dramatic contrasts of light and dark, striking naturalism in the portrayal of humans and animals, and the expression of deeply felt emotions.

Jan Lievens
Dutch, 1607 – 1674

The Feast of Esther,
about 1625

Oil on canvas
53 x 65 in.
(134.6 x 165.1 cm)

Purchased with funds
from the State of North
Carolina, 1952 (52.9.55)

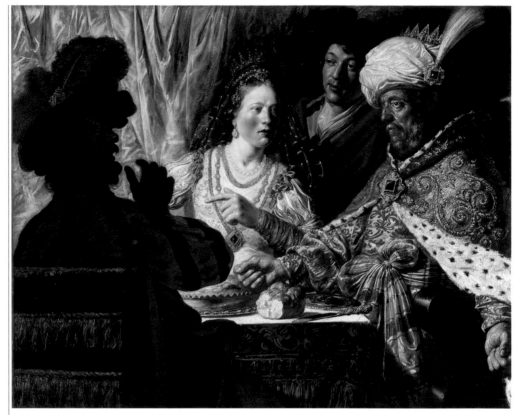

One of the most dramatic moments from the Book of Esther comes when the queen accuses the king's advisor Haman of treachery against her people (Esther 7:1–7). Through her efforts, Haman's plot for the slaughter of all the Jews in Persia was unmasked before King Ahasuerus (Xerxes). Seated before his chamberlain, Harbonah, the king reacts in anger with arms outstretched and hands clenched. Across from him sits the isolated, shadowy figure of Haman, who cowers at the king's wrath. Shortly thereafter, Haman's life would end on the gallows.

The broad, painterly style, bold colors, and dramatic energy of *The Feast of Esther* has much in common with works produced by the young Rembrandt in his native city of Leiden. In fact, the picture was formerly attributed to Rembrandt. Nevertheless, the artist of this provocative work is now identified as Jan Lievens, Rembrandt's slightly younger and more precocious Leiden colleague. The picture shares many similarities with other examples from Lievens's oeuvre. In its scale, clarity of spatial organization, bold palette, and description of materials, the painting is the masterpiece of the artist's youth.

Painted during a period when Lievens and Rembrandt may have shared a studio, the painting calls attention to the differences between their works. The scholar and art lover Constantijn Huygens, the first to discuss both artists, wrote in the early 1630s that Lievens's paintings from the 1620s had a grandeur of invention and boldness that Rembrandt did not achieve. *The Feast of Esther* confirms his insightful opinion.

DW

102

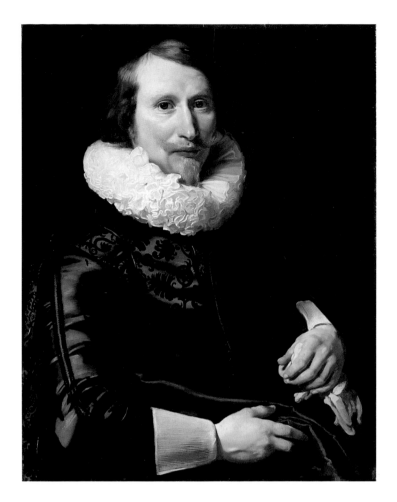

Thomas de Keyser
Dutch, 1596/97 – 1667

**Portrait of a
Gentleman**,
about 1626

Oil on panel
28 1/4 x 21 7/8 in.
(71.8 x 55.6 cm)

Anonymous gift, 1963
(63.18.1)

Thomas de Keyser was the preeminent portrait painter in Amsterdam prior to the arrival in 1632 of the young Rembrandt, whose early development as a portraitist de Keyser influenced. Portraits were in tremendous demand in seventeenth-century Holland, where members of the newly prosperous middle class had an insatiable desire for likenesses of themselves. These solid, practical Calvinist burghers preferred realistic portraits with careful attention to detail and accurate rendering of their elegant but somber clothing and accessories.

De Keyser's portrait of an unidentified man is characteristic of conventional Dutch portraiture in its straightforward portrayal of the sitter, restrained brushwork, and subdued color scheme. The artist employs the familiar half-length portrait formula, with the figure looking directly at the viewer and positioned at a slight angle against a neutral background. Wearing an elegant silk velvet costume with starched linen ruff and cuffs, the gentleman holds a pair of fine leather gloves, an indication of his social status and wealth. De Keyser's confident handling of the paint to indicate the textures of flesh and hair and to suggest the underlying bone structure is evident in the beautifully modeled head and the sensitively rendered hands of the sitter.

RMN

Jan Steen
Dutch, 1626 – 1679

**The Worship of
the Golden Calf,**
about 1671 – 72

Oil on canvas
70 1/4 x 61 1/4 in.
(178.4 x 155.6 cm)

Purchased with funds
from the State of North
Carolina, 1952 (52.9.58)

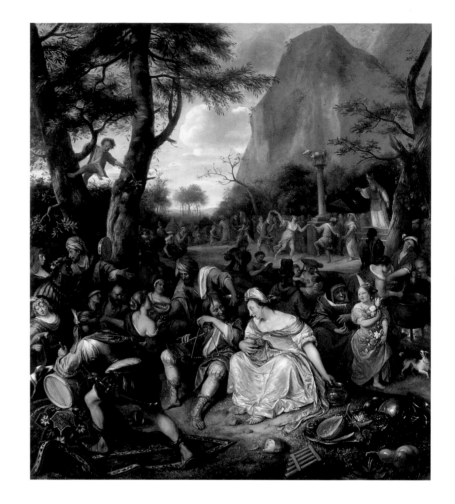

While Jan Steen is best known for his pictures of unruly merrymakers in humorous situations, he was, above all else, a storyteller. Whether he was painting proverbs, scenes from the theater, the battle between the sexes, or religious narratives, his talent to describe and animate a scene was unmatched among his contemporaries. As one of his largest and most ambitious works, *The Worship of the Golden Calf* clearly attests to this Dutch painter's extraordinary ability to tell a story. Exodus 32:1 – 6 describes the Israelites' loss of faith while they were waiting for Moses to return from Mount Sinai. By asking his brother Aaron to make idols for them to worship, they broke their covenant with God, which ultimately brought down God's wrath in the form of a plague.

Here, the consequence of their request still lies in the future, for after seeing the golden calf, the Israelites exclaimed:

> *'These are your gods, O Israel, who brought you up out of the land of Egypt!' When
> Aaron saw this, he built an altar before it; and Aaron made proclamation and said,
> 'Tomorrow shall be a festival to the Lord.' They rose up early the next day, and offered
> burnt offerings and brought sacrifices of well-being; and the people sat down to eat
> and drink, and rose up to revel (Exodus 32:4 – 6).*

Although Steen included Aaron, the golden calf, and many of the merrymakers in the distance, he concentrated his efforts on the riotous behavior of the figures in the foreground. Particularly noteworthy is the fancifully dressed young couple gazing lasciviously at each

other at the center. It is not surprising that the man holding the triangle bears a striking likeness to the painter, for Steen often portrayed himself in compromising situations of this type. The viewer is accosted by abundance and excess from all directions; adding to the decadence are ripened fruit, cut flowers, elaborately woven carpet, and most notably, musical instruments. The tambourine, flute, drum, triangle, and barking dog to the right only augment the revelry.

In light of this excess, how did Steen provide the viewer with a warning against the dangers of sensual pleasure and moral decay? Nearly lost in the crowd is the young boy at the left holding a parrot. Emblematic literature from the period suggests that parrots offered warnings against allowing sensual appetites to dictate actions. Just as this bird instinctively mimics human voices, people are easily led to imitate destructive behaviors. Alternatively, the parrot might be seen as the quiet voice of conscience, thereby alluding to the judgment to follow.

Steen, a native of the Dutch university town of Leiden, found inspiration for his painting in the central panel of an altarpiece depicting the same subject by Lucas van Leyden, the city's most famous painter of the previous century. In both examples, the dancers remain in the background, while the debauched merrymakers fill the foreground. Steen even went so far as to appropriate some of Lucas van Leyden's sixteenth-century costume elements. Steen's picture must date to the early 1670s, for it reflects the new elegance then entering into his paintings. The sparkling clarity, decorative and brilliant color, and delicate textures of the canvas would have appealed to an aristocratic class at ease with luxury.

DW

Attributed to Michiel
van Musscher
Dutch, 1645 – 1705

Allegorical Portrait of an Artist, about 1680 – 85

Oil on canvas
44 15/16 x 35 7/8 in.
(114.2 x 91.0 cm)

Gift of Armand and
Victor Hammer, 1957
(57.10.1)

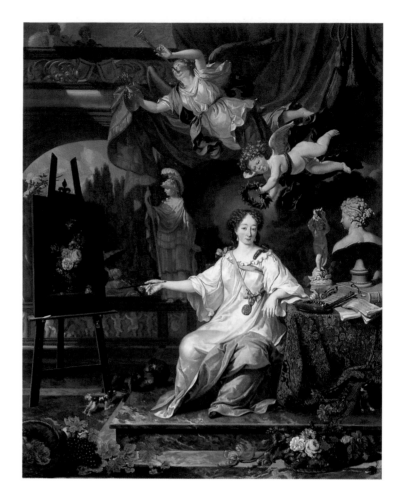

Gesturing with a paintbrush towards her creation, an artist sits in her lavish studio awaiting the praise of viewers. Her skill in transforming nature into art, confirmed by the floral still life sitting on the easel, is already celebrated. Fame trumpets her presence and a putto places a laurel wreath on her head. The statue of Minerva, the mythological patroness of the arts, and attributes of the liberal arts such as the palette and brushes, sculptural casts, and open music book on the table call attention to the painter's elevated status.

While the costume and hairstyle of the sitter suggest a date of about 1680 – 1685, her identity and that of the artist responsible for the picture are open to debate. Once thought to represent the Dutch still-life painter Rachael Ruysch (1664 – 1750), the woman pictured here does not correspond to known likenesses of Ruysch. A somewhat more plausible identification is that of Maria van Oosterwijck (1630 – 1693), at the time the most highly regarded female still-life painter in Holland. Considering the relatively young age of the woman, however, this suggestion also seems unlikely. Stylistically, the painting bears many likenesses to works by Michiel van Musscher, an artist who painted similar allegorical subjects during his career.

DW

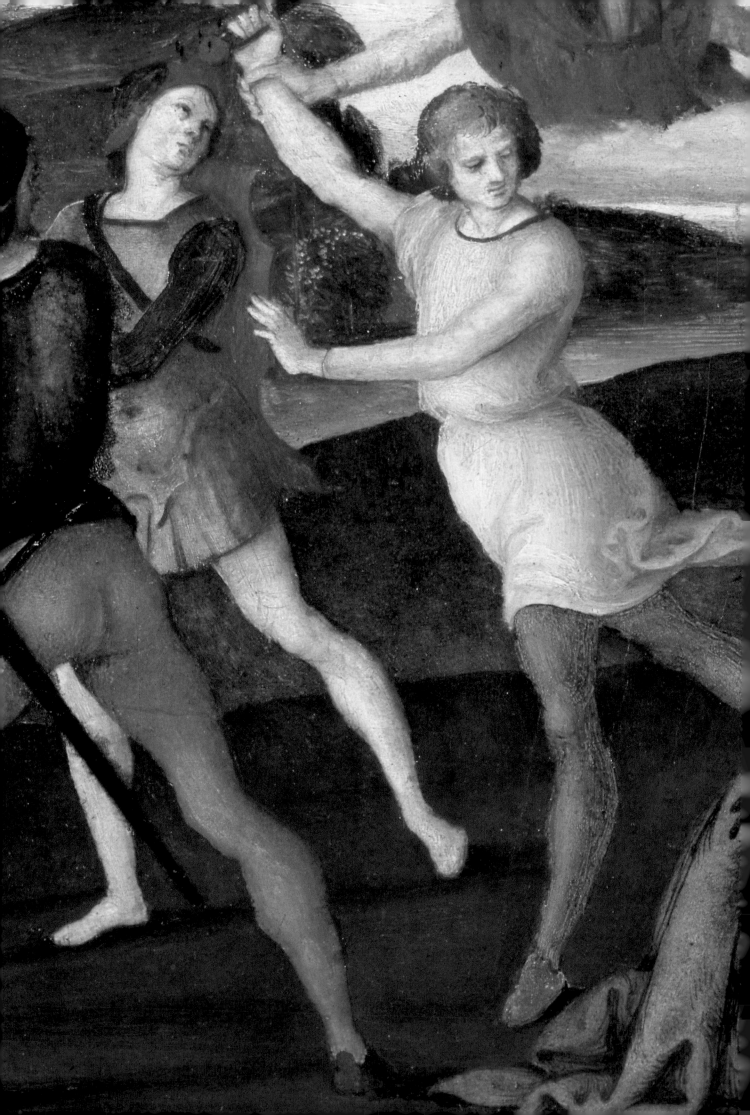

Late Medieval and Renaissance Art in Italy

THE ITALIAN RENAISSANCE, which flowered in the fifteenth and sixteenth centuries, originated in the early fourteenth century with the humanistic poetry of Petrarch and the profoundly original paintings of Giotto. In the art of Giotto and his contemporaries, Medieval and proto-Renaissance elements often existed side by side. In Giotto's *Peruzzi Altarpiece*, for example, pointed Gothic-shaped panels, a gold background, and the larger scale of the Christ figure are Medieval, whereas the well-rounded figures draped in subtly modeled robes point the way toward the early Renaissance, with its emphasis on natural-looking figures. For his new approach to portraying figures, Giotto drew inspiration from Classical art, just as Petrarch drew themes from ancient history and mythology. Thus they were both in the vanguard of the rebirth ("renaissance") of Classical antiquity.

During the Medieval and Renaissance periods, the Italian peninsula was not unified, but instead was divided into individual city-states. The diverse artistic styles that developed in cities such as Lucca, Florence, Siena, Bologna, and Milan are well represented in the NCMA's collection. As is true for late Medieval and Renaissance art in general, Christian themes predominate in the Museum's collection, although artists and patrons were increasingly interested in other subjects as well, including portraits and secular themes drawn from Classical history and mythology. Many of the religious paintings originally belonged to large altarpieces that have been dismantled and their individual parts dispersed. Raphael's *St. Jerome Punishing the Heretic Sabinian*, for instance, is a predella panel from the base of an altarpiece.

By the emergence of the High Renaissance in the first decades of the sixteenth century, artists had fully mastered the skills that would enable them to portray completely natural-looking figures, interiors, and landscapes: anatomy for realistically proportioned and posed figures, modeling with light and shade for naturally rounded forms, linear and atmospheric perspective to create the illusion of depth on a two-dimensional surface. These techniques were employed to capture a natural but idealized beauty and a sense of controlled movement and graceful repose within a balanced, harmonious environment. Bernardo Lanino's symmetrically balanced *Madonna and Child Enthroned with Saints and Donors* demonstrates this combination of realism (the donors and saints) and idealized beauty (the Madonna) in a composition based on mathematically exact linear perspective.

In Venice, artists successfully exploited the potential of the new oil medium, which gradually replaced water-based tempera paint during the Renaissance period. Oil paint can be applied in many thin, translucent layers to achieve a depth and luminosity of color that is not possible with tempera. In his *Madonna and Child in a Landscape*, Venetian painter Cima da Conegliano used oils to achieve remarkable effects of color, light, atmosphere, and texture, and in so doing created a Renaissance paean to human, divine, and natural beauty.

St. Jerome Punishing the Heretic Sabinian (detail)

Puccio Capanna
Italian, active
about 1325 – 50

Crucifixion,
about 1330

Tempera and gold
leaf on panel
7 x 51/2 in.
(17.8 x 14.0 cm)

Gift of the Samuel
H. Kress Foundation,
1960 (60.17.8)

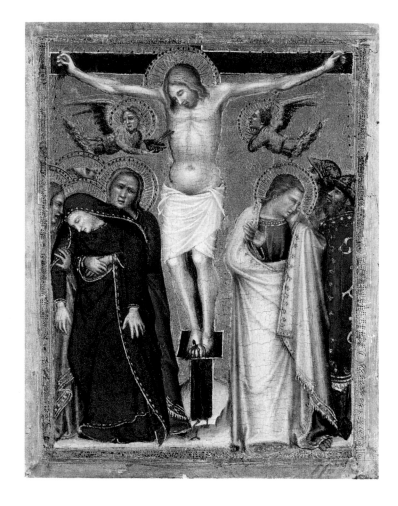

A native of Assisi, Puccio painted several frescoes in that city's basilica of San Francesco during the 1340s. These frescoes continued the ambitious decorative program of the basilica, where, in the first decade of the century, Giotto's pupils — and possibly the master himself — painted two extensive fresco cycles. They were among the most forward-looking and influential works of the period.

Giotto's influence is clearly evident in this *Crucifixion*. Like Giotto, Capanna focuses on the human aspects of the subject, making the Crucifixion a personal event. Profound and varied emotions are conveyed through the natural expressions and poses of the figures, and are intensified by the shallow, crowded pictorial space. These qualities, and Capanna's masterful use of color, reveal him to be one of Giotto's most sensitive and gifted followers.

The *Crucifixion* was the central compartment of one panel of a diptych. The other half of the diptych, which has survived intact and hangs in the Vatican Picture Gallery, features an enthroned Madonna and Child with attending angels in the central compartment, surrounded by eight smaller compartments depicting female saints and the Annunciation to Mary.

DS

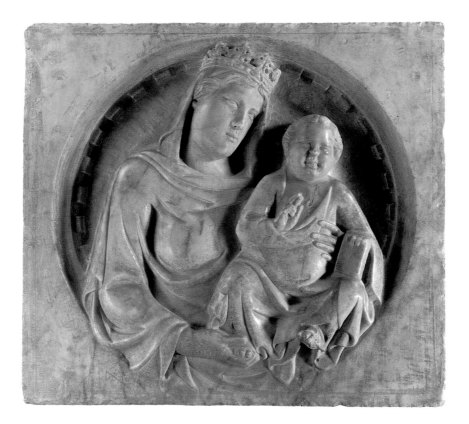

Tino di Camaino
Italian, about
1280 – 1337

Madonna and Child, about
1317 – 20

Marble
18 x 19 1/2 in.
(45.7 x 49.5 cm)

Gift of the Samuel H.
Kress Foundation,
1960 (60.17.4)

Tino was one of the most important and influential sculptors of his day. His particular specialty was creating elaborate sepulchral monuments, often composed of several individual sculptures and carved reliefs that comprised the building blocks for extensive architectural constructions. This *Madonna and Child* probably formed part of the decoration of one such monumental tomb, the shrine of St. Octavian, which once stood in the cathedral of Volterra.

Tino enjoyed an itinerant career, with extended sojourns in four of the most important art centers on the Italian peninsula: Siena, Pisa, Florence, and Naples, where he moved in the same circles as the writers Dante, Petrarch, and Boccaccio. Tino maintained close relationships with influential artists, including Giotto.

Works like this *Madonna and Child* demonstrate the significant "cross-pollination" that occurred between sculptors and painters during this period. The substantial, block-like massiveness and geometric structure of Tino's figures influenced painters throughout Tuscany, and they reflect concerns that are also addressed in Giotto's works. The graceful and rhythmic fluency of line that distinguishes Tino's draperies finds close parallels in the paintings of contemporary Sienese artists.

DS

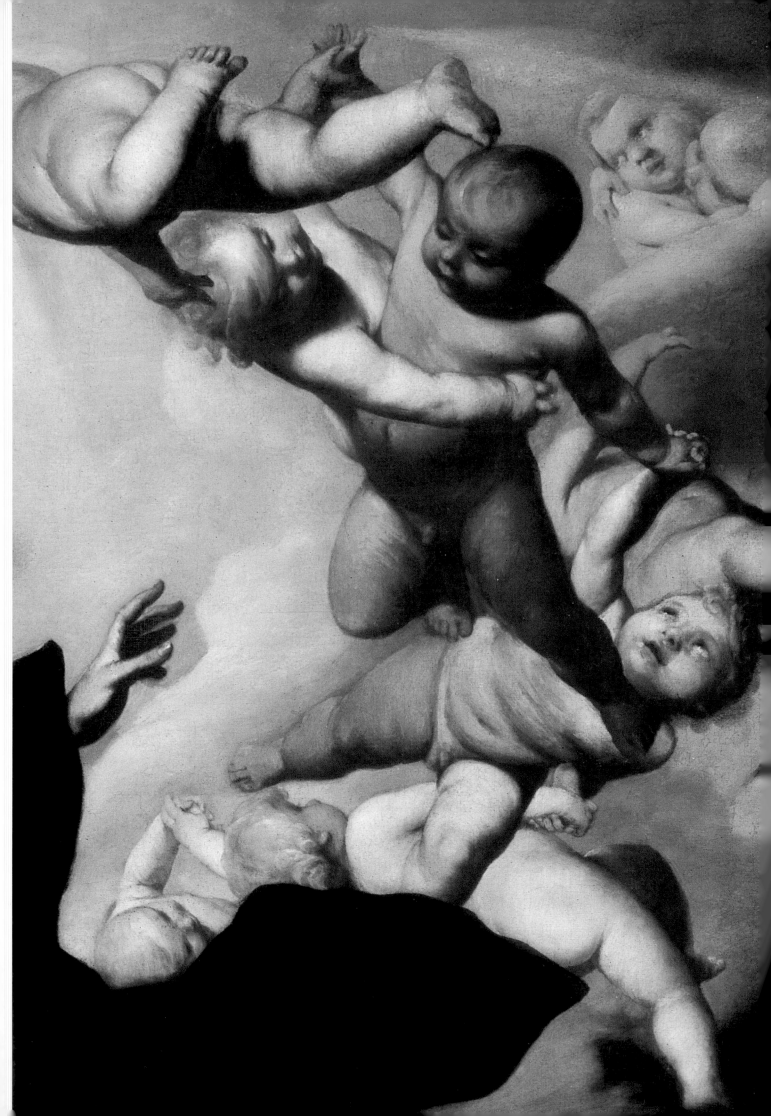

Italian Baroque Art

ONE OF THE SIGNIFICANT INFLUENCES ON BAROQUE ART in Italy was the patronage of the Roman Catholic Church during the Counter-Reformation period. Having seen the Church's influence severely shaken and weakened by the rise and growth of Protestantism, Catholic clergy employed every means at hand to reassert its power and authority and to attract worshippers to their ancient faith. Because the Church found Baroque art an effective means for spreading its ideological message, architects, sculptors, and painters were valuable allies in this tremendous effort. Religious art was viewed as "the Bible of the illiterate" and particular emphasis was placed on themes that reinforced the primacy of the Catholic Church and its teachings, such as martyrdom, the role of saints as intercessors with Christ on behalf of the faithful, and the unique sanctity of the Virgin Mary. The Museum's paintings depicting the Assumption of the Virgin by Lodovico Carracci and Massimo Stanzione, for example, celebrate the Catholic doctrine that Mary's body was assumed into heaven on the third day after her death so that it was not subject to the corruption of the flesh.

Another wide-reaching influence on Baroque art in Italy was an art academy founded in Bologna by Lodovico Carracci and his cousins Annibale and Agostino. The Carracci rejected the prevailing Mannerist idiom of the mid- to late sixteenth century, a highly sophisticated style characterized by fantastic inventiveness and, as often as not, by the intentional distortion and exaggeration of form and the use of dissonant colors. The Carracci advocated instead a return to naturally proportioned figures in logically constructed spaces, to harmonious colors and compelling, heartfelt emotions. These ideals were passed on to students at their academy, such as Domenichino and Guido Reni, who were taught to study nature and the art of Classical antiquity and the High Renaissance.

The painter Caravaggio, active in Rome and Naples, exploited the dramatic potential of using extreme contrasts of light and dark (chiaroscuro), and employed humble, rugged, working-class people as models for biblical figures and saints. Although Caravaggio did not establish an academy or a formal workshop, his earthy naturalism and striking light effects influenced many fellow Italians, including Bernardo Strozzi, and artists from other countries, such as the Spaniard Jusepe de Ribera and the Dutchman Matthias Stom. This international influence was not unique to Caravaggio. During the Baroque period, artists from many parts of Europe were drawn to Italy, where they could study Roman antiquities, masterpieces of the High Renaissance, and the achievements of their contemporaries. Some, such as French painter Claude Lorrain, were attracted by the light-filled Italian landscape, which featured natural beauty alongside spectacular ruins of Classical civilizations.

Lodovico Carracci
Italian, 1555 – 1619

**The Assumption
of the Virgin**,
about 1586 – 87

Oil on canvas
96 1/2 x 53 in.
(245.0 x 134.6 cm)

Gift of Mrs. J. L.
Dorminy in memory
of her husband, 1957
(57.21.1)

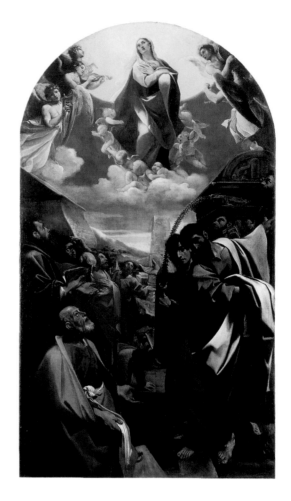

Carracci was one of the leading Italian painters of the Counter-Reformation period, when the Catholic Church sought to differentiate itself from the newly established Protestant denominations and to reassert its power and authority. As such, he often painted subjects with particular relevance to the Catholic tradition, including those that celebrated the special place of the Virgin Mary in the teachings of the church.

The story of the Virgin Mary's Assumption, when her body was taken up into heaven by angels, is not described in the Bible. It was a popular subject, however, for Counter-Reformation artists, who knew the story from literary texts. Here Carracci combines the Virgin's Assumption with the discovery of her empty tomb by the apostles, much as the Neapolitan painter Massimo Stanzione does in his portrayal of the same subject (page 136). The apostle John, whose outward gaze draws the viewer into the painting, holds a palm branch, symbolic of victory over death. St. Thomas, kneeling at the left, looks up and touches the girdle (sash), which the Virgin tossed down to prove to him the reality of her miraculous Assumption. Behind Thomas stands St. Peter, holding the book from which he conducted her funerary rites.

By showing the Virgin Mary triumphantly borne above funerary monuments of the Romans (on the far left), Egyptians (the obelisk inscribed with hieroglyphs in the center background), and Jews (the sarcophagus on the right that bears a relief of the stone tablets of Moses), the artist glorifies her and asserts the superiority of the Christian (in this case Catholic) faith.

RMN

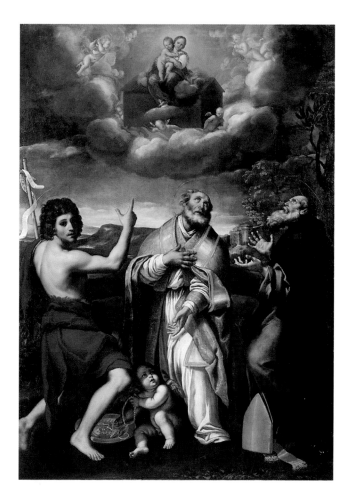

Domenico Zampieri,
called Domenichino
Italian, 1581 – 1641

**The Madonna of
Loreto Appearing to
St. John the Baptist,
St. Eligius, and St.
Anthony Abbot**,
about 1618 – 20

Oil on canvas
94 7/8 x 67 1/8 in.
(241.0 x 170.5 cm)

Gift of the Samuel H.
Kress Foundation,
1960 (60.17.51)

Like Guido Reni (page 138), Domenichino studied under Lodovico Carracci in the Carracci Academy in Bologna. After spending several years in Rome, Domenichino journeyed to the town of Fano, on the eastern coast of Italy, in order to execute a lucrative set of commissions for an aristocratic family. It was during this period that the goldsmith Antonio Salvatore commissioned from the artist this altarpiece for his family chapel in the church of San Francesco at Fano. The chapel was dedicated to St. Eligius, patron saint of goldsmiths, and St. John the Baptist, both of whom are depicted in the painting. The inclusion of St. Anthony Abbot is due to his role as Antonio Salvatore's patron saint. The altarpiece remained in the church until 1805, when it was sold by the monks of San Francesco to pay for a new roof.

Images of the Madonna of Loreto, depicting Mary and Jesus seated on the roof of a house borne aloft by angels, were especially popular in the region around Fano. According to legend, when the Saracens were driving the Crusaders out of the Holy Land in 1291, thereby threatening the safety of Christian shrines, angels were said to have carried the house of Mary and Joseph from Nazareth to Loreto, a town located some 40 miles down the Adriatic coast from Fano.

DS

Bernardo Strozzi
Italian, 1581 – 1644

**St. Lawrence
Distributing
the Treasures
of the Church**,
about 1625

Oil on canvas
46 1/2 x 62 in.
(118.1 x 157.2 cm)

Purchased with
funds from the State
of North Carolina,
1952 (52.9.168)

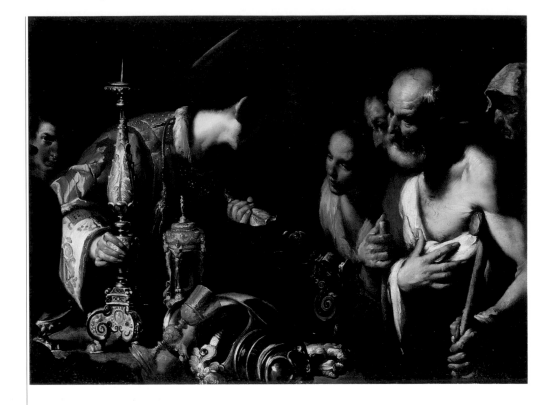

The story of the last days of St. Lawrence was recorded by several early Christian writers soon after his martyrdom in Rome in 258 during the persecutions of Emperor Valerian. As the archdeacon of the Roman church under Pope Sixtus II, St. Lawrence was horrified when the pope was imprisoned and condemned to die for his faith. He eagerly carried out the pope's final instructions that the treasures of the church be distributed to the poor of Rome. When the Roman authorities commanded St. Lawrence to turn over the treasures to the emperor, he presented an assembly of the poor, the disabled, and the orphaned to the authorities, explaining that these were the true treasures of the church. For this affront to the emperor's authority, St. Lawrence was condemned to die by being chained to a gridiron and roasted alive.

In his interpretation of the St. Lawrence story, Strozzi portrays a dark, shadowy atmosphere from which boldly modeled half-length figures emerge into the light. Gathered around St. Lawrence are rustic individuals rendered with naturalism and attention to detail. The saint himself is a more aristocratic-looking figure, delicately attenuated and dressed in heavily ornamented clerical robes of crimson and gold. The ice-blue garment of the young woman and the bright red mantle of the elderly man beside her, together with the metallic sheen of gold and silver objects, enrich the otherwise dark color scheme of the painting. A slightly discomfiting detail is the figure at far left, who gazes out of the painting to catch the eye of the beholder.

RMN

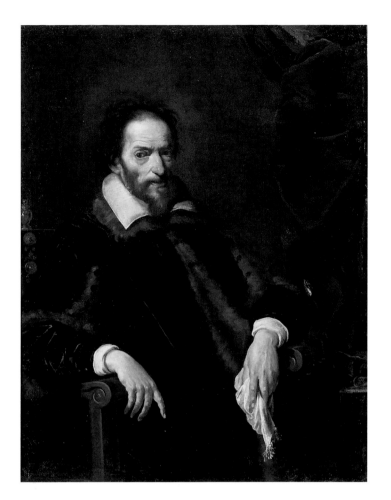

Bernardo Strozzi
Italian, 1581 – 1644

**Portrait of a
Gentleman**,
about 1629

Oil on canvas
46 1/2 x 35 1/2 in.
(118.1 x 90.1 cm)

Gift of R. J. and G. C.
Maxwell in honor of
their sister Rachel
Maxwell Moore, 1959
(59.36.1)

The unflinching realism of this portrait is characteristic of the Baroque naturalism of some seventeenth-century painters, particularly Caravaggio and his followers. As a resident of Genoa in his formative years, Strozzi was well situated to absorb the influence of some of the leading artists of his day, including northern and Italian followers of Caravaggio, and the Flemish painter Anthony van Dyck, all of whom spent time in the city in the 1620s. From the portraits of Van Dyck, Strozzi adopted the angled pose and the effect of spotlighting the figure against a dark background. The varied textures, depth of color, and broad, fluid brushwork are characteristic of Strozzi's Genoese canvases.

Although the identity of the sitter is not known, Strozzi has included attributes that offer some indication of the man's station in life. The understated elegance of his somber costume is apparent in the rich fabric, fur trim, and fine white collar and cuffs. His lace-trimmed handkerchief is another indication of wealth and high social position. On the table beside the man's chair are a book and a pen and inkwell, suggesting that he is a learned man. His disheveled hair and bloodshot eyes do not diminish the sharpness and intelligence of his gaze.

RMN

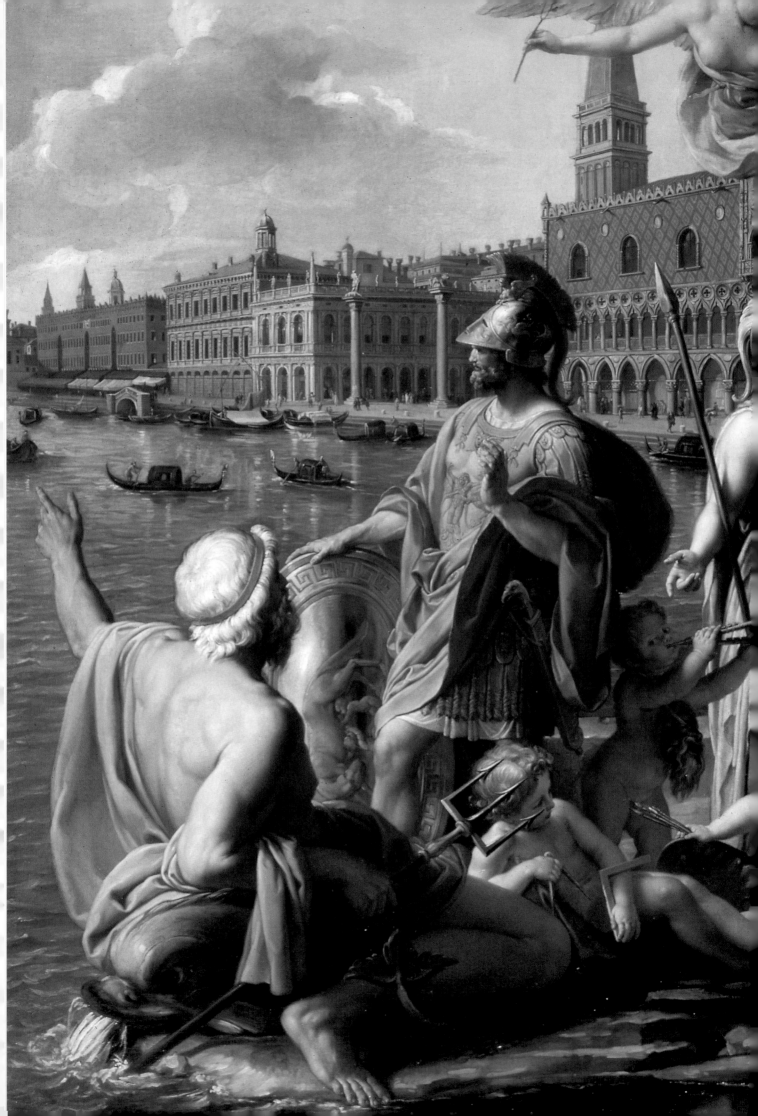

Eighteenth-Century Italian Art

IN EIGHTEENTH-CENTURY ITALY, the primary artistic patronage shifted from the Catholic Church, which had played a dominant role in defining the art of the preceding century, to the aristocracy. For the adornment of their houses these new patrons preferred paintings with secular themes, light and elegant forms, luminous colors, and an overall decorative emphasis. Venetian artists produced masterful paintings in this airy new style that employed pastel colors, even lighting, and illusionistic architectural perspective inspired by stage scenery. Although Venice was in the last stages of its decline as a commercial and political power, the city's nobility and wealthy bourgeoisie continued to furnish their palaces and villas lavishly. The glories of the Venetian Republic are celebrated as though yet untarnished in Pompeo Batoni's artistic tour-de-force, *The Triumph of Venice*, one of the masterpieces of eighteenth-century art in the NCMA's collection.

Eighteenth-century travelers from northern Europe, especially Great Britain, journeyed to Italy in record numbers on the Grand Tour, a journey through the cultural capitals of Europe that was considered an essential part of every gentleman's education. Because affluent travelers liked to take home works of art as souvenirs, many artists specialized in paintings of famous and picturesque sites. Canaletto's *Capriccio: The Rialto Bridge and S. Giorgio Maggiore* is such a *veduta*, or "view," of Venetian monuments. His nephew Bernardo Bellotto carried on the family tradition in marvelous cityscapes, as seen in his two views of Dresden.

Local patrons delighted in playful and fanciful subjects, such as Magnasco's scenes from the comic theater, the *Commedia dell'arte*, and Ubaldo Gandolfi's mischievous interpretation of the myth of Mercury and Argus.

The Triumph of Venice (detail)

Pompeo
Girolamo Batoni
Italian, 1708 – 1787

*The Triumph
of Venice*, 1737

Oil on canvas
68 5/8 x 112 5/8 in.
(174.3 x 286.1 cm)

Gift of the Samuel
H. Kress Foundation,
1960 (60.17.60)

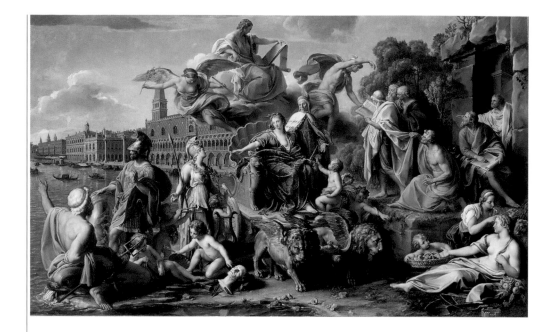

The Triumph of Venice reveals a great deal about eighteenth-century history painting and the complex, ambitious aims and expectations of both artists and patrons of the period. Batoni's first important secular work, it was painted for Marco Foscarini, the newly appointed Venetian ambassador to the papal court, a highly cultured bibliophile and historian. According to Foscarini's secretary, the painting illustrates "the flourishing state of the Venetian Republic when after the wars incited by the famous League of Cambrai, peace returned and the fine arts began to flourish again, summoned back and nurtured by Doge Lionardo Loredan [governor of Venice from 1501 to 1521]."

A female personification of Venice is enthroned upon a triumphal car drawn by two winged lions, the attributes of St. Mark, Venice's patron saint. To her left, Doge Loredan gestures toward harvest offerings, symbolizing the Venetian region's agricultural bounty from the goddess Ceres, who reclines in the lower right corner. To Venice's right, the goddess Minerva, patroness of the fine arts, presents putti bearing attributes of architecture, music and drama, painting, sculpture, and poetry. Neptune, the mythological patron of the Venetian Republic, points out the city to Mars, the patron of Rome. Above Venice are the figures of Fame, with trumpet and laurel branch, and double-faced History, her older face looking back to Venice's glorious past while her younger aspect contemplates her record of the city's equally glorious present. To the right of Fame, Mercury presents a history of the Republic's achievements to a group of ancient sages and historians, among them the blind Homer, who emerges from the entrance to Hades, as indicated by the presence of Cerberus, the three-headed canine guardian of the underworld. In the background is a view of Venice's Molo, the waterfront area at the entrance to the Grand Canal near St. Mark's Square and the Ducal Palace.

Commemorating events that occurred during the first quarter of the sixteenth century, the subject seems at first glance to be a rather peculiar choice for a commission some two hundred years later. Clear parallels existed, however, between Venice's earlier political situation during Loredan's rule and the circumstances in which the Republic found itself at the time of Foscarini's ambassadorship. These parallels would have been apparent to Foscarini, the official historiographer of the Republic, and to eighteenth-century visitors to the Palazzo Venezia in Rome, where the painting was to hang.

During Loredan's rule, Venice's existence had been threatened by the League of Cambrai, an alliance among France, Spain, the Holy Roman Empire, and the Papal States, whose sole intent was the destruction of the Republic. According to historical accounts, it was only due to Loredan's political astuteness that the League's designs were thwarted, and Venice's imminent defeat was ultimately transformed into triumph. The Republic retained its independence, entered an era of lasting peace, and enjoyed great prosperity at a time when the Italian peninsula was plagued by continual warfare and foreign domination. The price for achieving this peace and prosperity was that Venice had to abandon its policy of territorial expansion and surrender a substantial portion of its foreign empire, which included parts of northern Italy, much of the Dalmatian coast, Crete, Cyprus, and portions of Greece.

In the early eighteenth century, Venice's political situation was remarkably similar to that which it had faced under Loredan's dogeship two hundred years earlier. Under the terms of a 1718 treaty dictated by England and the Netherlands, Venice ceded her territorial possessions in the Near East to Austria. The foreign empire of the once-mighty Republic was reduced to only the city of Venice and the surrounding territory of the Veneto. As in the early sixteenth century, Venice once more found itself at a political crossroads, its political empire reduced by more powerful rivals. Batoni's painting reflected a political course for contemporary Venice similar to the one chosen two hundred years earlier. In 1737, no longer able to maintain its far-flung foreign possessions, Venice could again opt for the blessings of peace and prosperity that might foster a renaissance of the arts such as the one that occurred following the peace treaty concluded by Doge Loredan.

DS

Alessandro Magnasco
Italian, 1667 – 1749

The Supper of Pulcinella and Colombina,
about 1725 – 30

Oil on canvas
30 3/4 x 41 3/8 in.
(78.1 x 105.1 cm)

Gift of the Samuel
H. Kress Foundation,
1960 (60.17.56)

This work depicts figures from the *Commedia dell'arte*, a popular theatrical genre origi-
nating in sixteenth-century Italy that had its roots in ancient Roman comedies. During the six-
teenth, seventeenth, and eighteenth centuries, *Commedia* troupes delighted audiences across
Europe, presenting improvisational performances intended to illustrate the entire range of
human weaknesses. These performances featured stock characters, including the vulgar, hook-
nosed glutton Pulcinella and the naive servant girl Colombina, depicted here relaxing at home
with their children (*pulcinellini*) and friends. A pendant painting in the Museum of Art in
Columbia, South Carolina, depicts Pulcinella singing to several *pulcinellini*. Although Mag-
nasco has broken with artistic tradition by showing these characters off-stage rather than in
performance, his presentation nevertheless is quite theatrical.

In spite of the "lowbrow" nature of its subject, the painting demonstrates Magnasco's
considerable artistic sophistication, and it is this contrast between subject and style that was
appreciated by the artist's aristocratic clientele. Magnasco achieves a subtle chromatic harmony
within a limited palette of browns, creams, and grays, enlivened by his vigorous brushwork
and the thick smears of paint (*impasto*) that he uses to indicate foodstuffs, the ruffs of collars,
and highlights on various surfaces. The restricted range of colors also underscores the impov-
erished circumstances of the characters, as does the ramshackle condition of their surroundings.

DS

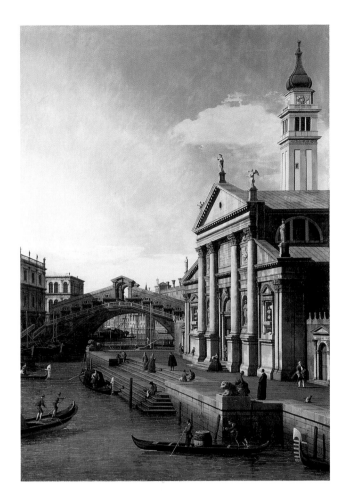

Giovanni Antonio Canal, called Canaletto
Italian, 1697 – 1768

Capriccio: The Rialto Bridge and the Church of San Giorgio Maggiore, about 1750

Oil on canvas
66 x 45 in.
(167.6 x 114.3 cm)

Purchased with funds from the State of North Carolina, 1952 (52.9.149)

Trained by his father, a painter of theatrical scenery, Canaletto specialized in views of his native Venice. By the 1730s, he was one of the most successful artists in Europe, his most avid patrons being the English aristocrats who came to Venice on their "Grand Tours" of Europe and commissioned painted views of the city as souvenirs of their visits. Canaletto's precise technique helped to invest these views with the illusion of topographical accuracy. A contemporary wrote: "He paints with such accuracy and cunning that the eye is deceived and truly believes that it is reality it sees, not a painting." However, the artist often subtly adjusted architectural details, viewpoints, and topography to create a more picturesque and harmonious work of art; on occasion, he took even greater artistic license. This painting combines in a single setting three famous landmarks from different areas of Venice: the church of San Giorgio Maggiore, designed by the famous architect Palladio and located on an island at the entrance to the Grand Canal; the Rialto Bridge; and at left, the Palace of the Ten Wise Men. The Italian word *capriccio*, meaning whim or fancy, is used to describe these fanciful compositions.

DS

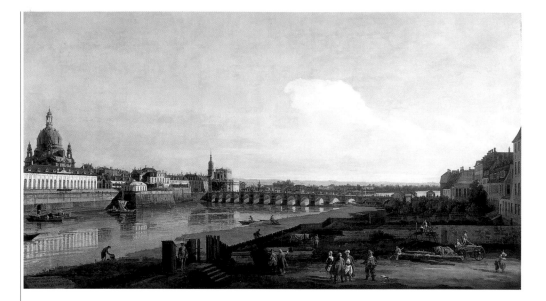

Bernardo Bellotto
Italian, 1720 -1780

**View of Dresden
with the
Frauenkirche
at Left**, 1747 [left]

Oil on canvas
51 1/2 x 91 1/2 in.
(131.0 x 232.4 cm)

**View of Dresden
with the Hofkirche
at Right**, 1748
[right]

Oil on canvas
53 1/2 x 92 in.
(135.9 x 233.7 cm)

Purchased with funds
from the State of North
Carolina, 1952, (52.9.145,146)

In 1747, Bernardo Bellotto was invited to the Dresden court of Augustus III, prince-elector of Saxony and king of Poland. At twenty-seven, Bellotto was a prodigious talent and a rising star in the field of painted city views. He was, however, still somewhat in the shadow of his mother's brother, Canaletto, and at the time still signed his canvases with both his given name and surname as well as the nickname "Canaleto," to highlight his relationship with his famous uncle.

During his reign (1694 – 1733), Augustus's father, Augustus II "the Strong," had transformed Dresden into one of the most culturally and intellectually sophisticated capitals in Europe. One of the most enlightened artistic patrons of his day, he established the porcelain factory at Meissen, created an important print collection, and opened the Royal Painting Gallery and the "Green Vault," the first treasure museum open to the public. His ambitious building program produced some elegant examples of Rococo architecture, including the Frauenkirche (Church of Our Lady) and the Zwinger palace and pavilion. Augustus III and his powerful prime minister, Count Brühl, continued this building program with such architectural master-pieces as the Hofkirche (Court Church) and Brühl's own palace on the Elbe.

Soon after his arrival in Dresden, Augustus commissioned Bellotto to produce, in the form of twenty-five views of Dresden and eleven of the surrounding Saxon countryside, a painted record of architectural accomplishments of the king and his father. To secure his position with Count Brühl, who also served as director of the royal art collections, Bellotto painted a series of twenty-one views for the prime minister, including the Museum's two paintings. They originally hung in Brühl's own art gallery, the long white building with nineteen windows on the left side of the view with the Frauenkirche.

The two complementary views were taken from opposite sides of the Elbe at either end of the city to emphasize Dresden's superb site and highlight its elegant architecture. Behind

148

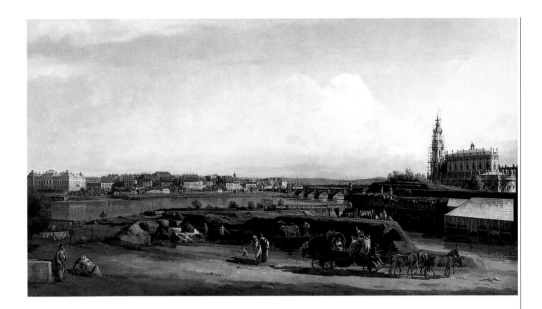

Brühl's art gallery looms the dome of Georg Bähr's Protestant Frauenkirche (1726–43); beyond the gallery is Brühl's palace, the twelfth-century Augustus Bridge (renovated under Augustus II), some of the Zwinger pavilions, and the Hofkirche, which is also the prominent structure at the right side of the other painting.

Bellotto's views are accurate in their architecture and topography, and reportedly have been used in the restoration and reconstruction of buildings (such as the Frauenkirche) damaged or destroyed in World War II. The only artistic license he seems to have taken here is with the belltower of the Hofkirche. In the 1747 view, it has not yet been constructed. In the other painting, the finished belltower can be seen through the scaffolding, despite the fact that it was not completed until 1755, seven years after Bellotto's picture was painted. Bellotto, who was friends with the Hofkirche's architect, Chiaveri, must have based his belltower on the architect's original drawings, and was thus giving Brühl and Augustus a preview of how Dresden's newest architectural jewel would dominate this particular view of the city.

Augustus was clearly delighted with Bellotto's efforts, for in 1748, he appointed the artist Court Painter at a very generous salary. Presumably Brühl was also pleased with his set of paintings, although these works brought the artist considerably less financial reward. Bellotto never received payment from Brühl for the paintings, and his suit against the minister's heirs was never allowed to go to court. Fifteen of the paintings from the Brühl series were sold to Catherine the Great in 1768, and are still in the Hermitage Museum in St. Petersburg. Five others were purchased by English collectors in the nineteenth century. Among these were the NCMA's two views, which were among the most important works purchased with funds from the original appropriation from the state legislature.

DS

Ubaldo Gandolfi
Italian, school of
Bologna, 1728 – 1781

**Mercury Lulling
Argus to Sleep,**
about 1770 – 75
[left]

Oil on canvas
86 x 53 5/8 in.
(218.4 x 136.7 cm)

**Mercury about
to Behead Argus,**
about 1770 – 75
[right]

Oil on canvas
86 1/8 x 53 7/8 in.
(218.7 x 136. 9 cm)

Purchased with funds
from the North Carolina
Art Society (Robert F. Phifer
Bequest), in memory of
Robert Lee Humber, 1983
(83.1, 83.2)

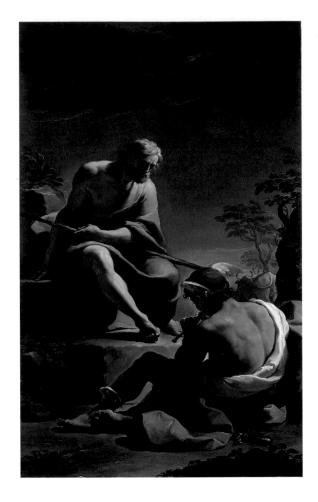

The Gandolfi family — Ubaldo, his brother Gaetano, and his nephew Mauro — were the last great painters of the Bolognese school, which rose to international prominence at the end of the sixteenth century through the works of the Carracci and their followers Guido Reni (page 138) and Domenichino (page 133). The confident understanding of human anatomy evidenced in these paintings reveals Ubaldo's debt to the Bolognese tradition, which was firmly based on drawing from live models.

Commissioned to adorn the walls of the palace of the Marescalchi family in Bologna, the two scenes originally formed part of a series of six works illustrating Classical myths. Io was a beautiful princess who was seduced by Jupiter, king of the gods. To conceal his infidelity from his wife, Juno, Jupiter changed Io into a white heifer. Suspicious, Juno cunningly asked for the heifer as a gift, a request that Jupiter could not very well refuse, and she placed the heifer under the guard of the hundred-eyed giant Argus (Gandolfi wisely decided to depict him with only two eyes). Sent by Jupiter to recover Io, Mercury lulled Argus to sleep with music and then cut off the giant's head.

The two paintings illustrate consecutive moments in the story. In the work on the left, Mercury — wearing a winged cap and winged ankle bracelets — lulls Argus to sleep by playing his flute. In the companion painting, Gandolfi represents the imminent dispatch of Argus with a touch of humor, as Mercury gestures for the viewer to be quiet so as not to wake the sleeping giant.

DS

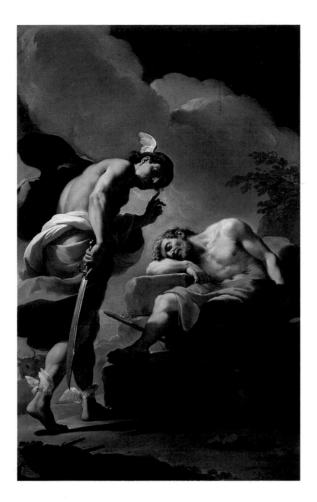

The Spanish Golden Age

AT THE BEGINNING OF THE SEVENTEENTH CENTURY Spain was the wealthiest and most powerful country in Europe, ruler of a far-flung colonial empire that included territories in the Low Countries, the Italian peninsula, and the Americas. Conservative and austere, Spain was geographically isolated from the rest of Europe, despite its vast territorial possessions and its role as a militant defender of the Catholic faith. During the seventeenth century Spain's political and economic power declined, but art and literature flourished. Roman Catholic monasteries and churches provided many commissions for artists, including Bartolomé Esteban Murillo and Esteban Márquez de Velasco.

In Spain, as in Flanders and Italy, art served Roman Catholicism during the Counter-Reformation period, when the Church sought to restore the authority and influence that had been weakened by the rise of Protestantism. Religious subjects dominated painting in seventeenth-century Spain, although portraiture, genre (scenes of everyday life), landscape, mythology, still life, and other secular subjects began to appear in painting, popularized by the work of Diego Velázquez and Francisco de Zurbarán.

By the eighteenth century, Spain's Golden Age had come to an end. The ensuing period saw increasing secularism in art, with a greater number of painters turning to genre and still-life subjects. Luis Egidio Meléndez, recognized today as the leading master of eighteenth-century Spanish still-life painting, emphasized the simple beauty of humble kitchen implements and victuals. In works such as *Still Life with Grapes and Figs* and *Still Life with Pigeons*, a variety of shapes, colors, and textures is revealed through the subtle play of light over forms arrayed on a shelf or dangling from hooks on rough walls.

Esteban Márquez
de Velasco
Spanish, died 1696

**The Marriage
of the Virgin**,
about 1693

Oil on canvas
96 x 60 in.
(243.8 x 152.4 cm)

Purchased with funds
from the State of North
Carolina, 1952 (52.9.180)

Surrounded by turbaned men and wide-eyed children, the Virgin Mary and Joseph pre-
pare to join hands in an age-old ceremonial gesture of marriage. The only mention in the Bible
of the marriage of the Virgin Mary concerns her betrothal to Joseph (Luke 1:27). The story is
told in considerable detail, however, in the thirteenth-century *Golden Legend* by Jacobus da
Voragine, a compilation of stories of saints that was an important sourcebook for artists.
According to these accounts, Mary was raised as a Temple maiden in Jerusalem. When she
reached marriageable age, the high priest of the Temple was aided by a miraculous sign in
selecting Joseph from among her many suitors. Each of them was instructed to bring the high
priest a rod. While those of the other suitors remained bare, Joseph's rod burst into bloom,
and a dove miraculously appeared from heaven, as shown in this work by Márquez de Velasco.
Demonstrating God's blessing upon these events, the heavens open to reveal a choir of putti
playing instruments and scattering pink roses upon the couple below. The rose is a traditional
symbol of Mary as a pure, flawless virgin, or a "rose without thorns." Indeed, a saintly radi-
ance surrounds her head and her youthful, innocent face is without blemish.

The Marriage of the Virgin is probably one in a series of eight paintings showing scenes
from the life of the Virgin Mary that Márquez de Velasco painted for the monastery of the
Unshod Trinitarians in Seville. The paintings were removed from Spain during the Napoleonic
Wars, and were sold and dispersed at auction in London in 1810.

RMN

British Portraiture

THE "GRAND MANNER" OF PORTRAIT PAINTING was introduced into Great Britain in the seventeenth century by Flemish Baroque master Anthony van Dyck. In his many portraits for the court and aristocracy, Van Dyck was able to capture each sitter's likeness, while making every person, however unattractive in reality, appear graceful, elegant, and beautiful or handsome. His large, full-length portraits, such as the Museum's *Lady Mary Villiers*, often incorporated Classical architectural elements, such as fluted columns, and allegorical references to Classical mythology to suggest that the sitter was wealthy and cultivated.

In the eighteenth century, British painters emulated the grand portrait style of Van Dyck. They were flooded with commissions from wealthy patrons wishing to add their likenesses to the family portrait galleries in their great houses. Not every painter was pleased by the popular demand for portrait likenesses. Joshua Reynolds, founding president of the Royal Academy of Arts, stressed the traditional preeminence of history painting, although he seldom had the opportunity to paint this type of work since his clients clamored for portraits. Although his career necessitated a studio in London, where he painted mostly portraits, Thomas Gainsborough was most enthusiastic about landscape painting and preferred the life of a country gentleman in the resort town of Bath. Landscape settings are prominent in his work, as can be seen in his portrait of Ralph Bell in the NCMA's collection.

Some British artists found a market for history and genre subjects, among them Scottish painter David Wilkie. His painting *Christopher Columbus in the Convent of La Rábida Explaining His Intended Voyage* portrays historical figures whose actual appearance was not known to the artist. By convincingly capturing the likenesses of the men and boy who modeled for these figures, however, he gave his canvas the look of a group portrait. Thus he used the illusion of portraiture to impart a compelling sense of reality and immediacy to this quiet moment in the lives of Columbus, his son Diego, and their companions.

The Oddie Children (detail)

Anthony van Dyck
Flemish, 1599 – 1641,
active in England
1632 – 1641

**Lady Mary Villiers,
later Duchess of
Richmond and
Lennox, with
Charles Hamilton,
Lord Arran,**
about 1636

Oil on canvas
83 3/8 x 52 9/16 in.
(211.8 x 133.5 cm)

Gift of Mrs. Theodore
Webb, 1952 (52.17.1)

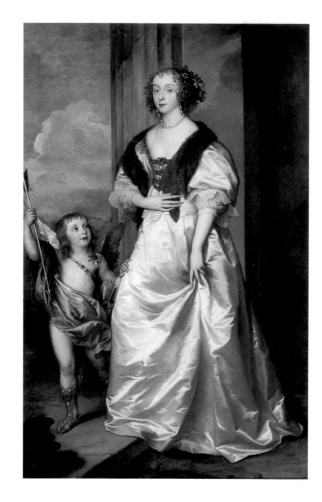

The most gifted and influential European portraitist of his age, Anthony van Dyck received major commissions while still in his teens. Before his twentieth birthday, he had become the chief assistant in Peter Paul Rubens's Antwerp studio. Eager to move beyond the shadow of Rubens, the young Van Dyck, after a brief stay in London in 1620, spent most of the following decade in Italy refining his elegant portrait style. He returned to Antwerp in 1628 and remained there for four years before being lured back to England to become a court painter to Charles I. Except for brief visits to the continent, Van Dyck was active in England until his untimely death. His legacy was a profound and lasting influence on English portraiture.

In England, Van Dyck expanded the definition of portraiture in a number of allegorical portraits; the likeness of Mary Villiers (1622 – 1685) is one of the few surviving examples. Describing this work in 1672, the noted Italian biographer Giovanni Bellori wrote, "This portrait because of its unique beauty put in doubt as to whether credit should be accorded to art or to nature. He portrayed her in the manner of Venus." Charles Hamilton (Lord Arran), accompanying his cousin in the role of Venus's winged son, Cupid, holds up one of the arrows with which the young god of love pierces unsuspecting hearts.

The only daughter of the duke of Buckingham, Lady Mary had been raised at the English court after the assassination of her father. The painting may have been commissioned to celebrate her marriage in 1635 at age thirteen to Charles Herbert.

DW

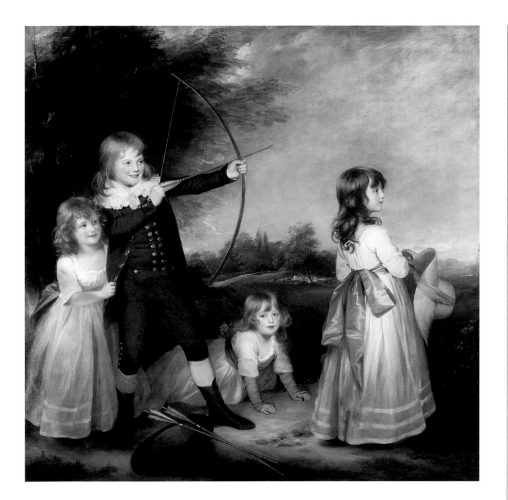

Sir William Beechey
British, 1753 – 1839

**The Oddie
Children**, 1789

Oil on canvas
72 x 71 7/8 in.
(183.0 x 182.6 cm)

Purchased with funds
from the State of North
Carolina, 1952 (52.9.65)

Before the eighteenth century, British artists often portrayed children in family portraits as if they were small adults. The subject of children at play reflects a new attitude of tolerance for childhood games in the second half of the century, although an opposing puritanical philosophy still viewed play as sinful. This charming picture of Sarah, Henry, Catherine, and Jane Oddie, the daughters and son of a London lawyer, must have achieved some popularity, since it was reproduced as an engraving. Young Catherine, careless of spoiling her white muslin dress, rests on all fours, gazing out as if to invite the viewer to join the children's activities. The artist simulates the textures of fabrics brilliantly, contrasting the simple white dresses of the girls with their colorful satin sashes and matching leather slippers. He also manipulates light and dark areas to great effect, silhouetting Jane's brunette hair against the sky and the heads of her fair-haired siblings against the dark foliage.

The Oddie Children was exhibited with six other Beechey portraits in the Royal Academy exhibition of 1791. Appointed portraitist to Queen Charlotte in 1793, Beechey also painted her husband, King George III, and the couple's sons, and gave painting lessons to their daughters. These services to the royal family earned a knighthood for the artist.

JPC

Sir David Wilkie
Scottish, 1785 – 1841

Christopher Columbus in the Convent of La Rábida Explaining His Intended Voyage, 1834

Oil on canvas
58 1/2 x 74 1/4 in.
(148.6 x 188.6 cm)

Gift of Hirschl & Adler Galleries, 1957 (57.17.1)

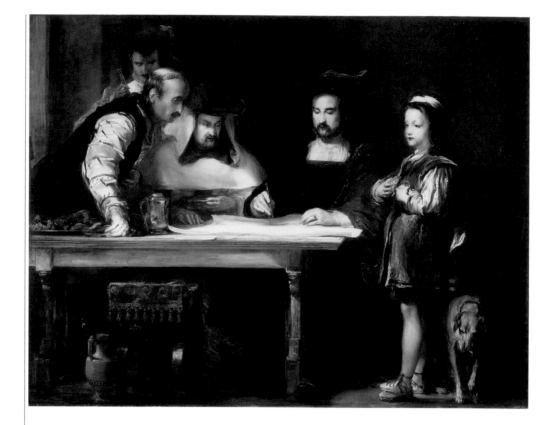

Wilkie's portrayal of the Italian explorer Columbus at the Convent of La Rábida in Spain was based on the *Life of Columbus* by the American writer Washington Irving, with whom Wilkie had become acquainted in Spain during the 1820s. When the painting was exhibited at the Royal Academy in London, Wilkie provided an identification for the figures and their activities, acknowledging Irving's text as his source.

Columbus is seated at the right, accompanied by his son Diego and their Italian greyhound. To the left of Columbus is the guardian of the Franciscan monastery of La Rábida, Friar Juan Perez de Marchena, who gazes at the chart with which Columbus explains his intended voyage. The friar assisted the explorer and was instrumental in gaining the support of the Spanish monarchs for Columbus's voyage. He took the young Diego into his monastery to be educated. Leaning across the table is the physician of Palos, Garcia Fernandez, who also became a supporter of Columbus's plan. The figure standing in the background holding a telescope is the sea captain Martin Alonzo Pinzon, who later helped Columbus outfit his expedition and sailed with him.

In the 1820s, Wilkie had traveled for three years on the continent, where he studied the paintings of the European Baroque masters and learned to emulate their lively compositions with dramatic lighting and bold, fluid brushwork. For his painting of Columbus, however, Wilkie chose a quiet moment, in which the emotions and excitement of the characters are internal and are only hinted at by their gestures and expressions.

RMN

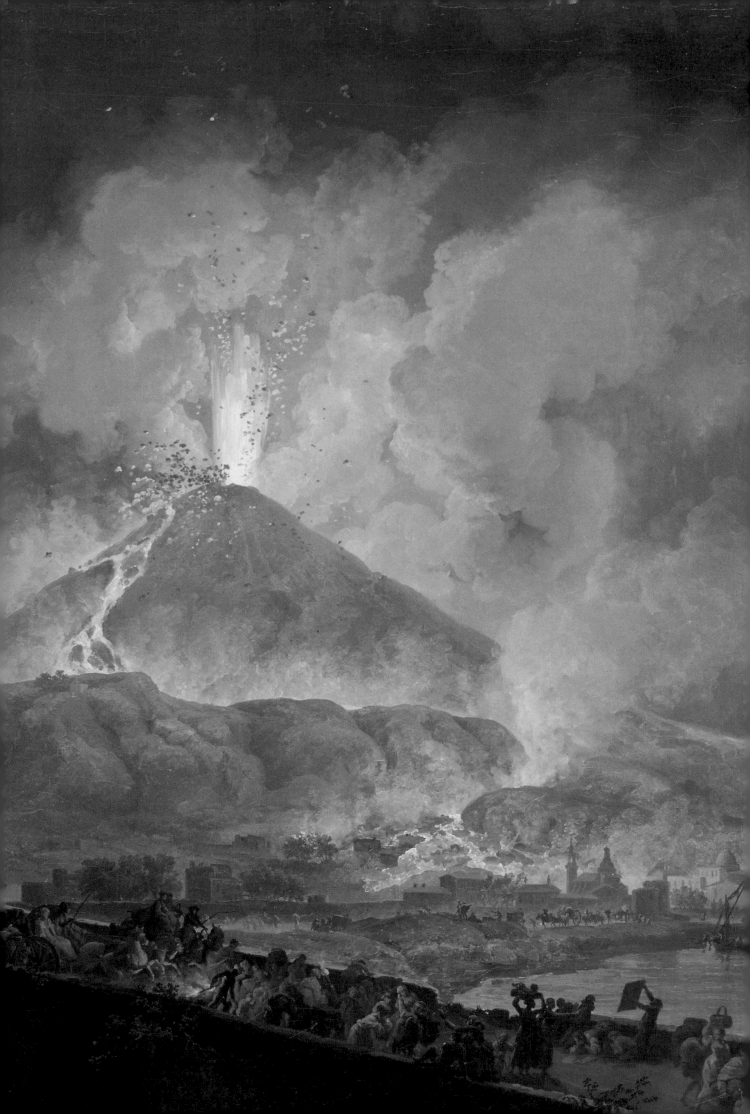

French Rococo Art

BETWEEN THE ACCESSION OF LOUIS XV TO THE THRONE in 1715 and the execution of his son and successor Louis XVI in 1793 at the height of the Reign of Terror in Paris, French manners and tastes were dominated by the royal court. Many foreign artists also adopted the Rococo style, characterized by playful sensuality, lightness of mood, delicate ornamentation, pastel colors, and gold and silver flourishes.

The term "Rococo" comes from the French words *rocaille* (rock) and *coquille* (shell) and refers to decorative motifs fashionable in eighteenth-century architecture, interior design, and gardens. Graceful S-curves and arabesques, often embellished with shells and other natural forms, abounded on various surfaces, from the ceilings and walls of fanciful garden grottos to the chandeliers whose lights sparkled from gilded ornaments and mirrored walls.

With the death in 1715 of the Baroque era's "Sun King," Louis XIV, the focus of court life shifted from the palace at Versailles back to Paris. In the city, the aristocracy resided in elegant but relatively small townhouses, where the heavy ornamentation of the preceding Baroque period was unsuitable. In art and interior design, as in social life, patrons appreciated cleverness and a sophisticated sense of humor, as evidenced by paintings such as Jean-Marc Nattier's *Portrait of a Lady as a Vestal Virgin*. Salons were furnished to be conducive to gallantry and witty conversation. Paintings were but components of a total interior decoration that included frames, lighting, furniture, carpets, tapestries, and porcelains. Small, collectible works of art, such as Joseph-Charles Marin's *Bacchante Carrying a Child on Her Shoulders*, fit well into such environments. Subjects from Classical mythology and history remained popular, with a preference shown for playful and romantic themes, as in François Boucher's painting of *Venus Rising from the Waves*.

Eighteenth-century French portraits were intimate and casual, with an air of fashionable nonchalance or, in the idiom of the day, "*negligence*," an apparent lack of concern for external appearances. Like Count Shuvalov in the portrait by Elisabeth Vigée Le Brun, the sitters were elegant but casual, as if relaxing among friends.

Neoclassical and French Nineteenth-Century Art

AT THE END OF THE EIGHTEENTH AND THE BEGINNING OF THE NINETEENTH CENTURY, the lighthearted, sensual Rococo style was replaced by the more austere Neoclassicism, whose proponents disdained the frivolity of Rococo art. They instead promoted noble and edifying subjects drawn from current events, and Classical mythology and history. Through painting and sculpture, French Neoclassicists, led by painter Jacques Louis David, endeavored to raise morals and inspire patriotism and self-sacrifice. In *The Death of Alcestis* by David's contemporary Pierre Peyron, the story, taken from a Classical Greek drama, celebrates marital devotion. The painting's style incorporates elements borrowed from Greek and Roman art.

For the Romantics of the early and mid-nineteenth century, Neoclassicism was too cerebral—devoid of imagination, emotional intensity, color, and movement. Romantic painters such as Eugene Delacroix explored themes from literature, history, and current events, with an emphasis on mankind's often violent relationship with nature. Meanwhile, other painters preferred a more down-to-earth approach to subjects based on their own experiences and those of ordinary working people, whose political rights they championed. The Realists portrayed the French landscape in its simple beauty, its rural inhabitants with dignity. Members of the Barbizon School of landscape painters, named for a town on the edge of the Forest of Fontainebleau, moved their easels outdoors and began to sketch and paint directly from nature.

This practice of painting out of doors was continued by the Impressionists, beginning in the 1860s. Like the Realists, the Impressionists found their subject matter in contemporary life. Urban dwellers at leisure in the city or on excursions to the countryside were viewed and painted with a cool detachment devoid of the Romantics' intense emotionalism and the Realists' social commentary. Interiors and landscapes were studied at various times of day and in many conditions of light and atmosphere. New chemical pigments provided a wide range of colors, often bright and intense. Black was virtually eliminated from the palette, and short, broken strokes of color were placed side by side to be "mixed" by the eye and mind of the viewer. Through these and other means, the Impressionists sought to capture their impressions of transient reality, of color in its infinite variations, of light and its transforming effects on color and form.

The Cliff, Etretat, Sunset (detail)

Pierre Peyron
French, 1744 – 1814

The Death of Alcestis, 1794

Oil on canvas
38 x 38 1/4 in.
(96.5 x 97.0 cm)

Purchased with funds
from gifts by Mr. and
Mrs. Jack L. Linsky, Mrs.
George Khuner, Cornelius
Vanderbilt Whitney, an
anonymous donor, Lady
Marcia Cunliffe-Owen,
William Walker Hines, and
Mrs. Alfred Elliot Dietrich,
by exchange, 1991 (91.1)

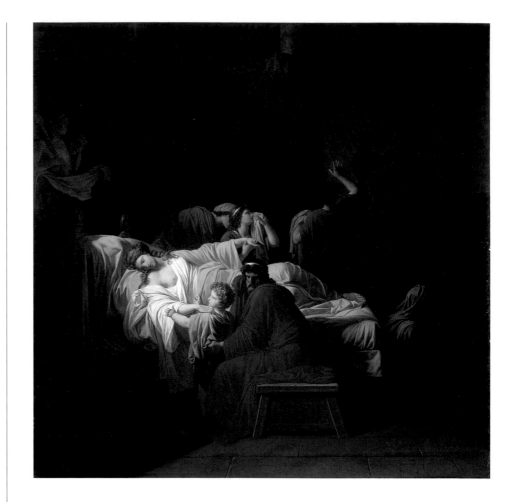

Ambitious young artists in eighteenth-century France aspired to the prestigious Grand Prix award, which enabled them to live and study in Rome as French painters had since the time of Claude Lorrain (page 140). Pierre Peyron won the Grand Prix in 1773, and his seven years in Rome absorbing the lessons of Italian and ancient examples were particularly useful in his development of the Neoclassical style, made famous by Jacques Louis David. Upon his return to Paris, Peyron enjoyed patronage that included a commission from King Louis XVI for a painting of the death of Alcestis. The original version was exhibited in 1785 and is now in the Louvre. Dated 1794, the Museum's smaller version reveals some compositional changes. The servant in the center has been repositioned and redrawn to present a profile suggested by antique sculpture. Details of ancient furniture are simplified, and more emphasis is placed on the classically inspired drapery folds.

The subject is the conjugal virtue of the heroine of the tragic drama *Alcestis* by the fifth-century B.C. Greek poet Euripides. When her husband angered the gods, Alcestis volunteered to give her life so that his might be spared. The grieving husband and especially the child heighten the sadness of the death scene. The earnestness of Peyron's subject, popularized in France a few years earlier by German composer Christoph Willibald Gluck's opera *Alceste*, reflects the official rejection of the frivolous Rococo period and its obsession with games of love. The attitude toward ancient models for feminine virtue makes an interesting contrast with the coquettish vestal virgin of Nattier (page 173).

JPC

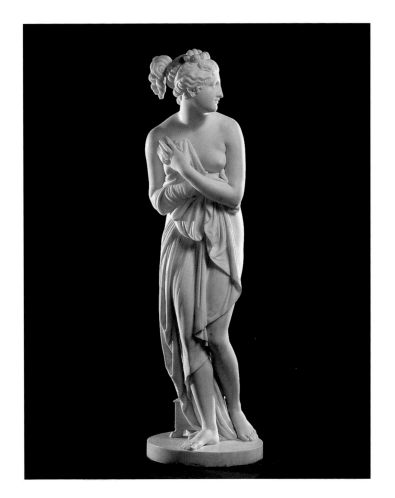

Studio of
Antonio Canova
Italian, 1757 – 1822

Venus Italica,
about 1815 – 22

Marble
h. 67 3/4 in.
(172.1 cm)

Purchased with funds
from the North Carolina
Art Society (Robert F. Phifer
Bequest), 1992 (92.2)

Canova carved the original *Venus Italica* to replace the ancient Roman *Medici Venus*, seized by Napoleon in 1802 from the Uffizi Gallery in Florence and taken to France. In the true Neoclassical spirit, Canova decided to reinterpret the ancient work rather than carve an exact replica. Drawing inspiration from other Classical statues of the goddess, he made several significant changes in the figure; as a result, his *Venus* appears more natural and her movement more gentle than the *Medici Venus*. The *Venus Italica* was immediately hailed as Canova's masterpiece and a worthy successor to the ancient Venus. "When I saw this divine work of Canova," wrote the poet Ugo Foscolo in 1811, "I sighed with a thousand desires, for really, if the *Medici Venus* is a most beautiful goddess, this is a most beautiful woman."

The beauty and fame of the first *Venus Italica* created a market for replicas, and at least four versions were executed in Canova's studio before his death. The finesse of the carving and the careful finish of the Museum's version indicate that it was probably carved by one of the master's more talented pupils under his supervision. In its conception and execution, the *Venus Italica* is a quintessentially Neoclassical work, combining the Classical ideals and the virtuosic technique that distinguished Canova as the greatest and most influential European sculptor of his day.

DS

Jean-François Millet
French, 1814 – 1875

Peasant Spreading Manure, 1854 – 55

Oil on canvas
32 x 44 in. (81.3 x 111.8 cm)

Purchased with funds from
the North Carolina Art
Society (Robert F. Phifer
Bequest), 1952 (52.9.128)

The son of farmers, Jean-François Millet was devoted to cataloguing aspects of peasant life and preferred the village existence near the Forest of Fontainebleau to the art establishment of Paris. Unlike the Impressionists, who began to paint about a decade after this work, Millet made several preparatory drawings for figures such as the farmer in his wooden shoes. Though he represented his subjects with dignity, his views present a life of struggle and toil. "It is never the cheerful side of things that appears to me," he wrote of his work. By the late 1870s, Millet and the like-minded painters known as the Barbizon group were gaining acceptance in exhibitions, with collectors, and in the eyes of the young Impressionists, who admired the naturalness of their landscapes.

Millet wanted to finish this canvas for the Paris World's Fair of 1855, but his projects for that year proved to be too ambitious. Millet's peasant subjects and his realistic style were ahead of popular taste and would have seemed out of step with the urban novelties of the fair. His friend and fellow painter Theodore Rousseau bought *Peasant Spreading Manure* even without its finishing details. The open landscape, new to Millet's paintings, no doubt appealed to the other artist, but Rousseau probably purchased it primarily to assist Millet with his debts.

JPC

Alfred Stevens
Belgian, 1823 – 1906

The Porcelain Collector, 1868

Oil on canvas
26 7/8 x 18 in.
(68.3 x 45.7 cm)

Gift of Dr. and Mrs. Henry
C. Landon III, 1981 (81.11.1)

Belgian Alfred Stevens was attracted to the art world of Paris and became one of its most successful painters, held in high regard by the important French and American artists of his day. Stevens was notable for his modernism. Like his friends the Impressionist painters Edgar Degas and Edouard Manet, he turned away from mythological and historical subjects. He preferred painting people of his own time, especially Parisian ladies wearing the latest fashions, some of which the artist borrowed from the daughter of Emperor Napoleon III. While Stevens's painting style appears less daring to modern viewers than that of the Impressionists, there are elements such as subtle color harmonies in his work that appealed to other artists, including the Americans James A. M. Whistler and William Meritt Chase, who collected several of Stevens's pictures. Also then in vogue among Parisian painters and collectors were Oriental art objects such as the Japanese screen and fan and the porcelain being studied by the woman in this painting. Stevens's greatest triumph came at the 1867 Paris World Fair, where he exhibited eighteen works and was rewarded with a first-class medal and promotion to Officer in the Legion of Honor.

JPC

American Art

DURING THE COLONIAL AND EARLY FEDERAL PERIODS most Americans concentrated their attention on practical concerns of surviving in a challenging new environment. They had few resources and limited leisure for the pursuit of art and other perceived luxuries. Puritan and other Protestant congregations provided no church commissions for artists, and there were few large public buildings that required decoration. A political philosophy that stressed the rights and potential of the individual did, however, prove sympathetic to portraiture. With no art academies and no established masters under whom they could study, early American portrait painters were largely self-taught. A fortunate few, including John Singleton Copley, whose work can be found in the following pages, were able to study—in some cases pursue careers—in Europe.

After the War of 1812 the new nation achieved greater self-confidence and a sense of pride in its vast territories and tremendous natural resources. By the early decades of the nineteenth century, Americans began to feel that they had succeeded in taming the wilderness and imposing civilization on their "New Eden." This sense of conquest over Nature brought with it not only the desire to celebrate the continent's bounty, but also a sense of nostalgia that its pristine beauty and abundance were already compromised. This was the great age of landscape painting in the United States, led by the artists of the Hudson River School, including Thomas Cole, a founder of the movement, and second-generation Hudson River School painters such as Jasper Cropsey, Albert Bierstadt, and Louis Rémy Mignot.

In the middle of the nineteenth century, scenes of everyday life (genre paintings) also became quite popular. Although they painted ordinary people going about their daily activities, genre painters tended to romanticize their subjects, celebrating the American dream of democracy and egalitarianism. The Civil War brought disillusionment and a more truthful portrayal of American life in the work of Realist painters such as Winslow Homer and Thomas Eakins, both of whom are included in the NCMA's collection and in these pages. Although known for their distinctively American vision, Homer and Eakins, like so many other American artists, traveled in Europe and studied the artistic traditions of that continent. The influence of Europe on American culture continued to the end of the nineteenth and into the twentieth century, as evidenced by Frederick Frieseke's very French *Garden Parasol*.

John Singleton Copley
American, 1738 – 1815,
active in Great Britain
from 1774

**Mrs. James Russell
(*Katherine Graves*),**
about 1770

Oil on canvas
50 1/4 x 40 in.
(127.5 x 101.7 cm)

Purchased with funds
from the North Carolina
Art Society (Robert F.
Phifer Bequest) and the
State of North Carolina,
by exchange, 1992 (92.9)

Although largely self-taught and without benefit of European study, John Singleton Copley invented a powerfully convincing style of portraiture that summarized the expansive ambitions and self-confidence of colonial American society on the brink of independence. His mature style is marked by a somber richness of color, dramatic lighting, exacting observation, and a virtuoso ability to realize in paint both the physical and psychological being of the sitter.

Katherine Graves Russell (1717–1778) of Charlestown, Massachusetts, was the daughter and wife of magistrates and the mother of eleven children. Judging from her portrait, she was a formidable personality in her own right. Elegantly if soberly dressed—as befits a Puritan woman of means—and seated in an amply upholstered Chippendale armchair, she eyes us with calm assurance and perhaps a touch of *hauteur*. The artist encourages a ready rapport with her by the studied informality of the pose: apparently we have interrupted her reading. While Copley leaves no doubt that Mrs. Russell is a woman of rank and importance, his portrait of her is neither sentimental nor dishonest. He respects the testimony of his eyes, depicting the woman forthrightly as the aging matron that she was. Similar attention is given to the precise rendering of fabrics and other materials. The painter delights in the luxuriant sheen of satin and the crisp white of the apron and lace-trimmed kerchief. Against a dark background, Copley casts an opulent light, imparting a vivid, almost sculptural presence to the ensemble.

JWC

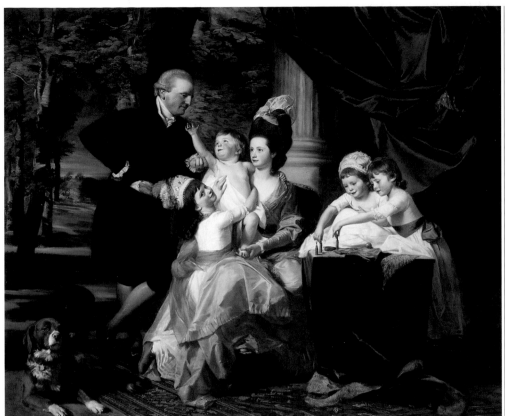

John Singleton Copley
American, 1738 – 1815,
active in Great Britain
from 1774

Sir William Pepperrell and His Family, 1778

Oil on canvas
90 x 108 in.
(228.6 x 274.3 cm)

Purchased with funds
from the State of North
Carolina, 1952 (52.9.8)

John Singleton Copley was never content with being the preeminent portrait painter in a provincial outpost of the British Empire. While building his career and fortune in Boston, he dreamed of making the voyage to Europe to study the works of the old masters and prove himself against the best of London's painters. Finally, in 1774, after years of vacillation, Copley left for Europe. His exit was surely hastened by the increasing political turmoil in the colonies. Though he assiduously avoided politics and courted the patronage of both high Tories and such rebels as Samuel Adams and John Hancock, revolutionary Boston was no place for a society painter. Leaving America, never to return, Copley looked forward to a more hopeful future abroad.

After a study tour of Italy, Copley and his family settled in London, where he set about the daunting task of establishing himself as a painter of the front rank. As might be expected, a number of his earliest patrons were fellow Americans, including Sir William Pepperrell (1746 – 1816), who had arrived in London a year after Copley. Sir William was the grandson and heir of William Pepperrell (1696 – 1759), a prosperous merchant, politician, and soldier — and the first native-born American to be awarded the title of baronet. The younger Pepperrell further enhanced the family's stature by marrying the daughter of Isaac Royall, one of the wealthiest men in British America. However, during the turbulent years leading up to the American Revolution, Pepperrell remained steadfastly loyal to the British Crown. Fearing mob violence and the wholesale confiscation of his property, he sailed from Boston with his family toward an uncertain exile. Soon after arriving in 1775, Pepperrell commissioned Copley to paint a family portrait. When finished, the painting was more than the standard, flattering

celebration of a proud, illustrious family. It also symbolized with poignant irony the tragedy of the Pepperrells.

No doubt in accord with the wishes of his client, Copley staged an extravagant, yet intimate portrayal of Sir William, his wife, Elizabeth, and their three daughters and newborn son. He invented a setting that is neither a proper interior nor a landscape, but a studio fantasy. The colossal fluted column, Baroque drapery, plush "Turkey" carpet, and the inviting glimpse of a twilight park were stock devices in royal and aristocratic portraiture, signifying wealth, gentility, and dominion. Within this setting the Pepperrells are presented in a moment of studied informality. Striking a pose of courtly nonchalance, Sir William presides over the happy domestic scene. His solemn and beautiful wife holds up to him their gleeful son. The oldest daughter embraces her brother while turning a coquettish eye to the viewer. At right, the two younger Pepperrell daughters play at skittles. The boy, heir to his father's title and fortune, is the center of the painting and of his parents' hopes.

Unfortunately, the portrait is an elaborate fiction, perpetrated by client and artist to mask an unacceptable reality. The Pepperrells were not English gentry, but exiles, bereft of country and much of their fortune. Moreover, Elizabeth Royall Pepperrell had died in Boston two years before the portrait was painted. (For her likeness, Copley probably relied upon a portrait miniature.) For the widower and his children, Copley offered a comforting vision of what might have been, had not war and death come knocking.

The painting was equally important for Copley in promoting his nascent career in England. Exhibited in the annual exhibition of the Royal Academy in 1778, it served to advertise the artist's abilities. He demonstrated his mastery at organizing a complex arrangement of figures, fitting the family within a strict pyramidal composition and linking each figure with graceful and telling gestures. The American flaunted his virtuosic skills at rendering the sheen and textures of costly fabrics. He also theatrically orchestrated the colors and the play of light and shadow, spotlighting the family against a background of deep, luxuriant greens. The painting is a sumptuous tapestry, every part enlivened: the spaniels are treated with nearly as much attention as their masters. Shortly after arriving in London Copley had written that "you must be conspecuous in the Croud if you would be happy and great." With the exhibition of *Sir William Pepperrell and His Family*, Copley signaled to the British public that he had arrived.

JWC

Thomas Cole
American, born Great
Britain, 1801 – 1848

**_Romantic
Landscape_**,
about 1826

Oil on panel
16 1/16 x 21 15/16 in.
(40.7 x 55.8 cm)

Purchased with funds
from the State of North
Carolina, 1952 (52.9.7)

More than any other artist, Thomas Cole created the myth of the wilderness in which divinity and America's destiny dwelled. For him and other Romantic painters, landscape was not just scenery, but the play itself, an eloquent means of addressing profound questions of human and divine purpose. The founder and presiding presence of the Hudson River School of landscape painters, Cole celebrated the vast, unconquered wilderness as a metaphor for the American republic. Through his pictures of "uncivilized" nature, the viewer was led to contemplate the purity and promise of the "New World."

This small painting dates from the early years of Cole's career when the young and largely self-taught painter was first exploring the dramatic possibilities of landscape art. The composition is based on studies made in the Catskill Mountains in upstate New York. It presents a vision of primeval nature: gnarled trees, crags, mountain peaks mirrored in a silent lake, and a turbulent sky suffused with sunlight. The wildness—and Americanness—of the scene is further heightened by the presence of Native Americans in the middle distance. (Here it is worth noting that this picture was painted in the same year as the publication of James Fenimore Cooper's _Last of the Mohicans_). That Cole intended such paintings as visible sermons is amply born out in his poem "Lines from Lake George," in which he implored:

> _O may the voice of music that so chime_
> _With the wild mountain breeze and rippling lake_
> _Ne'er wake the soul but to a keener sense_
> _Of nature's beauties . . ._

JWC

Christian Mayr
American,
born Germany,
about 1805 – 1851

**Kitchen Ball at
White Sulphur
Springs, Virginia,**
1838

Oil on canvas
24 x 29 1/2 in.
(61.0 x 75.0 cm)

Purchased with funds
from the State of North
Carolina, 1952 (52.9.23)

The portrayal of African Americans by white artists before the Civil War almost invariably reflected the harsh prejudices of society. American painters generally accepted the crude racial stereotypes, casting black people in marginal and often comic roles that emphasized their political and social inferiority. *Kitchen Ball at White Sulphur Springs, Virginia* is a rare exception, all the more remarkable for its vivid depiction of the private lives of blacks in the antebellum South. It is probable that the artist, as a recent immigrant from Germany, felt less constricted by American racial attitudes, and thus freer to see and paint African Americans as people, not chattel.

White Sulphur Springs, Virginia (now West Virginia), was a favorite summer resort among Southern plantation families. Though Mayr arrived at the spa in search of portrait commissions, he seems to have lost interest in the high society of the planters, preferring instead the "low" if equally polite society of their servants. In this painting, Mayr recreates a joyful gathering among the household slaves, whose dress and manner mirror those of their masters. Almost certainly, they are celebrating the wedding of the white-clad couple at center. Far from being caricatures, the men and women are convincing individuals. According to Frederick Marryat, an English guest at the resort, Mayr "introduced [in the picture] all the well-known coloured people in the place." However, he deliberately omitted one musician, joking that the poor man's inability to play in tune "would spoil the harmony of my whole picture!"

JWC

William Tylee Ranney
American, 1813 – 1857

First News of the Battle of Lexington, 1847

Oil on canvas
44 1/16 x 63 5/16 in.
(111.9 x 160.8 cm)

Purchased with funds
from the State of North
Carolina, 1952 (52.9.25)

As the defining moment in the history of the United States, the American Revolution quickly acquired the grandeur and aura of a sacred myth, a myth constantly retold and reimagined by artists of the young republic. Most, following the European tradition, depicted the violent birth of the nation as grand opera, its heroes larger than life, their struggles titanic, and their virtues triumphant. (Emmanuel Leutze's *Washington Crossing the Delaware*, now in New York's Metropolitan Museum of Art, is only the most celebrated example.) In marked contrast, William Ranney conceived the Revolution on a less elevated, though no less moral, plain.

First News of the Battle of Lexington is one of a series of paintings depicting scenes of ordinary people responding to extraordinary events. The skirmish between redcoats and minutemen at Lexington on April 19, 1775, signaled the beginning of the War of Independence. However, rather than represent the actual encounter, Ranney turns our attention to the aftermath. An unnamed commentator, possibly the artist himself, describes how "the tidings spread—men galloped from town to town beating the drum and calling to arms. The people snatched their rifles and fowling pieces, and hurried towards Boston. The voice of war rang through the land, and preparations were every where commenced for united action."

Ranney's anonymous farmers and tradesmen, rallying to the call of their country, exemplified the collective heroism of Americans. It was no coincidence that the artist's evocation of selfless courage and patriotism appeared just as the United States was preparing for war against Mexico. In *First News of the Battle of Lexington*, Ranney created an image of a valiant past to stir a new generation of Americans to glory.

JWC

Severin Roesen
American, born
Germany, 1814/15 – 1872

Still Life with Fruit,
about 1855 – 60

Oil on canvas
30 1/4 x 25 in.
(76.8 x 63.5 cm)

Gift of the North Carolina
Art Society (Robert F. Phifer
Bequest) in honor of Mr.
and Mrs. Charles Lee
Smith, Jr., 1977 (77.8.1)

Little is known about the painter Severin Roesen. He was born in Germany, possibly in Cologne, and emigrated to this country in 1848, living first in New York and later in Williamsburg, Pennsylvania. His career was confined to the painting of fruit and floral still lifes. Although Roesen achieved only modest success in his lifetime, his work has come to represent Victorian American painting at its most exuberant.

In both subject and style, Roesen's paintings descend from the great still-life tradition of seventeenth-century Holland. In *Still Life with Fruit*, he serves up a luxuriance of ripe, succulent delights—grapes, cherries, blackberries, strawberries, plums, peaches, pears, a sectioned lemon—heaped high, overwhelming the reed basket and cascading off the marble ledge. Of course, the picture is completely contrived. The composition follows Roesen's tried-and-true formula: there exist many related versions, both vertical and horizontal. It is unlikely that the artist painted the picture from life. He probably relied on memory, selecting and combining elements into a dynamic and intricately staged ensemble. Even so, the artist attends scrupulously to the facts, bestowing upon each grape and berry a vivid particularity.

Such princely bounty was rarely seen in America, even in the most affluent households. Though all of the pictured fruits might be had for a price, their perfection and sheer abundance are uncanny, as though they had been plucked from some earthly paradise. Roesen's still lifes may have struck a nationalist chord with his patrons, affirming the special generosity of Nature—and Nature's god—toward the American people.

JWC

Jasper Cropsey
American, 1823 – 1900

Eagle Cliff,
Franconia Notch,
New Hampshire,
1858

Oil on canvas
23 15/16 x 39 in.
(60.8 x 99.0 cm)

Purchased with funds
from the State of North
Carolina, 1952 (52.9.9)

The pioneer family blazing a new life in the wilderness is one of the great identifying themes of the American experience. In the mid-nineteenth century, no one better exemplified the spirit of the young republic than the self-reliant, hard-working homesteader. Jasper Cropsey's depiction of backwoods America celebrates the romantic myth of frontier life with little regard to the often harsh reality. Though derived from sketches made in the White Mountains of northern New Hampshire, the picture was painted while Cropsey was living in London.

It is morning in early autumn. The chill sun brightens a clearing in the remote valley where a charming, if ramshackle, log cabin sits. It is evidently a new settlement: the land is still coarse and scraggly. In the cabin doorway, a woman watches her young daughter play with chicks while another daughter totes water from the nearby river. Hand in hand, two small children walk toward their father, who talks casually with an Indian. The precariousness of the family's existence is implied by the dark, encircling forest and by the gaunt pair of dead trees, whose shadows fall across the cabin. Yet, the scene does not beg our pity, but only our admiration for the courage and resourcefulness of these pioneers. By their industry, the forest will surrender to fields and pasture: livestock graze, grain awaits cutting and stacking, while cabbage, corn, and pumpkins ripen in the garden. In the foreground, a newly laid "corduroy" (or log) road promises an end to the valley's isolation.

JWC

Thomas Eakins
American, 1844 – 1916

**Portrait of Dr.
Albert C. Getchell,**
1907

Oil on canvas
24 x 20 1/16 in.
(61.0 x 51.0 cm)

Purchased with funds
from the State of North
Carolina, 1967 (67.6.1)

Although he studied in Paris, Thomas Eakins was influenced more by the somber color, precise observation, and unsentimental humanism of seventeenth-century Dutch and Spanish painting. No other American portrait painter has equaled his ability to reveal the essential, unvarnished character of his subject. The poet Walt Whitman considered his friend Eakins the only artist "who could resist the temptation to see what [he] think[s] ought to be rather than what is."

Eakins's commitment to honesty earned him a reputation for harsh realism that sorely cost him friends and commissions. As a result, many of his later portraits were initiated by the artist, who doggedly sought to document in paint the range of humanity within his acquaintance. An example is this portrait of Albert C. Getchell (1857–1950), a prominent Worcester, Massachusetts, physician who reportedly met Eakins at a medical conference. Rather than flatter his subject as was customary, Eakins executes a frank, unpretentious likeness expressive of the doctor's quiet strength, but also of his fatigue and isolation. Strong light and shadow sculpt the face. Superficial details of clothing or setting are only cursorily noted. What concerns the artist is the physical structure of the head, how skin stretches and sags over muscle and bone, and how it all comes together to signify a man.

JWC/VB

Frederick Carl Frieseke
American, 1874 – 1939,
active in France
from 1898

The Garden Parasol, 1910

Oil on canvas
57 1/8 x 77 in.
(145.1 x 195.5 cm)

Purchased with funds
from the State of North
Carolina, 1973 (73.1.4)

The lure of France and of French Impressionism proved irresistible to a generation of American painters. Frederick Frieseke arrived in Paris as a student in 1898 and, save for occasional visits home, remained an expatriate. He once insisted that in France "I am more free and there are not the Puritanical restrictions which prevail in America." Unrestricted, Frieseke devoted himself almost exclusively to the painting of women: dressed or nude, lounging in the boudoir or taking tea in the garden. His is a gentleman's fantasy, his women inhabiting a charmed world — sheltered, sensual, and eternally sunlit. To render that world, the artist embraced a highly decorative Impressionist style, remarkable for its intense, rapturous color and vivacity of brushwork.

Large and dazzling, *The Garden Parasol* grandly evokes the serene pleasure of a summer idyll. It ranks among Frieseke's finest achievements: a sumptuous confection of light and color. The setting is the garden of the artist's house at Giverny, where Frieseke spent many summers as the next-door neighbor to Claude Monet. The seated woman is Sarah Frieseke, who frequently modeled for her husband. She is depicted as a cultivated woman of leisure whose reading is interrupted by the arrival of a visitor — or visitors, for it is our approach that distracts Mrs. Frieseke from her book and prompts her to fix us with a questioning stare. However, any drama that would arise from so genteel an encounter is fully upstaged by the garden setting, and especially by the Japanese parasol. It spices the scene with the fiery, swirling colors of the Orient.

JWC

Art of the Twentieth Century

AT THE BEGINNING OF THE TWENTIETH CENTURY European artists conducted daring experiments that set the stage for the avant-garde movements of subsequent decades. A young Spanish artist, Pablo Picasso, working with French painter Georges Braque, invented Cubism with its fracturing of forms and space into angular shapes. French artists led by Henri Matisse employed brilliant, saturated colors and bold brushwork that delighted—and provoked. In the Netherlands, Piet Mondrian introduced a geometric abstraction of straight horizontal and vertical lines, rectangles, and primary colors, while Russian painter Vasily Kandinsky created the first abstract paintings based on forms in nature. The German Expressionists employed brilliant color with a vigorous, even raw, style that often used distortion and exaggeration of forms to express intense feelings and emotions.

In the years between world wars, Europe continued to be the center of advanced art. The Bauhaus, an innovative school of art, architecture, and design in Germany, established many of the principles and standards that guide architects and designers to this day. Young iconoclasts founded the Dada movement, the influence of which still echoes among artists who incorporate found objects into their work, use texts as images, and emphasize concept over finished product. Artists drawn to fantasy, dreams, and the unconscious formed the Surrealist movement, which resonated with artists in the United States and Mexico.

Not until the years after World War II did the United States become the acknowledged center of avant-garde art. Drawing on Surrealism's experiments with the unconscious mind, the Abstract Expressionists in New York and California became the new leaders of the art world in this country and Europe. However, not all artists shared their enthusiasm for abstraction and flamboyant self-expression. Some painters, including Thomas Hart Benton and Andrew Wyeth, employed a representational style to capture aspects of life in America. Others, such as Georgia O'Keeffe and Alex Katz, adhered to recognizable imagery, but simplification and flattening of forms gave their work a decidedly modern feel.

The 1960s and 1970s saw new energy and creativity surging in many directions, from Pop Art, with its celebration of popular culture and consumer society (exemplified in the works of Andy Warhol and Ed Ruscha), to Minimalism, which reduced painting and sculpture to the most essential geometric forms, supposedly devoid of emotion and self-expression, as in Ronald Bladen's *Three Elements* in the NCMA's collection.

In the 1980s European artists again became the international art world superstars. Some of the leading figures in this European renaissance—Gerhard Richter, Georg Baselitz, and Anselm Kiefer, all Germans—are represented in the Museum's collection. Other internationally renowned painters in the collection include Guillermo Kuitca of Argentina and Moshe Kupferman of Israel.

The Calligrapher Replies I (detail)

Ernst Ludwig Kirchner
German, 1880 – 1938,
active in Switzerland
after 1917

Panama Girls,
1910 – 11

Oil on canvas
19 7/8 x 19 7/8 in.
(50.5 x 50.5 cm)

Bequest of W. R.
Valentiner, 1965 (65.10.30)

In 1905 Ernst Ludwig Kirchner, Erich Heckel, and Karl Schmidt-Rottluff issued a manifesto. The young German artists called for "a bridge" to move art from stale academic conventions to a visceral expressionism. Their loose alliance, Die Brücke (The Bridge), shared convictions with other groups (like the Fauves and the Cubists) who sought a radical departure from the picture that reproduced or copied nature. The Brücke artists, led by Kirchner, developed a terse vocabulary of agitated line and discordant color to convey their subjective response to the startling, exotic, *modern* urban spectacle.

Panama Girls, one of several dance-hall paintings by Kirchner, is typical of Brücke subject matter and characteristic of its expressive style. Kirchner's rejection of naturalism was encouraged by his exposure to Henri Matisse and ethnographic sculpture. After seeing work by Matisse in Berlin in 1909, he adapted the Fauve palette, using broad patches of vibrant colors for *Panama Girls*. South Pacific carvings Kirchner found in a Dresden museum influenced the composition. The Panama girls, boldly articulated and lined up in a shallow space, suggest a condensed frieze, a compositional device based on decorated house beams from the Palau Islands. Kirchner uses the left-right, left-right rhythm of the turned faces to add the sensation of movement, with the dancers' long, thin legs punctuating the beat. In escaping imitation, Kirchner helped revolutionize modern art.

HP

Ernst Ludwig Kirchner
German, 1880 – 1938,
active in Switzerland
after 1917

Two Nude Figures in a Landscape, 1913

Oil with small additions
of wax on canvas
47 1/2 x 35 1/2 in.
(120.6 x 90.2 cm)

Bequest of W. R.
Valentiner, 1965 (65.10.48)

Often stereotyped as tortured souls who transferred their angst directly to canvas, the German Expressionists treated various subjects in various moods. They realistically appraised themes of city life, and as Ernst Ludwig Kirchner's *Two Nude Figures in a Landscape* demonstrates, they celebrated nature in pastorals idealizing the primitive.

Two Nude Figures was likely done at Fehmarn, the picturesque Baltic Sea island where several Brücke members spent time painting. Using the same palette applied in the same feathery brushstroke for the figures and their surroundings, Kirchner has integrated the two nudes into the landscape rather than making them the dominant element of the composition. He aimed to express a perfect union between man and nature but not necessarily in a naturalistic vocabulary. The figures have elongated proportions, and the simplified palette relies on salmons, red-browns, blues, and greens. The pebbly texture of the ground breaks up the liquid tones, giving the colors an airy freshness that suits the seashore setting.

The painting, done about the time the short-lived Brücke disbanded, was until recently assigned to another group member, Otto Mueller—an indication of the ongoing reciprocal influence among the German Expressionists. Sharing outlook and interests, all these artists saw nature as a panacea. The painted arcadia of *Two Nude Figures*, flooded with sun-soaked color, offers refuge from a society in upheaval.

HP

Maurice Sterne
American, born Latvia,
1878 – 1957

Dance of the Elements, Bali, 1913

Oil on canvas
56 3/4 x 65 1/2 in.
(144.1 x 166.4 cm)

Purchased with funds
from the State of North
Carolina, 1952 (52.9.28)

What Tahiti was for the French artist Paul Gauguin, the Indonesian island of Bali was for Maurice Sterne: a tropical Eden, undefiled by Western civilization, where people lived in accord with nature and the rhythms of an ancient culture. A self-described nomad, Sterne arrived on the remote island in 1912 and remained nearly two years. For the artist, life on the island was a rapturous dream, "an undulating spectrum of colors . . . which moved to the constant, exotic pulsing of the Balinese music."

Dance of the Elements is one of Sterne's largest paintings from his stay on Bali. It is certainly his most ambitious. Painted in the colors of night, it depicts a ritual ceremony within a crowded temple court. In the center sit an elderly priestess and her attendants, circled by dancers bearing bowls, fans, and braziers of smoking incense. (A keen observer but with little understanding of the Hindu rites, Sterne erroneously interpreted these offerings as symbolic of the elements: water, air, and fire.) Some of the dancers appear lost in an ecstatic trance common to Balinese religious rites. The composition—a pyramidal architecture of twisting, contorted figures compressed within a shallow space—was inspired by French modernism, specifically Paul Cézanne's *Great Bathers* (in the Philadelphia Museum of Art). When Sterne's Balinese paintings were first exhibited in New York in 1915, their exotic subject matter and avant-garde treatment provoked a genuine sensation and inspired the American fantasy of "Bali Hai."

JWC

Marsden Hartley
American, 1877 – 1943

Indian Fantasy, 1914

Oil on canvas
46 11/16 x 39 5/16 in.
(118.6 x 99.7 cm)

Purchased with funds
from the State of North
Carolina, 1975 (75.1.4)

Living as an expatriate in Berlin prompted Marsden Hartley to reflect upon his native country and his own identity as an American. In the summer of 1914 he began a series of paintings exploring what he later called "the idea of America." The series—abandoned after only four pictures—was no jingoist anthem, no pictorial "America the Beautiful." The artist had long been troubled by what he judged as the soulless greed and violence of modern industrial society. (To Gertrude Stein, he damned New York City as an "inferno . . . run to the machinery of business"). For Hartley, the cure for civilization was to be found in the rapturous embrace of the "primitive." Like many artists and writers before and after him, he idealized pre-Columbian America, which he imagined as a promised land, inhabited by a virtuous, pacific, and deeply spiritual race. To a friend he confessed that "I find myself wanting to be an Indian—to paint my face with the symbols of that race I adore[,] go to the West and face the sun forever—that would seem the true expression of human dignity."

Indian Fantasy is just that, a romantic fantasy upon a Native American theme. In style and execution the painting owes much to the European avant-garde, which also celebrated the "primitive" arts of Africa, Oceania, and the ancient Americas. However, the subject—an ascending arrangement of Pueblo and Plains Indian motifs and symbols, presided over by a totemic eagle with wings outstretched against a rising (or setting) sun—is purely, uniquely American. The insistent symmetry and the bold patterning only heighten the mystical character of the image. Here, Hartley conjures a redemptive vision of earthly and spiritual harmony, all the more poignant for being painted just before the outbreak of World War I.

JWC

Lyonel Feininger
American, 1871 – 1956,
active in Germany
1887 – 1937

The Green Bridge II,
1916

Oil on canvas
49 3/8 x 39 1/2 in.
(125.4 x 100.3 cm)

Gift of Mrs. Ferdinand
Möller, 1957 (57.38.1)

An American resident in Germany since 1887, Lyonel Feininger met Karl Schmidt-Rottluff and fellow Brücke founder Erich Heckel just after this radical group had relocated to Berlin in 1912. More important to Feininger's development as a painter was his discovery of Cubism at about this same time. In 1907, he had abruptly left a successful career as an internationally known political cartoonist and comic-strip artist to devote himself to painting, dividing his time for the next several years between Paris and Berlin. It was not, however, until he absorbed the lessons of Cubism, which he saw in a Paris exhibition in 1911, that he found himself as an artist. In the five years between seeing the Cubism exhibition and painting *The Green Bridge II*, Feininger experimented. The work falls into two distinct groups, one in which he employs the sinuous, energetic line of his cartooning style and a second in which he begins shaping the austere vocabulary of crystalline, light-soaked abstraction on which his renown rests. *The Green Bridge II* reveals the artist confidently merging the strengths of these approaches.

Feininger painted the first *Green Bridge* in 1909 and repeated the composition in a 1910 etching before painting the 1916 version. In this slight variation of the original, the bridge, an incongruous and coolly alluring mint green, functions as a somewhat askew proscenium arch. It encloses a "stage set" of mildly caricatured figures, some in work clothes and others dressed for an evening out, who fill a small-town street. The woman snugged into the lower right corner serves as a mediator between viewers and the townspeople. This unassuming painting, with its dancing marionette-like figures and enticing atmosphere, modestly celebrates modest

pleasures—an end-of-the-day moment of relaxation and recreation. Set against the war-torn days of 1916, the scene takes on added poignancy.

If the painting represents a wish to salvage life's simple satisfactions, it also blends in nostalgic memories of the artist's years in France in the preceding decade, a time which nurtured Feininger's lifelong affection for that country. Exploring Paris and its environs, Feininger saw bridges and viaducts passing over urban streets, like the Meudon and Arceuil aqueducts that he often sketched—and much like the setting with its unidentified bridge in the Museum's painting. Bridges intrigued Feininger; their engineering appealed to him—and inspired him.

In the Museum's painting, Feininger uses the imposing green curve to tie the composition together. The people, as well as the buildings and street, are created of rounded facets of transparent colors, echoes of the overarching viaduct. This fragmentation, in sometimes unlikely colors, and the repeated curve, which pinwheels throughout the composition, set the painting in motion. In the next decade Feininger's paring-down process would replace people, movement, and semicircles with a vast, otherworldly realm of calm stability, mostly horizontals and verticals in harmonious equilibrium. Anticipated here are the deep space that would always be important to Feininger and the glowing luminosity of his future palette.

Feininger defies categorization. He thought of himself as an American, yet he is closely identified with early twentieth-century German painting. Indeed, he lived in Germany for fifty years, taught at the Bauhaus, and exhibited with various avant-garde German groups. (Feininger was also included in the Nazis' *Entartete Kunst* exhibition, the demagogic 1937 show exposing "degenerate art"—a development which precipitated his return to the United States.) But his subject matter, handling of color and structure, and refinement of feeling set him apart. In contrast to the German Expressionists, Feininger maintains a mild temperature in his open-ended, atmospheric universe, so lyrically lit that it seems to hold magical healing powers.

Feininger individualized everything he learned. As can be seen in *The Green Bridge II*, he shared Italian Futurism's fascination with machines and motion and French Orphism's ambition to resurface Analytic Cubism with color. Ultimately, however, he found both movements disappointingly flat in feeling. Beguiled by the way Cubism fractured the subject into its parts, Feininger was equally curious about how things are put together. Witness his tinkering with toys and scale models and his passion for music. Moved by the clarity he found in the strict architectural patterns of music, especially Bach, he sought its visual equivalent. There is indeed a correspondence between the translucent, overlapping, repeated geometric forms in his paintings and the contrapuntal character of fugues, which Feininger himself composed. An innate romantic, Feininger invented an uplifting, mysteriously delightful artistic language.

HP

Karl Schmidt-Rottluff
German, 1884 – 1976

Portrait of Emy,
1919

Oil on canvas
28 5/16 x 25 3/4 in.
(73.5 x 65.5 cm)

Bequest of W. R.
Valentiner, 1965 (65.10.58)

The member who thought up Die Brücke's name, Karl Schmidt-Rottluff exercised a raw talent that made his style the most vigorous of the group. Exploiting an innate understanding of composition, he carved out a crudely monumental style characterized by drastically reduced forms rendered in hotly contrasting colors. His formal vocabulary reflects the impact of French Cubism, which had been exhibited in Germany since 1912; Schmidt-Rottluff was the Brücke artist most affected by the Parisian school.

If Cubism played its part in Schmidt-Rottluff's development, so did his interest in African art and his experiments with woodcut. These influences are interwoven in his *Portrait of Emy*, with its face like a mask sculpted from a block of wood. Schmidt-Rottluff contorts physical facts to emphasize emotion. Painted the year after he married Emy Frisch, the portrait of his bride manifests the aggressively anti-naturalist colors, the emphatic outlines, and the heightened distortion of appearance that typify German Expressionism. The artist allows the rough texture of the canvas to show through, further denying the illusion of reality. In succeeding decades, though he gradually softened this harsh, almost barbaric simplification of form, Schmidt-Rottluff continued extracting from his subjects a potent expressivity.

HP

Emil Nolde
German, 1867 – 1956

Still Life, Tulips,
about 1930

Watercolor on paper
18 3/4 x 13 7/8 in.
(47.6 x 35.2 cm)

Bequest of W. R.
Valentiner, 1965 (65.10.51)

Emil Nolde was a relatively little-known Impressionist when Karl Schmidt-Rottluff invited him to join the artists' alliance known as Die Brücke in 1906. Though he, like the younger Brücke artists, believed in nature's spirituality and color's expressive power, the independent Nolde soon left the group. A thrilling colorist in various media, he depicted Bible stories and primordial legends, as well as landscapes, seascapes, and flowers throughout a long career.

Nolde's watercolors best reveal his extraordinary gifts as a colorist. Watercolors, and works on paper in general, provided a crucial testing ground for many German artists of the early twentieth century. Few, however, approached watercolor with the daring intuitive panache of Nolde. An improviser, he applied the watercolor to moistened Japan paper and in effect dyed the paper with the pigment, imbuing the saturated colors with a luminous depth. Nolde also knew how to coax eloquence from paper left blank.

Still Life, Tulips has the feel of a spontaneous, exultant response to nature's glory, found in the rare and the ubiquitous. Flamboyant amaryllis oversee tulips bunched along the lower border—vermilions and scarlets radiating around one golden orb of a tulip blossom and set against the modulated tones of a dusky purple sky. The cropped composition fills the sheet, suggesting that it extends beyond its edges. This reverent, romantic watercolor sings praise to nature's awe-inspiring dynamism.

HP

Max Beckmann
German, 1884 – 1950,
active in United States
from 1947

Self-Portrait, 1932

Watercolor and
charcoal on paper
24 3/4 x 18 7/8 in.
(62.8 x 48 cm)

Bequest of W. R.
Valentiner, 1965 (65.10.4)

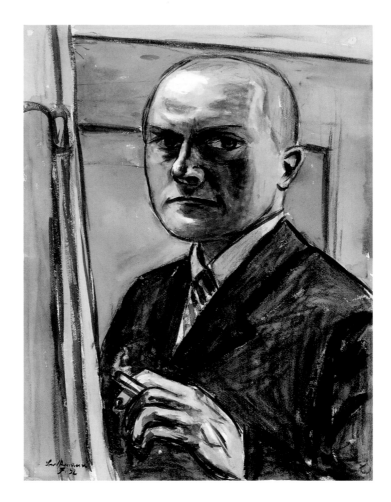

Although Max Beckmann belonged to the German Expressionists' generation, as a young painter in the second and third decades of the twentieth century he stood resolutely apart from them. In his view, their inclination toward abstraction threatened to reduce painting to mere decoration. World War I only confirmed Beckmann's determination to use art to address man's tragic fight against evil. In Beckmann's paintings, this epic struggle takes place in a stage-set world, crowded with haunting presences and relying on the symbolism of cabaret and carnival. For Beckmann, role-playing represented a survival strategy, an outlook that also found expression in a career-long series of more than eighty self-portraits in which the painter often cast himself in such guises as a circus performer or mythological hero.

In the Museum's self-portrait, however, he presents himself straightforwardly as Beckmann the artist. Without mask or costume, Beckmann retains only his ever-present cigarette and a stretched canvas on an easel, his lone weapon against the irremedial asperities of an inhuman world. The tense linearity of the watercolor's pictorial architecture squeezes the subject into a claustrophobic space typical of Beckmann — and transforms the portrait into a metaphor for the imprisonment of a soul. In the dual role of vulnerable man and intransigent artist — on the eve of the Nazi takeover when art was threatened and life itself was uncertain — he personifies the suppressed tensions of an entire age.

HP

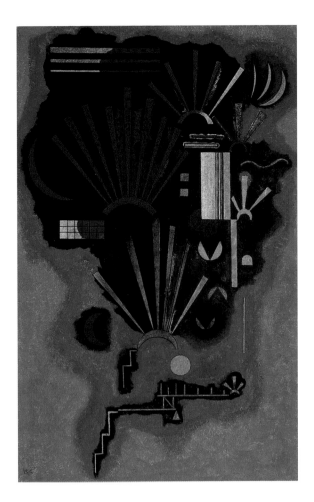

Vasily Kandinsky
Russian, 1866 – 1944,
active in Germany
and France

Zunehmen
(also known as
Croissance), 1933

Oil, egg tempera,
and ink on paper
20 1/16 x 12 3/8 in.
(51 x 31.4 cm)

Bequest of W. R.
Valentiner, 1965 (65.10.29)

Though World War I forced Vasily Kandinsky home to Russia, he spent many years before and after the war in Germany, actively involved in the artistic ferment. His influential book, *On the Spiritual in Art*, first appeared there in 1912. Acquainted with the avant-garde Brücke artists, he formed associations with more like-minded innovators such as Franz Marc and Lyonel Feininger. After the war, Kandinsky joined Feininger on the faculty of the Bauhaus, where he taught until this revolutionary school of art and design was closed by the Nazis in 1933.

Zunehmen, done that same year only shortly before Kandinsky sought refuge in France, is a testament to the artist's conviction that nonrepresentational art could be pictorial rather than decorative. The title helps reveal Kandinsky's intent. "Zunehmen" and the French name he inscribed on the painting's reverse, "croissance," both connote growth or improvement. Both words are idiomatic for the waxing crescent moon, a recurring shape in the painting.

Zunehmen has a meditative, almost cosmic quality, as though one is looking at the clustered constellations of a distant galaxy. The work's calming restraint, its lofty message pose a soft-spoken rebuke to the conditions in Germany in the early 1930s. Kandinsky, never abandoning hope for an end to, in his words, "the nightmare of materialism," envisioned an art for a new spiritual epoch.

HP

Georgia O'Keeffe
American, 1887 – 1986

Cebolla Church,
1945

Oil on canvas
20 1/16 x 36 1/4 in.
(51.1 x 92.0 cm)

Purchased with funds
from the North Carolina
Art Society (Robert F. Phifer
Bequest), in honor of Dr.
Joseph C. Sloane, 1972
(72.18.1)

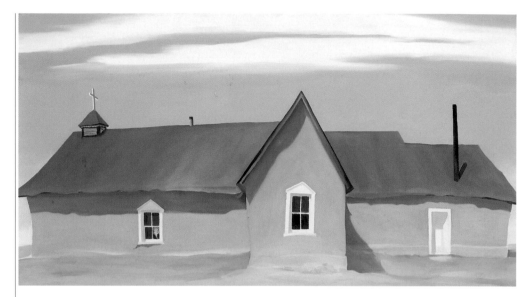

Georgia O'Keeffe was in the vanguard of artists who in the first decades of the twentieth century synthesized an energetic, self-consciously American response to European modernism. She outlived all of her contemporaries, becoming in later years a hallowed and almost mythic figure. Her best-known work was inspired by the light and rugged landscape of northern New Mexico. Beginning in 1929, she spent many summers there and eventually took up year-round residence. Never comfortable with the loud and crowded life of New York City, O'Keeffe found sanctuary among the remote highlands and valleys. Her paintings are spiritual distillations of places and things. Whether it was the wild, sensuous topography of the desert, the antlered skull of a deer, or the austere facade of a mission church, O'Keeffe invested her subjects with a mystical aura that transcended the mundane reality of desert, bone, or church.

Often on her drives through the New Mexican highlands near her home, O'Keeffe would pass through the village of Cebolla with its rude adobe Church of Santo Niño. The artist was moved by the poignancy of the little building: its sagging, sun-bleached walls and rusted tin roof seemed "so typical of the difficult life of the people." When she came to paint the church she addressed it forthrightly, emphasizing its isolation and stark simplicity. Literally formed out of the earth, the building affirms the permanence and the hard, defiant patience of the people of Cebolla. For O'Keeffe, the church symbolized human endurance and aspiration. Writing about the painting in 1973, the artist volunteered that "I have always thought it one of my very good pictures, though its message is not as pleasant as many others."

JWC

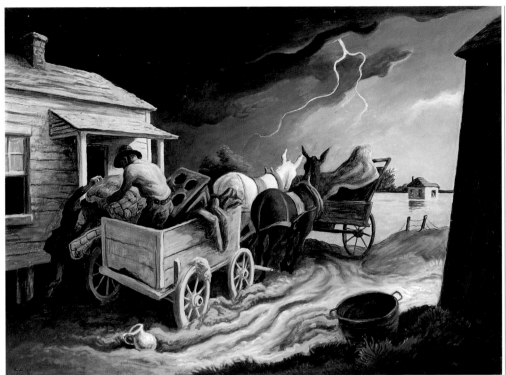

Thomas Hart Benton
American, 1889 – 1975

Spring on the Missouri, 1945

Oil on masonite
30 1/4 x 40 1/4 in.
(76.7 x 102.2 cm)

Purchased with funds
from the State of North
Carolina, 1977 (77.1.3)

In February 1937, Thomas Hart Benton was sent by the *Kansas City Star* to sketch the flood-devastated areas of southeastern Missouri. The artist reported that "the roads of the flood country were full of movers Every once in a while seepage from under the levee would force evacuation of a house and you would see a great struggle to get animals and goods out of the rising water." Benton's quick, vivid sketches later became the inspiration for *Spring on the Missouri*. However, in translating the cursory drawings into a painting, the artist reimagined the scene as epic theater, symbolic of the common man's valiant, if ultimately tragic, struggle with the forces of nature. Against a backdrop of threatening storm, two sharecroppers scramble to rescue their few possessions from the advancing river. The wagons and mules create a strong upward diagonal, evenly dividing the picture into light and dark. Within this dynamic composition, the forms are agitated and willfully distorted. Further heightening the melodrama, a low, eerie sunlight plays across the scene.

Benton not only celebrated the courage and stoic endurance of rural America; he also defied the rising tide of abstract art which he dismissed as a pretentious European import. In such pictures as *Spring on the Missouri*, he preached a nativist art, rooted in the experience of the American heartland, and as plain and eloquent as an Ozark ballad.

JWC

Eugene Berman
American, born Russia,
1899 – 1972

**Sunset (*Medusa*),
1945**

Oil on canvas
57 5/8 x 45 in.
(146.3 x 114.3 cm)

Purchased with funds
from the North Carolina
Art Society (Robert F. Phifer
Bequest), in honor of Beth
Cummings Paschal, 1974
(74.8.2)

Eugene Berman rejected modernism's faith in progress and the future. Instead, he drew inspiration from Classical antiquity, painting strange and melancholy reveries on time and the transience of life. Beginning in the 1940s, he painted a series of enigmatic women, each solitary against a backdrop of decay. Often the figures stand or sit with their backs to the viewer, or crouch with their faces hidden, as in *Sunset (Medusa)*. In each painting, the woman is visually and emotionally remote. Berman's sense of drama derived from his work as a celebrated theatrical designer.

In *Sunset (Medusa)* the female figure, clothed in velvet and lace, kneels grandly on a shallow stage before a ruined wall — an ominous setting for this eerie and uncertain drama. The heightened clarity of the image as much as the *trompe l'oeil* monogram at the bottom edge suggest Northern Renaissance art, specifically that of the German master Albrecht Dürer. According to Emily Genauer, writing in *Art Digest* in 1949, Berman explained that the "curious, spattered, almost mouldy surface" of his paintings symbolized "all the bullet-holes with which the world's walls have been peppered during [World War II], as well as our whole moral and spiritual degeneration." The beauty of the writhing locks of Berman's Medusa, modeled by the film actress Ona Munson (later Berman's wife), suggests a comic, Freudian interpretation of the snake-haired Gorgon of Greek mythology, whose horrific features turned men to stone.

VB

Andrew Newell Wyeth
American, born 1917

Winter 1946, 1946

Tempera on
composition board
31 3/8 x 48 in.
(79.7 x 121.9 cm)

Purchased with funds
from the State of North
Carolina, 1972 (72.1.1)

Andrew Wyeth's meticulously imagined art conveys a tragic vision. Considered together, his paintings comprise a lifelong meditation upon the frailty of life and the imminence of death. The artist celebrates the bleak landscape of late autumn and winter, the weathered barns and farmhouses of Maine and Pennsylvania, and the people who endure a hardscrabble existence on the margins of society.

Winter 1946 is one of the artist's most autobiographical works, painted immediately after the death of his father, the celebrated illustrator N. C. Wyeth. According to the artist, the hill became a symbolic portrait of his father, and the figure of the boy running aimlessly, Allan Lynch, "was me, at a loss—that hand drifting in the air was my free soul, groping." Even without this story, the image is troubling: a dark, jagged form set awkwardly against an oceanic swell of brown. A skilled dramatist, Wyeth eliminates all distracting elements from the scene. The boy and his thoughts are visually isolated, his eyes averted. Further deepening the physical and emotional alienation of the boy, the artist has us look down upon the scene from an improbable height. The heightened clarity of the picture results from Wyeth's use of the egg tempera medium: ground earth and mineral colors mixed with yolk and thinned with water. Wyeth liked tempera for its "feeling of dry lostness."

JWC

Joseph Cornell
American, 1903–1972

*Suzy's Sun
(for Judy Tyler)*, 1957

Wooden box construction,
with objects, paper
collage, and tempera
10 3/4 x 15 x 4 in.
(27.3 x 38.1 x 10.2 cm)

Purchased with funds
from the State of North
Carolina, 1978 (78.1.1)

Joseph Cornell, an autodidact with an associative mind, is identified with the enthralling shadow boxes he fabricated and filled with disparate objects—collected both by chance and by choice. Time and memory, themes central to Cornell, are pointedly addressed in *Suzy's Sun (for Judy Tyler)*. The sun (a cutout from an antipasto tin) and the sea (an implied presence) speak with eloquent authority of life cycles and passing time. Equally potent symbols, driftwood and the infinitely spiraling seashell readily bring to mind the tides on which they ride, summoning a universal metaphor for the ebb and flow of life itself.

The assembled elements oddly—and poetically—lead to a sense of irrevocable loss; Cornell equates the human condition with a state of permanent longing. Perhaps that outlook explains his attraction to the theater, a world where dreams become real, if only temporarily. Cornell dedicated this box to an actress, one of the many starlets who fascinated him. Judy Tyler had just achieved a certain celebrity when she was killed in an automobile accident. Suzy probably refers to the artist's assistant Suzanne Miller. The sun, designated as Suzy's, presides over the box as a life-sustaining force counteracting the finality of death. Cornell is paying homage to the magical powers of transformation possessed by both the sun and art. The elegy culminates in an ode to fantasy and creativity.

HP

Paul Delvaux
Belgian, 1897 – 1994

Antinoüs, 1958

Oil on plywood
49 1/8 x 75 1/8 in.
(124.8 x 190.8 cm)

Gift of John L. Loeb,
1962 (62.22.3)

Paul Delvaux was nearly forty when he discovered the Italian Surrealist Giorgio de Chirico, whose work was to have decisive impact on his style. Though Delvaux never officially joined their ranks, both he and the Surrealists relied on the unconscious as a source of revelation. As a result his paintings, like theirs, are haunted by enigmas. Delvaux's statuesque females—unfazed by their public nudity and largely indifferent to one another—occupy phantasmal settings. The artist's themes, shaped by incongruity and contradiction, often relate to the impenetrable isolation in which each individual dwells.

Delvaux acknowledges Marguerite Yourcenar's 1954 novel, *Memoires d'Hadrien*, as the inspiration for his painting. In this vivid reconstruction of the Roman emperor's life, Yourcenar has Hadrian musing on the nebulous borders between real-life experiences and dreams and on the inability of reason to explain matters of the heart—ideas with ready appeal for Delvaux. The artist then ignores the details of the ruler's infatuation with the exotic, ill-fated Antinoüs, who drowned in the Nile. Instead he confronts viewers with a sad and strange deathbed ritual. Only three figures pay Antinoüs any heed. The rest of the solemn celebrants—all women, many in extravagant hats, some scantily clad—Delvaux arranges frieze-like in the background and middle ground. The entire cult has been transported beyond the rational to a dream world of inexplicable mysteries.

HP

229

Morris Louis
American, 1912 – 1962

Pi, 1960

Acrylic on canvas
103 x 175 in.
(261.6 x 444.5 cm)

Gift of Mr. and Mrs.
Gordon Hanes, 1982 (82.15)

Morris Louis's paintings appear serene, almost ethereal, belying the technical difficulties involved in their making. Working within a cramped studio, the artist pleated and tacked large spans of cotton canvas to a wooden stretcher, then poured dilute paint down the pleats, tilting the stretcher to further guide the course of the liquid. Paint soaked the fabric, like watercolor into paper. Critics at the time praised the flat, uninflected character of surfaces. Writing in 1960, the critic Clement Greenberg insisted that Louis's "suppression of the difference between painted and unpainted surfaces causes pictorial space to leak through — or rather, to seem about to leak through — the framing edges of the picture into the space beyond them."

Pi is one of the earliest of the *Unfurleds*, a series of 150 monumental paintings each characterized by symmetrical banks of streaming color separated by an empty expanse of white. Despite the simplicity and flatness of the design, the bleached white of the canvas and the rivulets of color interact to create the illusion of vibrant space. In *Pi* the progression of color, warm to cool, furthers the sense of recession, as through a valley, towards a luminous void. Occupying two-thirds of the canvas, that void becomes the dominant element, uniting as well as dividing the sides. In such paintings, Louis aspired to a sublime purity of expression, cleared of the rhetorical and nonessential — a singularly visual experience.

JWC/VB

Minnie Evans
American, 1892 – 1987

King, 1962
Colored pencil on paper
11 7/8 x 8 3/4 in.
(30.2 x 22.2 cm)

Gift of Mr. and Mrs. D. H.
McCollough and the
North Carolina Art Society
(Robert F. Phifer Bequest),
1987 (87.7)

All her life Minnie Evans was pestered by admonitory dreams—and uplifted by visions of hope and happiness. Inspired by these communications she felt were from God, the self-taught artist employed a psychedelic palette to spread the good news of salvation. A long life spent entirely in southeastern North Carolina included twenty-six years as a gatekeeper at Airlie Gardens near Wilmington. Influenced by this Edenic environment, Evans realized her visions in bursting compositions matching the natural exuberance around her. Nature is one source for her abstract motifs of flowers, petals, and leaves; the Bible, another. Some drawings exude the lyricism of the Psalms; others virtually illustrate the supernatural phenomena recounted in the Revelation to John.

Nearly fifty years old before she started drawing in earnest, this African-American artist slowly evolved the emblematic presentation for which she is best known—an iconic head set in a vivid floral mandala, a format more closely resembling Near Eastern art than Western prototypes. As exemplified by the 1962 *King* (one of seven drawings by Evans in the Museum's collection), symmetry controls the lush foliage, imposing a balance that underscores the artist's view of God's proportioned design. Evans's colored-pencil representations of paradise make a joyful noise, testifying to her faith in a world harmony. This rhapsodic visionary dwells on earthly abundance rather than hardship, heavenly reward rather than retribution.

HP

Henry Spencer Moore
British, 1898 – 1986

Large Standing Figure: Knife Edge, 1961, cast 1976

Bronze
h. (including base)
137 1/2 in. (349.3 cm)

Bequest of Gordon Hanes, 1997 (97.1)

A pioneering genius, this long-lived, prolific sculptor made work in wood, stone, and bronze that can be found all over the world. As a young student in London, Henry Moore absorbed the influences around him, both the work of his contemporaries (notably the Surrealists, Picasso, and the Romanian sculptor Constantin Brancusi) and in particular the pre-Columbian and ancient art in the British Museum. It is easy to see a connection between *Large Standing Figure* and ancient art. Interestingly, Moore first called an earlier version of this work *Winged Victory*, acknowledging a debt to an earlier "Winged Victory," the Louvre's Hellenistic *Nike of Samothrace*.

The three variants of this sculpture have a second source; they are based upon a bone. Moore liked the shape of bones. He studied and drew them in museums, in the landscape, or in his kitchen. This practice reached a climax in the early 1960s, at about the time Moore had the idea to model a work on the knife-edge thinness of a bird's breast bone. Moore worked up the maquette extensively in clay, adding vestigial head and arms and elaborating the torso with drapery — and thus drawing out an affinity with Greek sculpture. The relationship to a bird, however, is not lost. The sculpture retains a suggestion of a wingspread and, with the wings' diagonal orientation, a sensation of rising skyward.

HP

Henry Spencer Moore
British, 1898 – 1986

Large Spindle Piece,
1968 – 69, cast 1974

Bronze
h. 128 x w. 127 x
diam. 77 1/4 in.
(325.1 x 322.6 x 196.2 cm)

Gift of Mr. and Mrs.
Gordon Hanes, 1980
(80.6.3)

Henry Moore especially admired Constantin Brancusi for returning sculpture to uncomplicated, basic shapes, a lesson he took to heart. A striking formal simplification is a hallmark of Moore's oeuvre.

The soft curves and bulges of *Large Spindle Piece* reflect the artist's abiding interest in organic form, yet its pointed projections — echoing machine parts — demonstrate that he was not unaffected by modern technology. For Moore's concern was not just with nature and the human figure, but with their relationship to the man-made environment. The colossal *Spindle* represents a variation on the "points" theme which Moore first used in the 1930s. For Moore, the points activate form. He further enlivens the mass by introducing a void into the solid, manipulating empty space as deftly as he does metal. Not an inert shape, the sculpture weighs in as an elemental force. Sited to honor Moore's intention that the work be viewed from different angles, *Large Spindle Piece* is perhaps best seen — its robust upward spiral explicit — against the backdrop the artist preferred above all others, the sky.

HP

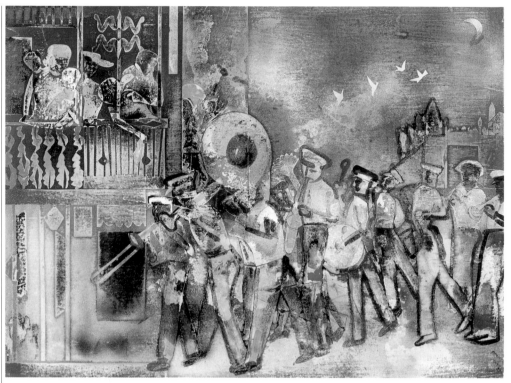

Romare Bearden
American, 1912 – 1988

**New Orleans:
Ragging Home**, 1974

Collage of plain, painted,
and printed papers, with
acrylic, lacquer, graphite,
and marker, mounted
on masonite
36 1/8 x 48 in.
(91.7 x 122 cm)

Purchased with funds
from the State of North
Carolina and various
donors, by exchange,
1995 (95.3)

Using a basically Cubist composition and adopting techniques from Abstract Expression-ism, Romare Bearden lays lush veils of pigments over cutouts of printed and painted papers, infusing his collages with remarkable emotional power. The artist exploits technique to rein-force theme — the black matriarch, his North Carolina heritage, the Civil Rights movement, and music. Collage, pieced and patched, serves as a metaphor for the struggle of African Americans in this society to establish identity. In Bearden's hands, collage also reminds the viewer that humankind, for all its fragmented diversity, enjoys common bonds.

New Orleans: Ragging Home is from *Of the Blues*, a series in which Bearden commemo-rates the blues of his native South and the jazz he heard in Harlem from his boyhood on. The collages tell the story of the music, while at the same time Bearden builds with color and repeating shapes an approximation of the jazz sound. In *New Orleans: Ragging Home*, Bearden uses modulated tones as an equivalent of the slurred or bent quality of blue notes to convey a transcendent message. A brass and drum band, ragtiming its way home from a funeral through a mercurial blue twilight, pulls off that miraculous transformation: consoled by song, the mourners become celebrants of art and life.

HP

Robert Rauschenberg
American, born 1925

Credit Blossom
(*Spread*), 1978

Solvent transfer, quilt,
and other fabrics on
paperboard applied to
gessoed wood panel
84 1/8 x 108 1/4 in.
(213.7 x 275 cm)

Purchased with funds
from the National
Endowment for the
Arts, the North Carolina
Art Society (Robert F.
Phifer Bequest), and the
State of North Carolina,
1979 (79.2.6)

Robert Rauschenberg is a synthesizing innovator. As a student at Black Mountain College in western North Carolina, he shared ideas with the iconoclastic composer John Cage and learned from the austere abstract painter and former Bauhaus teacher Josef Albers. While with Cage he could detect the aesthetic in the banal, he also was receptive to the disciplined training that Albers insisted upon. A formidably gifted renegade, Rauschenberg bridged the divide between Abstract Expressionism and Pop Art, helping keep the representational tradition viable. His use of materials, however, is imaginatively nontraditional. In 1955, he made a painting out of his own bed (*Bed* is in the Museum of Modern Art in New York). Nearly twenty-five years later, in perhaps a mischievous nod to that well-known "combine" (a hybrid of painting, collage, and sculpture), he constructed — rather than painted — *Credit Blossom* (*Spread*). Made of a worn quilt and fabrics, the work is printed with images appropriated from the media.

The primary colors and the patterned surface give *Credit Blossom* a gaily decorative lift that at first camouflages the work's structure and message. The multiple clockfaces (which the repeating patterns in the quilt somewhat resemble) testify that time rules in these assembled pictures of rest and activity. The artist also pairs other contrasts: the natural and the technological, the homespun and the factory-made, the supposedly simpler past and the undeniably complicated present. The images around all four edges of the quilt are like quilters at a quilting bee, drawn up to their work-in-progress. Repose is at *Credit Blossom*'s heart, the necessary center, the eternally elusive goal.

HP

242

Anselm Kiefer
German, born 1945

Untitled, 1980 – 86

Oil, acrylic, emulsion,
shellac, lead, charcoal, and
straw on photographic
print, mounted on
canvas; with stones,
lead, and steel cable

Three parts, left panel:
130 1/4 x 73 in.
(330.7 x 185.4 cm);
center panel:
130 5/8 x 72 5/8 in.
(331.7 x 184.9 cm);
right panel:
130 1/4 x 72 7/8 in.
(330.7 x 185.0 cm)

Purchased with funds
from the State of North
Carolina, W. R. Valentiner,
and various donors, by
exchange, 1994 (94.3/a – c)

A German born in the last months of World War II, Anselm Kiefer grew up in the ashes of the Third Reich. Among his earliest memories were bombed-out cities and scorched fields, indelible images that the artist would later recycle in his work. Though Kiefer in his art frequently addresses historical themes, including the Nazi era, he neither commemorates nor illustrates. Rather, he employs history and mythology (another form of memory) together with science, literature, and philosophy in a sustained meditation upon time, existence, and the tragic course of human events.

The Museum's painting summarizes many of Kiefer's central concerns. The viewer is first confronted with a grandeur of scale, a density of material, and a complexity and opacity of meaning that demands complete attention. The painting presents a vast, cosmic vision, the interpretation of which is left deliberately and maddeningly ambiguous. The three-part format, suggestive of an altarpiece, identifies the painting as a symbolic representation of a spiritual mystery. The drama is played out against a scarred landscape that can be readily imagined as the dark and rain-sodden aftermath of battle. The central image is of a great serpent coiled at the foot of a ladder. The ladder, forged of lead, might refer to the dream of the patriarch Jacob, who saw angels descending and ascending a ladder from heaven (Genesis 28:12). Kiefer's ladder seems to offer a similar conduit between the material and the spiritual worlds. The identity of the serpent is more puzzling. Is it the snake who brought evil into the Garden, or is it one of the angelic host come to earth? (Kiefer has used serpents in other paintings to represent seraphim and cherubim, the angels closest to God.) Likely, the artist accepts the serpent as indivisibly good and evil, its duality a metaphor for the confusion of earthly and spiritual desires.

Gilbert and George
British, born Italy 1943
British, born 1942

Cabbage Worship,
1982

30 hand-colored
gelatin silver prints
Each 23 1/2 x 19 1/4 in.
(59.7 x 48.9 cm)
Overall 118 3/4 x 120 in.
(302 x 305 cm)

Purchased with funds
from the Madeleine
Johnson Heidrick
Bequest, 1984 (84.5)

Though two human beings (albeit surnameless), Gilbert and George are in fact a single artistic entity. Collaborators since they met in 1967 at St. Martin's School of Art in London, they have made a name for themselves with wacky, stilted work existing in a netherworld somewhere between conservative and liberal attitudes, titillation and seriousness.

By 1977, Gilbert and George had settled on a format—exemplified by *Cabbage Worship*—for their billboard-size "photo-pieces": rectangular photographs abutted to form a grid and creating one overall image. Contradiction and contrivance energize this blaring visual language, whose strict order contains highly expressionistic content. *Cabbage Worship*, with its heavy black outlines and intense colors suggesting a stained-glass window, is from a series about current spiritual crises entitled *Modern Faith*; this photo-piece spotlights the growth industry of cultism. The object of devotion is not the Godhead but a head of cabbage, lampooning how human beings place their faith in dubious causes—which they promote with fanatical extremism as denoted by the clenched-fist salutes. The artists are present (Gilbert at the top, George at the bottom), while in the foreground an ambiguous youth mouths the credo but turns away from the Cabbagehead. Is he a malleable mind ripe for brainwashing or society's hope for freedom from manipulation and zealotry?

HP

Roger Brown
American, born 1941

American Landscape with Revolutionary Heroes, 1983
Oil on canvas
84 x 144 in.
(213.4 x 365.8 cm)

Purchased with funds from the Madeleine Johnson Heidrick Bequest, 1984 (84.2)

Convinced that much of modern art is irrelevant to real life, Alabama native Roger Brown addresses varied subjects of current interest in an emblematic visual language devised for accessibility. Nonetheless, complexity resides in these snappy images with their quick impact. Relying on symmetrical compositions, the Chicago Imagist painter also balances clarity and paradox, the jokey and the serious, and lessons learned from the museum and the streets.

American Landscape with Revolutionary Heroes salutes the founding fathers of the United States: (from left to right) Alexander Hamilton, Benjamin Franklin, Thomas Jefferson, George Washington, James Madison, and John Marshall. Cloaked in shadow and solemnly posed in a cramped stage-like space, the life-size figures form a frieze before a countryside quintessentially American in its vastness. But the background is more like a backdrop. And characteristically, Brown has secreted a puzzle of meaning in the patterned landscape. The pinwheel arrangements of the sumac plants and the horizontal bands of fields read as stars and stripes, as if these eighteenth-century heroes backed up to a scrim painted with a Pop version of the American flag.

Silhouetting these men in a setting of eerie, turquoise luminosity suggests that the ideals which the founding fathers represent risk abasement. This brooding history painting, in which past and present meet across a great divide, is commentary turned cautionary.

HP

Guillermo Kuitca
Argentine, born 1961

People on Fire, 1993

Mixed media on canvas
76 1/4 x 109 7/8 in.
(193.7 x 279.1 cm)

Purchased with funds
from various donors, by
exchange, 1993 (93.3)

Argentine artist Guillermo Kuitca is fascinated by maps, houseplans, and genealogical charts as metaphors for locating the self. His paintings, highly analytical and devoid of the human figure, awaken a disquieting sense of alienation and psychological vacancy. In _People on Fire_, Kuitca charts a bleak human terrain. Instead of towns, the lines connect people, stitching a taut fabric of names, faceless others of our species. We read them as we might read stones in a cemetery, presuming significance in the rhythms and coincidences: Laura Orellana, Ramon Rivas, Gabriela Rivas, Juan Pablo Villa, Helena Rivas, Joaquin Burgos, Monica Pratti, Norberto Podesta, Selva Orfila, Alfredo Rivas, Ariel Rivas — ourselves by any other name.

With the routine fervor of a clerk, the artist diagrams this community, ordering and systematizing, even color-coding each name by gender: males are orange, females pink. Oddly, he leaves several sites blank, explaining them as symbolic of the people unknown, yet connected to the whole. But to anyone aware of modern Argentine history, the blanks would as readily call to mind the _Desparecidos_, the thousands of the artist's countrymen who "disappeared" in the military terror of the late 1970s. Still, there is more than random fear and menace. There is something grandly apocalyptic in this image of the human tribe encircled by roiling washes of carmine and ash. Against the chaos, the intricate architecture of kinship and relations seems little more than a jerry-built folly. Here, in time for the millennium, is a prophetic vision of the burnt and the burning.

JWC

Edward Ruscha
American, born 1937

**Scratches on
the Film**, 1993

Acrylic on canvas
36 1/16 x 72 in.
(91.6 x 182.9 cm)

Purchased with funds
from the North
Carolina Museum
of Art Foundation,
Art Trust Fund,
1997 (97.2)

The term "Pop art" may first bring to mind Andy Warhol and the New York scene, but among the key works of the Pop movement are wry, painted images of words by Los Angeles artist Edward Ruscha. Throughout a long career (which anticipated the language-oriented art prevalent in the 1980s), Ruscha has captured the poetic intensity of simple words and phrases culled from the American vernacular. Ruscha manifests, as Peter Plagens wrote in *Sunshine Muse: Contemporary Art on the West Coast*, an "easygoing, nonmilitant Pop, as at home in Southern California as was Impressionism on the banks of the Seine."

In *Scratches on the Film*, Ruscha exploits the canvas nap to convincingly create the surface texture of an old piece of film, scratched and faded to a sepia color. Floating on the simulated celluloid are the final words of a vintage movie, "The End," spelled out in Gothic lettering. The oversized, old-fashioned typeface immerses viewers in the nostalgic romanticism of old movies, a mood done in by the apocalyptic implications of the inscribed message and the creeping realization that the artist's tone might well be mock-serious. By giving everyday phrases glorified treatment, Ruscha encourages a reconsideration of the complex relation between word and image, as well as between word and speaker.

HP

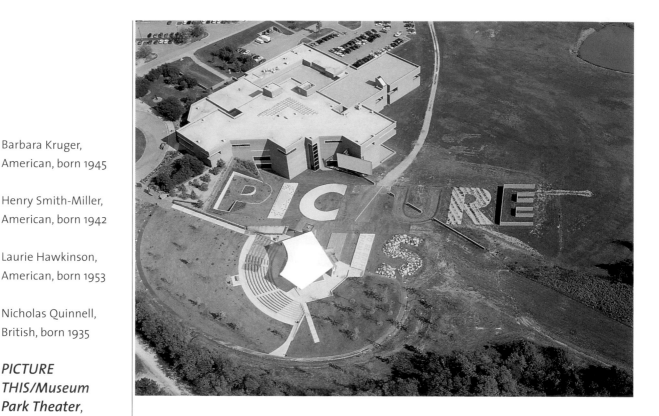

Barbara Kruger,
American, born 1945

Henry Smith-Miller,
American, born 1942

Laurie Hawkinson,
American, born 1953

Nicholas Quinnell,
British, born 1935

*PICTURE
THIS/Museum
Park Theater*,
designed
1992 – 94,
constructed
1994 – 97

The Museum's new outdoor stage and cinema is the result of a unique collaboration by an artist, architects, and a landscape architect. An amalgam of art and architecture, this work's dominant feature is the phrase PICTURE THIS. The giant letters are sculpted into the landscape and sprawl over two-and-one-half acres, while the stage, seating, and enormous film screen are woven into the fabric of the text.

The "P" is cut into a slope, its massive retaining wall cast with Barbara Kruger's provocative phrases. The two concrete "I"s consider North Carolina's history and geography, one with roadside historic markers tethered to a giant map of the state, the other filled by the state's motto, "TO BE RATHER THAN TO SEEM." The paved "T" reminds us of North Carolina as "the good roads state" while the "U" and "R" are planted. The "S" is formed by playfully piled boulders, and the "C" is an enormous sandbox for games and movie watching. Scattered within the walled "E" are stainless-steel plaques inscribed with quotations selected by Kruger. The stage canopy with its "walking strut" system articulates an off-balance movement over the shifting planes that form the letter "H" and the stage. Together, these elements create a collection of sculptural events in the landscape that expand the vocabulary of contemporary environmental art being produced internationally.

PICTURE THIS seems an open-ended cajole, an obvious response to gallery pictures. The design conceptually represents a turning inside-out of traditional notions of a museum. It offers a complement to and creates a dialogue with the great treasures held within the Museum walls.

DPG

Glossary of Selected Terms

References for Quotations

Index

abstraction

A work of art without a recognizable subject, or a work in which certain aspects of the subject are emphasized, simplified, or otherwise altered from natural appearance.

altarpiece

A painted or carved work of art situated behind and above the altar in a Christian church.

Analytical Cubism

The earliest phase of Cubism, in which portrait or still-life subjects can be recognized, but the figure or object is broken into many geometric shapes, portrayed from several different angles simultaneously, and represented in a narrow range of muted colors such as browns, grays, and greens.

aquatint

A printmaking process in which a copper plate is partly or completely covered with a solution of asphalt, resin, or salts, producing a granular surface. The plate is then immersed in acid, which etches the exposed areas. After the surface of the plate has been cleaned, ink is pressed into the acid-etched surface. When the ink is transferred to paper, the resulting print has rich tonal areas.

ba

In Egyptian art and thought, a manifestation of the soul of the deceased in the form of a bird with a human head.

Bauhaus

An innovative German school of architecture, art, craft, and design founded in 1919 by the architect Walter Gropius in Weimar. The school moved to Dessau and finally to Berlin before being closed by the Nazis in 1933.

black-figure vase painting

A technique of Greek vase painting in which figures and designs are defined in black pigment against the reddish-colored clay of the vessel. Internal details are scratched in with a needle, or painted in contrasting white or purple pigment.

Byzantine

Having to do with the history, culture, or art of the medieval Eastern Christian empire whose capital was Constantinople (called Byzantium by the ancient Greeks, and known as Istanbul today).

Canopic jars

Four containers used to contain the internal organs (intestines, liver, lung, stomach) removed during the mummification process in ancient Egypt, often with lids representing the heads of the four sons of the sky/sun god Horus.

Caravaggisti
Followers of the Italian Baroque painter Caravaggio (1571 – 1610).

caryatid
A sculpted female figure that serves as a supporting column.

chiaroscuro
In painting and drawing, a method of using gradations of light and shade (Italian *chiaro*, light + *oscuro*, dark) to model forms so that they appear three-dimensional.

collage
From the French *coller* (to paste): a composition made by gluing onto a flat surface scraps of cut or torn material, such as various types of paper or cloth, to which drawn or painted elements may be added.

Corinthian
a) One of the Classical orders of architecture, consisting of a system of carefully proportioned structural elements and designated ornament, including acanthus leaf decoration on the column capitals; b) Of or relating to the ancient Greek city of Corinth.

Counter-Reformation
The efforts of the Roman Catholic Church in the sixteenth and seventeenth centuries to combat the influence of the Protestant Reformation, and the resulting renewal and reform in the Catholic Church.

Cubism
A non-realistic style of art pioneered in Paris in the early twentieth century, which fractures forms and space into angular, geometric shapes.

Cupid
The Latin name for the young god of love, called Eros by the Greeks, who is often shown as a boy with wings, carrying a bow and arrows, with which he pierces hearts with passion.

Die Brücke
The name of an association of avant-garde German artists, founded in Dresden in 1905. The name, which means "The Bridge," expressed their desire to form a bridge toward the art of the future.

Danube School
A loosely associated group of artists active in the German-speaking territories flanking the Danube River during the first half of the sixteenth century. Alpine landscape backgrounds feature prominently in paintings and prints produced by these artists.

diptych
A work of art consisting of two painted and/or carved panels, called wings, hinged together.

Doric
One of the Classical orders of architecture, consisting of a carefully proportioned system of structural elements and specified ornament, such as a horizontal band or frieze of triglyphs and metopes.

emblematic literature
A type of literature especially popular in the Netherlands in the seventeenth century, but which apparently originated earlier in Italy. Its most common form was that of the emblem book, in which images (emblems) were briefly described through a motto, then more fully analyzed in a longer text.

engraving
A printmaking process in which lines are incised into a copper plate using a sharp metal tool. Ink is pressed into the incised lines, the surface of the plate is wiped clean, and the ink is transferred onto paper, producing a reverse of the design on the plate.

etching
A printmaking process in which a copper plate is coated with an acid-resistant resin and a drawing is made on this surface with a sharp metal tool, exposing the metal. The plate is immersed in acid, which eats into the metal where it has been exposed. When the resin coating has been removed, ink is pressed into the etched areas, then transferred to paper to produce a reverse image of the design on the plate.

Eros
The Greek name for the young God of Love, called Cupid by the Romans, who is often shown as a boy with wings, carrying a bow and arrows, with which he pierces hearts with passion.

fresco
True fresco (Italian *fresco*=fresh) is the technique of painting on moist plaster with ground pigments suspended in water so that the paint is absorbed into the plaster and becomes part of the wall as it dries. Dry fresco is the technique of painting with water-based pigment on dry plaster.

Futurism
An early twentieth-century Italian art movement which combined Cubism's fracturing of forms with an emphasis on rapid movement inspired by the modern machine age.

genre
a) A style or category of art; b) A work of art that portrays scenes from everyday life.

Hellenistic
Of or relating to Greek history and culture from the death of Alexander the Great in 323 B.C. to the accession of Augustus as the first Roman emperor in 27 B.C.

hieroglyphic
A form of writing in which a picture of a figure, animal, or object stands for a word, syllable, or sound.

icon
A sacred image of one or more divine or holy personages, such as Christ, the Virgin Mary, or saints, usually painted on a wooden panel and venerated by Eastern Christians.

iconography
The study of the symbolic meanings of objects, persons, and events portrayed in works of art.

in situ
A Latin term meaning "in position" or "in location," which describes an object or work of art which is in the location for which it was originally intended.

International Style
The International Style of Gothic art originated in France and northern Italy in the mid-fourteenth century and spread to other parts of Europe and was characterized by a combination of naturalism with lavish use of rich ornament.

Ionic
One of the Classical orders of architecture, consisting of a system of carefully proportioned structural elements and designated ornament, including a double volute (a spiral, scroll-shaped form) on the column capitals.

mandala
A geometric symbol for the cosmos in Buddhist and Hindu art and thought.

maquette
A small preliminary model for a three-dimensional work of art.

mastaba
An ancient Egyptian tomb of rectangular form with sloping sides and a flat roof that covered a funerary chapel for offerings to the deceased and a shaft to the burial chamber.

metope
One of the square areas alternating with the triglyphs on a Doric frieze.

Biblical quotations come from *The New Revised Standard Version*, 1989, except for those in the section "Jewish Ceremonial Art," which follow the translation authorized by the Jewish Publication Society, 1985.

[Stanzione] p. 136
Jacobus de Voragine. *The Golden Legend of Jacobus de Voragine*. Trans. Granger Ryan and Helmut Ripperger. Salem, New Hampshire, 1969, p. 454.

[Reni] p. 138
Carlo Cesare Malvasia. *Felsina Pittrice*. Vol. 2. 1678. Ed. cited: Bologna, 1841, p. 53.

[Batoni] p. 144
Francesco Benaglio. "'Abbozzo' della vita di Pompeo Battoni pittore luchese . . ." In *Vita e prose scelte di Francesco Benaglio*. Ed. Angelo Marchesan. 1747–57. Ed. cited: Treviso, 1894, pp. 62–63.

[Canaletto] p. 147
P. A. Orlandi. *Abecedario Pittorico, corretto e accresciuto da P. Guarienti*. Venice, 1753.

[Van Dyck] p. 162
Giovanni Pietro Bellori. *Le vite de pittori, scultori et architetti moderni*. Ed. E. Borea. Turin, 1976, p. 262.

[Nattier] p. 173
Pierre de Nolhac. *Nattier: Peintre de la cour de Louis XV*. Paris, 1910, pp. 206–07.

[Volaire] p. 176
Roger Hudson, ed. *The Grand Tour*. London, 1993, p. 199.

[Canova] p. 181
Ugo Foscolo. *Epistolario* 17–IV. 1954, p. 177.

[Millet] p. 182
Eric Zafran. *French Salon Paintings from Southern Collections*. Atlanta, 1982, p. 148.

[Boudin] p. 184
Charles F. Stuckey, ed. *Monet: A Retrospective*. New York, 1985, p. 271.

[Pissarro] p. 186
John Rewald, ed. *Camille Pissarro: Letters to his Son Lucien*. New York, 1943, p. 270.

ibid., pp. 282–83.

[Copley] p. 191
Jules David Prown. *John Singleton Copley*. Vol. 2. Cambridge, Mass., 1966, p. 246.

[Cole] p. 193
Marschall B. Tymn, ed. *Thomas Cole's Poetry*. York, Penn., 1972, p. 47.

[Mayr] p. 196
Frederick Marryat. *Diary in America*. Ed. Jules Zanger. Bloomington, 1962, p. 273.

[Ranney] p. 197
Francis S. Grubar. *William Ranney: Painter of the Early West* (exh. cat.). Washington: National Gallery of Art, 1962, p. 29.

[Bierstadt] p. 202
Fitz Hugh Ludlow. *The Heart of the Continent: A Record of Travel Across the Plains and in Oregon, with an Examination of the Mormon Principle*. New York, 1870, p. 440.

[Homer] p. 204
Nicolai Cikovsky, Jr. and Franklin Kelly. *Winslow Homer*. Washington, 1995, p. 117.

[Saint Gaudens] p. 206
Homer Saint-Gaudens, ed. *The Reminiscences of Augustus Saint-Gaudens*. Vol. 1. New York, 1913, p. 354.

[Eakins] p. 208
Horace Traubel. *With Walt Whitman in Camden*. Vol. 1. Boston, 1906.

[Frieseke] p. 209
Clara T. MacChesney. "Frieseke Tells Some of the Secrets of His Art." *New York Times*, 7 June 1914, sec. 6, p. 7.

[Sterne] p. 214
Charlotte Leon Mayerson, ed. *Shadow and Light: The Life, Friends and Opinions of Maurice Sterne.* New York, 1965, pp. 105–06.

[Hartley] p. 215
Hartley to Alfred Stieglitz, 3 November 1914. Collection of American Literature, Beinecke Rare Book and Manuscript Library, Yale University.

Hartley to Stieglitz, Dec. 1913. Yale.

Hartley to Stieglitz, 12 Nov. 1914. Yale.

[Kandinsky] p. 221
Vasily Kandinsky. *Concerning the Spiritual in Art and Painting in Particular.* 1912. Reprint: The documents of modern art series. Robert Motherwell, dir. New York, 1947, p. 24.

[O'Keeffe] p. 222
Georgia O'Keeffe to Dorothy B. Rennie, October 1973. NCMA curatorial files.

[Benton] p. 223
Thomas Hart Benton. *An Artist in America.* New York, 1937, p. 147.

[Berman] p. 224
Emily Genauer, "Less Theater, More Drama for Berman." *Art Digest* 24 (1 Nov. 1949), p. 9.

[Wyeth] p. 225
Richard Meryman. *Andrew Wyeth: A Secret Life.* New York, 1996, p. 227.

[Diebenkorn] p. 226
Dan Hofstadter. "Almost Free of the Mirror" *New Yorker*, 7 Sept. 1987, p. 59.

[Kline] p. 227
Katharine Kuh. *The Artist's Voice: Talks with Seventeen Artists.* New York, 1962, p. 144.

[Louis] p. 230
Clement Greenberg. "Louis and Noland." In *The Collected Essays and Criticism.* Vol. 4. Ed. John O'Brian, 1993, p. 97.

[Lawrence] p. 235
Ellen Harkins Wheat. *Jacob Lawrence: The Frederick Douglass and Harriet Tubman Series of 1938–40.* Hampton, Va., 1991, p. 30.

[Stella] p. 236
Bruce Glaser. "Questions to Stella and Judd" *Art News*, Sept. 1966, p. 5.

[Baselitz] p. 241
"The Upside-Down Object," in Diane Waldman, *Georg Baselitz* (exh. cat.). New York: Solomon R. Guggenheim Museum, 1995, p. 214.

[Kiefer] p. 243
Charles W. Haxthausen. "The world, the book, and Anselm Kiefer," *Burligton Magazine* 133 (December 1991), p. 850.

[Williams] p. 248
Williams quoted in Valerie J. Mercer, *William T. Williams: Fourteen Paintings* (exh. cat.). The Montclair Art Museum, 1991, n.p.

Henry J. Drewal and David C. Driskell. *Introspectives: Contemporary Art by Americans and Brazilians of African Descent* (exh. cat). Los Angeles: The California Afro-American Museum, n.p.

[Richter] p. 249
Roald Nasgaard. *Gerhard Richter: Paintings.* London, 1988, p. 27.

[Murray] p. 253
Sue Graze and Kathy Halbreich. *Elizabeth Murray: Paintings and Drawings.* New York, 1987, p. 130.

[Ruscha] p. 255
Peter Plagens. *Sunshine Muse: Contemporary Art on the West Coast.* New York, 1974, p. 142.